Edited by Kasia Redzisz and Stephanie Straine

EDWARD KRASIŃSKI

Tate Liverpool

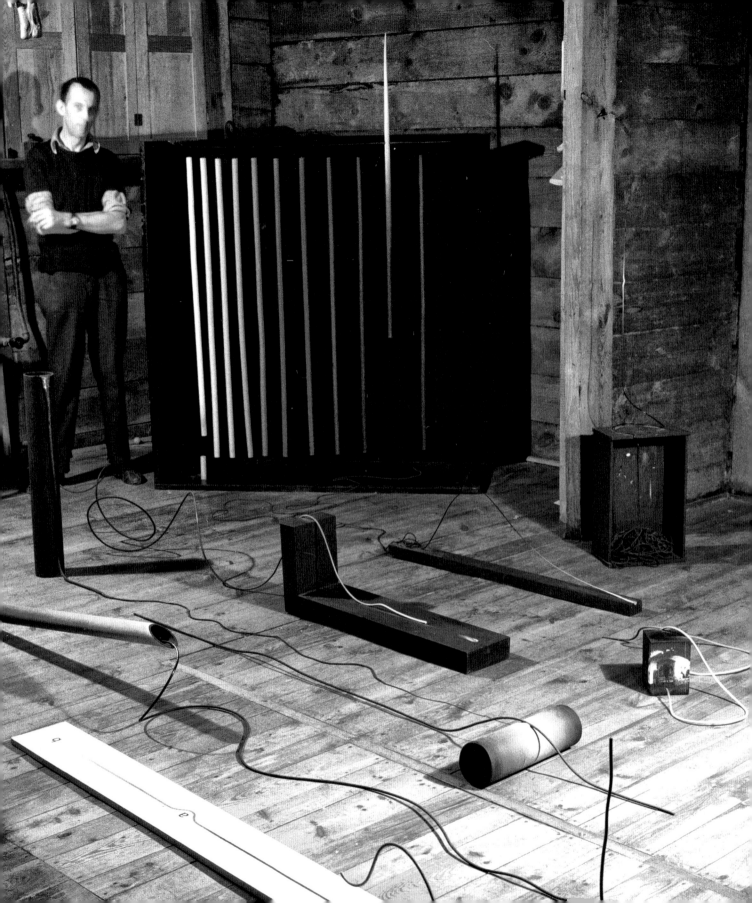

Edward Krasiński with his works at his house,
Zalesie, 1968

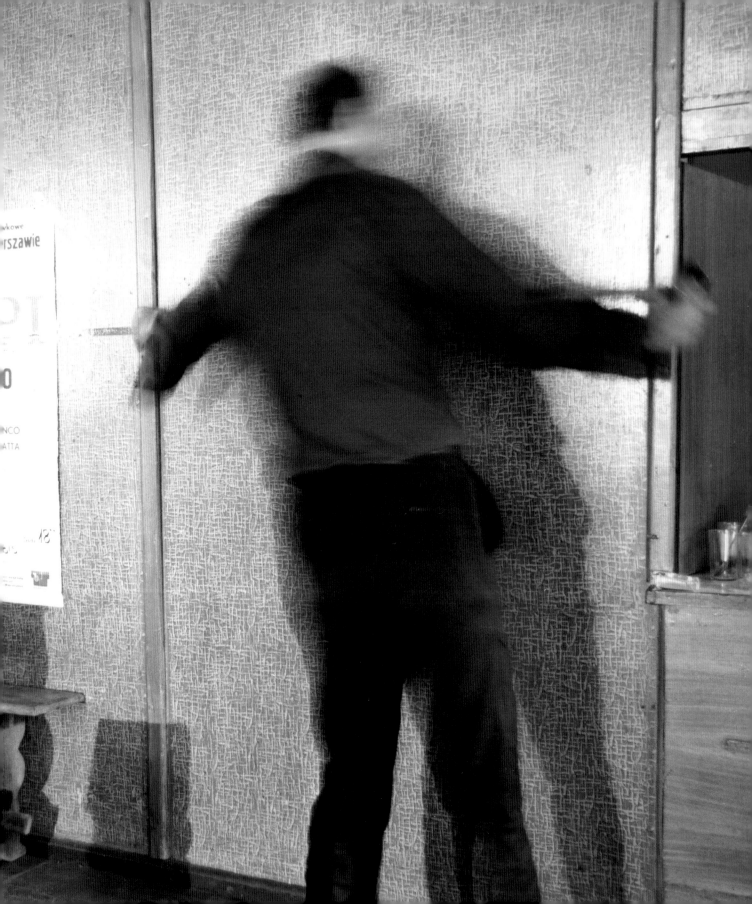

FOREWORD

Tate Liverpool and Stedelijk Museum Amsterdam are honoured to present this timely exhibition of works by Edward Krasiński (1925–2004), one of the most significant Eastern European artists of the twentieth century. This catalogue is the first major publication in over a decade on the work of Krasiński, marking the occasion of his first-ever institutional retrospective in the United Kingdom and the Netherlands. Together, the exhibition and publication will enable this compelling and influential body of work to be discovered by a new generation, reflecting the continued and growing international critical interest in the artist's work.

The exhibition, which spans over forty years of Krasiński's remarkable career from the early 1960s to the 2000s, investigates the development of the artist's unique formal language and approach to art and exhibition-making, showcasing his dynamic sculptures, interventions and installations. Bringing together an impressive number of the artist's works, *Edward Krasiński* offers visitors a rare insight into Krasiński's often overlooked contribution to the global tendencies of the 1960s, including minimalism and conceptual art, while also focussing on the artist's work from a contemporary perspective, underlining his importance for present-day visual-arts practice and theory.

Tracing his interest in the reduction of sculpture to mere line, as witnessed in his suspended sculptures of 1964 and 1965 that often appear gravity-defying in their combination of invisible wires, visual puns and trickery, the exhibition examines Krasiński's preoccupation with blue adhesive tape, an off-the-shelf commercial material he introduced in 1969 and used until the end of his career to physically unify objects and space. He once remarked: 'I place it horizontally at a height of 130cm everywhere and on everything. I encompass everything with it and go everywhere.' Re-creations of Krasiński's landmark exhibitions from across his career, such as his early solo shows and his contribution to the 1970 Tokyo Biennial, help to track his progressive interest in staging spatially dynamic situations or installations, while major groups of his axonometric *Interventions* from the 1970s, 1980s and 1990s open up the spatial possibilities for his use of blue tape.

An exhibition of this ambition, scope and innovation requires the collaboration and knowledge of a great many people, both within our institutions and beyond. Our thanks must go first of all to the exhibition's curator, Kasia Redzisz, Senior Curator at Tate Liverpool, for her role in championing the project and the artist's work more widely within Tate, underlined by her dedicated involvement with Tate's Russian and Eastern European Acquisition Committee, established in 2012. Kasia's expertise, tenacity and passionate belief in these works have propelled this exhibition and its publication forward at every turn.

Kasia joins us in thanking the many people who have made the exhibition possible, including the numerous lenders to the show, whom we are pleased to acknowledge by name at the end of the publication. Our sincere gratitude goes to the artist's daughter and head of the artist's estate, Paulina Krasińska, for her generosity, openness and guidance, along with Andrzej Przywara, Director of the Foksal Gallery Foundation, who has been so helpful with his extraordinary knowledge of the artist

Edward Krasiński at the *17th Meeting of Artists, Art Scholars and Art Theorists – Osieki '79. The Fourth Dimension*, Osieki, Koszalin, 1979

Francesco Manacorda, Andrea Nixon and Beatrix Ruf

and his artworks, encouraging the evolution of the exhibition throughout. Equally, Aleksandra Ściegienna of Foksal Gallery Foundation has given freely of her time and expertise in assisting the development of the project and sharing with the curatorial team her in-depth knowledge of this singular artist. Deserving particular mention is the estate's generous loan of works and its support for this publication. We also thank Anka Ptaszkowska for her insightful observations about Krasiński's work and for kindly sharing with us the photographs of Eustachy Kossakowski, so prominently featured in this publication. We would also like to mention the involvement of Katarzyna Krysiak and Lech Stangret from Foksal Gallery in Warsaw, which holds an extensive archive of the artist, and of Ewa Skolimowska, whose archival research significantly informed the work of our curatorial team. Finally, we are grateful to Babette Mangolte for the generous loan of her 2012 film *Edward Krasiński's Studio*, which enables our audiences to gain a crucial insight into the artist's most sustained artwork/environment: his own living and working space.

In this catalogue, we are honoured to feature a new essay by Professor Jean-François Chevrier of École nationale supérieure des Beaux-Arts, Paris, which considers the artist's studio in philosophical and art-historical terms. We thank him for his willingness to engage so meaningfully with the artist's studio as both environment and artwork. Art historian and critic Karol Sienkiewicz contributes a valuable essay on the social fabric of Krasiński's practice as it manifested across many decades within the avant-garde artistic scene of postwar Warsaw, while an essay by Senior Curator Kasia Redzisz explores the artist's relationship with performance and his approach to exhibition-making. Finally, Stephanie Straine, Assistant Curator at Tate Liverpool, provides an informative essay on Krasiński's participation in a pivotal group exhibition of the 1960s in New York. For the production of this publication, we are deeply grateful to catalogue designer Sara De Bondt for her characteristically intelligent ideas, creative layouts and impeccable overall design. We would like to acknowledge Catherine Hooper, whose role as freelance Project Editor has been crucial to this publication from its inception. We would also like to thank Jemima Pyne, Ian Malone and Laura Deveney for their efficiency and enthusiasm in supporting the production of this publication. Essential to our project was obtaining updated photography and unearthing new archival research, for which Aleksandra Ściegienna of Foksal Gallery Foundation must again be commended.

We are, as ever, immensely grateful to our two teams for the skill and commitment with which they have made this complex project possible. At Tate Liverpool our first thanks go to Registrar and Production Manager Daniel Smernicki, who, together with Art Handling Managers Barry Bentley and Ken Simons, negotiated the complicated shipping and extensive installation with their usual flair, working closely with Elisa Nocente and our trusted team of art-handling technicians. We would like to thank our Tate colleagues in collection care and conservation for their expertise and consideration during this intricate installation. Our Learning team, headed by Lindsey Fryer, has planned an inspiring programme of activities for children and young people, alongside study days and public events developed with Curator of Public Practice Michael Birchall to enable the ideas of this exhibition to reach and inspire the widest possible audience. Tate Liverpool's Development team, led by Jo Warmington, has ably supported and fostered Tate Liverpool's roster of patrons, sponsors and donors. For managing the press and marketing of

the exhibition at Tate Liverpool, we thank Alison Cornmell and Jennifer Collingwood, together with Content Editor Mike Pinnington, who has developed the interpretation materials and in-gallery guide for our autumn 2016 season.

The Edward Krasiński exhibition is of great importance to the Stedelijk Museum, whose works of minimal and conceptual art are key aspects of its collection. The show presents Krasiński in the context of the avant-garde movement of the 1960s and 1970s, which the Stedelijk has always championed. Now, as well as an emphasis on artists from Western Europe and the USA, the museum is focussing on artists who were perhaps overlooked in the past, thus offering a new angle on (the history of) abstract and conceptual art.

At the Stedelijk Museum we would like to thank Managing Director Karin van Gilst, Chief Curator Bart van der Heide, Curator Leontine Coelewij, who organised the Amsterdam stage of this exhibition, and Project Managers Geert Wissink and Sophie Cramer for their invaluable contribution to this undertaking. We extend our gratitude to Head of Art Handling Hans Lentz and the floor managers, together with their team of art handlers, for the installation, and to the registrars for making the shipping arrangements. The Education and Interpretation team, headed by Margriet Schavemaker, has worked on a special programme of events, lectures and activities for children, students and our general audience. The Development team, led by Maudy van Ommen, has provided essential support for the exhibition through her close work with foundations and donors. For managing the press and marketing of the exhibition at the Stedelijk Museum, we thank Karin Sommerer and her indispensable team.

The exhibition and catalogue would not have been possible without the generosity of numerous people. Crucially, we extend our deep thanks to the supporters of the publication: Foksal Gallery Foundation and Grażyna Kulczyk, without whose support the project could not have been realised. At Tate Liverpool, we also take this opportunity to gratefully acknowledge funding from the Adam Mickiewicz Institute, the Ministry of Culture and National Heritage of the Republic of Poland, Culture.pl and the Polish Cultural Institute in London, who supported the exhibition from its inception.

Finally, the exhibition has been made possible by the provision of insurance through the Government Indemnity Scheme. Tate would like to thank HM Government for providing Government Indemnity and the Department for Culture, Media and Sport and Arts Council England for arranging the indemnity.

Francesco Manacorda
Artistic Director, Tate Liverpool

Andrea Nixon
Executive Director, Tate Liverpool

Beatrix Ruf
Director, Stedelijk Museum Amsterdam

Jean-François Chevrier

THE SPHERE OF SURVIVAL

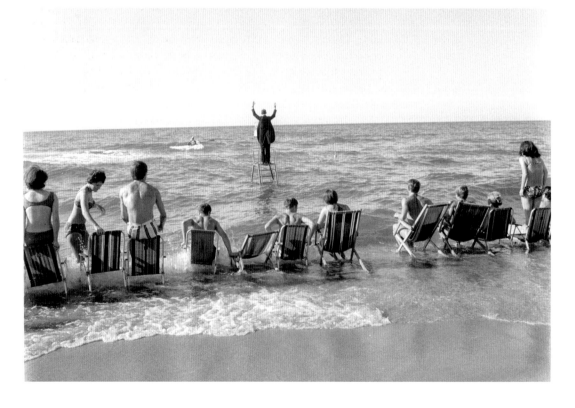

Tadeusz Kantor, *Panoramic Sea Happening* (Edward Krasiński conducts the waves of the sea),
5th Summer Academy in Koszalin. International Meeting of Artists and Art Theorists, Osieki, Koszalin, 1967

So many strings and never a shaft.
Samuel Beckett, *Malone Dies*[1]

In sculpture's recent history, string has figured prominently in the repertoire of 'poor' materials that have helped to expand the experiential and technical range of the plastic arts. Sculptural processes are among the many 'techniques of the body' that are linked to material life and daily activities. The link created by twisted or woven threads is at one and the same time an accessory and a symbolic form. In 1969, Barry Flanagan ran a rope along the floor to provide a connection between three exhibition halls (overleaf). The bound threads of the cord or string combined and connected.

The shaft or arrow, on the other hand, is a *pointer*. That is why it is part of the vocabulary of signal systems and symbolises direction. A cord stretched out corresponds to the arrow as a pointer, whereas its woven link is more akin to a line. Threads and strings wind and intermingle like the lines of a rough sketch, and a collection of such links does not in any way guarantee a direction. However, a cord can also be stretched by the interaction of two contrary forces. A tightrope walker, for instance, advances along a wire that is taut, like a pointer.

String, therefore, is somewhat ambivalent in its situation between the sinuous line and the directional pointer. This is a characteristic feature of Edward Krasiński's work.

In 1969, Krasiński uttered a pitiful appeal in French from the Foksal Gallery in Warsaw: '*J'AI PERDU LA FIN!!!*' He had lost the end – and not the beginning. But in the sphere of survival, the one cannot go without the other. Whoever has lost the end finds himself in the awkward situation of disorientated time – a present without direction, symbolised here by the confused heap of the cable. Losing the end is the same as losing the plot. It can be a dramatic experience – just as we sometimes talk of life as a drama – but here the problem is one of dramatic structure, a *dedramatisation*. At the same time, however, losing the end might mean leaving the finite world and entering the infinite. The caption – also in French – seems to suggest precisely this meaning: 'bleu mince longlonglonglonglonglong...' (blue thin long × 31, see p.62).

The artist who has 'lost the end' is playing a game of who loses wins. He has lost the aim of his work with its sense of dramatic action, but he has also freed himself from the obligation of a finished work to provide a result, and he has gained the freedom to go on indefinitely creating aleatory forms. In 1969, the year of Edward Krasiński's photographic performance, Flanagan declared:

> Truly, sculpture is always going on. With proper physical circumstances and the visual invitation, one simply joins in and makes the work.... I mean that there is a never-ending stream of materials and configurations to be seen, both natural and man made, that have visual strength but no object or function apart from this. It is as if they existed for just this physical, visual purpose – to be seen.[2]

Flanagan rejects the object as a separate form, and instead talks of a continuous flux. The work proceeds, literally, from an appeal: something demands to be seen and to take on a form that emerges from the flux. Flanagan's confident assertion that 'sculpture is always going on' echoes Krasiński's declaration of loss.

Jean-François Chevrier

Krasiński's art took shape during the 1960s and 1970s, when performance art developed in Poland, breaking away from the constructivist heritage. His work emanated from a specific environment that combined the demand for autonomy that characterises the period between the world wars with the playfulness, freed from programmatic seriousness, typified by Dada performances. Shortly after the Second World War, Tadeusz Kantor (1915–1990) had formed his own experimental theatre and had created a new space for dramatic expression; the performative element of Krasiński's work is partly linked to the hieratic and farcical pathos that Kantor produced. In 1967, Krasiński played the role of the conductor in the *Sea Concert* – the first of four parts that made up Kantor's *Panoramic Sea Happening*. Krasiński conducted the waves.

From the 1920s onwards, in Poland as elsewhere, constructivist ideas had evolved in conjunction with the primitivist and informal trends of modern art. This informal tendency – broader than any unified movement – sprang from a defiance of established, conventional forms. Before declaring its official opposition to the constructional norms that grew out of cubism, informal art already opposed the principles of composition and ideal geometry laid down by the system of the fine arts.

Constructivism went through all the variations of modernity, ranging from programmatic art to improvisation. No artistic programme, no 'ism', has ever provided a definitive answer to the question: what is art. Since impressionism, artists have broken away from the confines of the studio. What poet and critic Stéphane Mallarmé (1842–1898) called the 'question du plein air' ('question of the open air') has persisted, even after the constructivists – in the wake of the cubists – transformed the studio into a laboratory of the object.[3]

A remarkable demonstration of the persistence of this question during the evolution of constructivist ideas, is the flying machine named *Letatlin*, which, between 1929 and 1932, was the brainchild of inventor and pioneer of Russian constructivism Vladimir Tatlin (1885–1953). The *Letatlin*, inspired by the morphology of birds, was a small machine with beating wings and no engine (bottom right). Apart from duralium (an alloy of aluminium and copper that was often used in the early days of aeronautics), the materials used in its construction were simple and common: wood, cork, silk thread, steel wire, whalebone and bands of copper. Tatlin conceived his flying machine as a practical extension of the human body. In contrast to the idea of the machine as a separate tool, he envisaged a realisation of the age-old dream of flight that would allow human beings to have direct experience of 'movement in the air'. Thus, *Letatlin* epitomised the 'question of the open air' as well as offering a constructive ideal that could never have been incorporated into the programmes of state-controlled technology. It was a typical example of DIY, far removed from the procedures of engineering (according to the well-known distinction proposed by Claude Lévi-Strauss in *La Pensée sauvage* 1962). One might even argue that Tatlin produced a prototype of constructive primitivism, anticipating the anti-technological stance that was a fundamental feature of the counterculture of the 1960s.

Let us not, however, restrict Krasiński's work or the art of the 1960s to the framework of an historicist interpretation of the neo-avant-gardes. As suggested in the epigraph, it is useful to consider certain texts by Samuel Beckett (1906–1989), with particular reference to some of his writing from the late 1940s. Here is a decidedly original response to the crisis that art underwent during the 1920s. Linking Krasiński and Beckett shows how in the late 1960s it became possible to come to terms with that crisis.

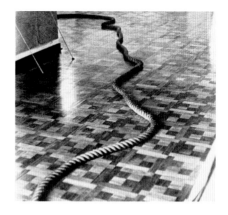

Barry Flanagan (1941–2009)
3 Space Rope 1969
Sisal rope, 365.8m × 15.2cm × 15.2cm
View of the exhibition *Object Sculptures*,
Museum Haus Lange, Krefeld, 1969

Edward Krasiński, *Dévidoir*, Warsaw, 1970

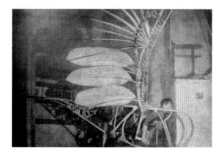

Vladimir Tatlin (1885–1953) in one of the three models of his *Letatlin*, c.1929–32

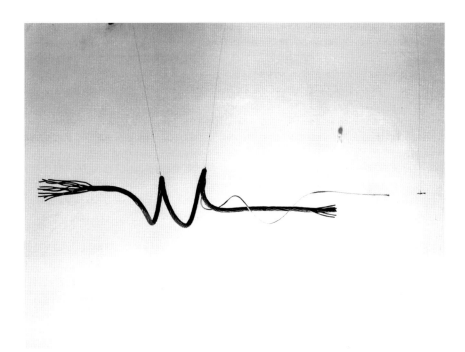

Edward Krasiński
Composition in Space 11 1965
Steel, metal and acrylic paint, 22.5 × 85 × 19

Krasiński and Beckett, or Performance Without End

From the end of the nineteenth century, in both art and poetry, the studio was lit by an electric bulb known as the 'soleil du plafond' ('the sun in the ceiling'): this was the title that poet Pierre Reverdy (1889–1960) – inspired by Alfred Jarry's metaphor (in *L'Amour absolu* [*Absolute Love*], 1899) – gave to one of his collections.[4] According to the (numerous) interpretations of the studio offered by Philip Guston, the sun in the ceiling is – in a situation of minimal survival – the ultimate light in an interior world that is naturally dark to the extent of complete blackness.

　　Russian artist Kazimir Malevich (1878–1935) developed the notion of suprematism based on the negation of solar light and, by extension, on the negation of the ideal of open-air naturalism. He proclaimed the power of nothingness, condensed into a black square, and condemned the anthropocentrism of theological representation, according to which the sun had been created to illuminate the earth. This rejection of anthropocentric naturalism underlay his contribution (costumes and set designs) to the futurist opera *Victory Over the Sun* (1913, composed by Mikhail Matyushin), which saw the appearance of his black quadrangle and the birth of suprematism.

　　Suprematism is often associated with speculations about 'negative theology', an approach recently revisited by medievalist and philosopher Olivier Boulnois (b.1961), who writes: 'The absolute invisibility of God implies that one can only gain access to him by negative means, contradiction and monstrosity.'[5] Negative theology is not naturalistic, but it is anti-idealistic, just as naturalism can also be. That is why the ugly and the grotesque can have a theological function by contributing to a transgressive image of the body. Boulnois explores what he calls 'la voie de la dissemblance' ('the path of dissimilarity') as seen – in its association with the

monstrous – in the work of Dionysius the Areopagite and his disciple Duns Scotus (c.800–876). Dionysius argues that as God is invisible, he is denoted or symbolised in the visible world by things that are 'mixed, confused, deformed' rather than by things that are naturally well-shaped and 'simple'.

Beckett's work comes closer than suprematism to Boulnois' thesis. The epigraph 'So many strings and never a shaft' comes from the novel *Malone Dies* (1951), which is the monologue of a dying man. The first sentence sets the tone: 'I shall soon be quite dead at last in spite of all.' Malone does not simply say: 'I shall soon be dead.' The form of this utterance paves the way for a long process of delay: 'soon… quite… at last… in spite of all' – we are in for a good deal of chat and delirium.

Below is the context from which the epigraph is taken. It offers the counter-model of the good life associated with the open air:

Edward Krasiński
Untitled 1968
Wood, rope, metal and acrylic paint, 57 × 240 × 80

> Be born, that's the brainwave now, that is to say live long enough to get acquainted with free carbonic gas, then say thanks for the nice time and go. That has always been my dream at bottom, all the things that have always been my dream at bottom, so many strings and never a shaft…. And yet it sometimes seems to me I did get born and had a long life and met Jackson and wandered in the towns, the woods and wildernesses and tarried by the seas in tears before the islands and peninsulas where night lit the little brief yellow lights of man and all night the great white and coloured beams shining in the caves where I was happy, crouched on the sand in the lee of the rocks with the smell of the seaweed and the wet rock and the howling of the wind the waves whipping me with foam or sighing on the beach softly clawing the shingle, no, not happy, I was never that, but wishing night would never end and morning never come when men wake and say, Come on, we'll soon be dead, let's make the most of it.[6]

This long, ironic account of primitive life in the open air is clearly the development of a project involving a kind of backward rebirth, starting from death, the foreseeable but delayed ending. This project itself springs from an urge for self-fictionalisation. What comes out of the mouth is not the cry of a newborn babe but a torrent of words, of jumbled sentences, with no particular aim and therefore leading nowhere…. Nowhere, that is, except for the birth of the word itself – the biblical beginning.

Malone tells himself stories in order to alleviate or lend some charm to his miserable earthly condition. The whole project is pathetic. The physical and atmospheric environments make it impossible for him to escape from his situation. He cannot free himself from time, even if he loses all sense of it. He has lost the chronology that defines biographical status and stature, but this loss does not help – there is no compensatory gain, because he still cannot escape from temporality. He remains a sentient being in time. He perseveres in his being, though he would like to abolish time and simply be, or rather not be (he is not really sure what he wants), outside time. Malone fails to shed his carnal wrappings and to detach himself from the illusions associated with this condition. He reaffirms this whenever he says 'I feel', as he acknowledges: 'For my stories are all in vain, deep down I never doubted, even the days abounding in proof to the contrary, that I was still alive and breathing in and out the air of earth.'[7]

Ever since Paul Cézanne (1839–1906), the primacy of sensation has been at the heart of the constructivist approach. It induces an elementary experience of the environment in which artistic activity takes place. The manner in which the elements of construction are assembled stimulates a sensual experience of the body in the space that surrounds it. Tatlin spoke of the sensations of flight associated with *Letatlin*. László Moholy-Nagy (1895–1946) saw sensation as the basis of artistic activity linked to collective life. In 1929, he wrote: 'the most personal expression must be constructed on the objective basis of biologically conditioned experiences (sensations) if it does not want to be isolated.'[8] In brief, the sensation is a link, inasmuch as it emanates from a shared biological experience. That does not mean, however, that it guarantees a place in the world or, a fortiori, that we all have a world in common. A sensation can derive from hallucination, according to the canonical psychiatric definition, from 'perception without an object'. Malone himself talks of hallucinatory hypotheses with regard to the noises coming from the building in which he is lying. In *The Unnamable* (1949), which follows on from *Malone Dies*, the hypothesis is confirmed: the hallucination arises from the narrator's enforced immobility, trapped as he is in his pillory: 'To have forever before my eyes, when I open them, approximately the same set of hallucinations exactly, is a joy I might never have known, but for my cang.'[9]

When he says 'I feel', Malone places himself below the level of organised perception and on that of infra-verbal experience, but this idea comes to him in his delirium: 'I feel' corresponds here to the level at which delirious talk permeates the (auto)biographical construction. In other words, 'I feel' is no longer the basis of being present to oneself, but it is the paradoxical springboard of delirium. Lying there dying, Malone already feels different, stretched out on a rack: 'All strains towards the nearest deeps'.[10] His feet especially, the furthest away from his head-refuge, have become insensible. The expansion of the body is perhaps the psychotic destiny of an art that is separated from the model of nature and responds to the question of the open air in the manner of a negative theology without God.

The constructivist concept is indeed one of expansion, but it is still contained within the framework of variations on *the image of the body*. This image itself requires a definition of the particular environment. Malone, for example, is confined to a room that anticipates his tomb. With Beckett, the image of the body is governed by the experience of a state of horizontal survival. The recumbent body stretches out. It has had to renounce verticality. In order to move, if it *can* move, it does not walk but has to crawl. Malone is akin to Worm, a character in *The Unnamable*. Worm, Beckett's anti-hero, survives and persists in his own being, or rather in the remains and semblance of his being, and his persistence is a state of confinement, the embodiment of which is the black box of the 'tomb-womb'. The crawling being is the antithesis of Tatlin's flyer, just as the black box is the antithesis of the open air, and the room of the crawling being is a unique place of birth and death: Malone is dying – or surviving – in the room where he first entered the world. This unique location creates a biographical loop, like a mystic circular fusion of opposites. The darkness of the black box is the exact opposite of broad daylight; day and night go round and round in a circle in which being constantly meets non-being. The circle provides the ideal form for the anti-drama developed by Beckett both as narrator and as dramatist.

Beckett was always interested in painting. The anti-dramatic tenor of his work has much in common with a certain concept of painting or, to be more precise, of the

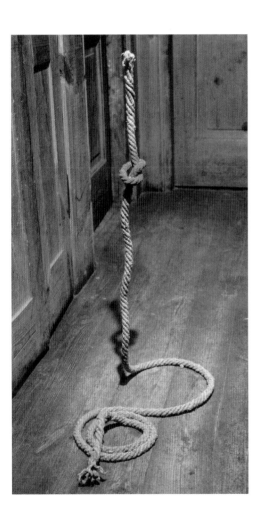

Edward Krasiński
Untitled 1968
Rope, steel and acrylic paint, 92 × 39 × 56

kind of painting that, in the absence of objects, we term 'abstract'. In Poland, this idea was systematised by a disciple of Malevich, the painter Władysław Strzemiński (1893–1952), the inventor of unism. In unism, as the name implies, a picture had to be a unified surface, centripetal, and totally free from the model of nature and from all dramatic effects. Strzemiński regarded unism, following on from suprematism, as a constructivist approach to art and as the only legitimate offshoot of cubism in its opposition to naturalism and to baroque theatricality.[11] Form took over from expression, and this antithesis governed his concept of an ideal history of painting accomplished within the unitary space of the picture, i.e., the end of painting is the unitary form of the picture. There is no content preceding 'pure form', and so the picture is not even the setting for form – it *is* form in which space and object are indistinguishable. This inseparability of pictorial field and pictorial object is the guiding principle of unism.

Later in this essay, it will become apparent how Strzemiński could not continue along the path of unism without integrating a form of anti-unism. First, however, let us return to Krasiński's situation at the end of the 1960s. The 1969 poster *J'AI PERDU LA FIN!!!* illustrates his contribution to an exhibition at the Foksal Gallery in Warsaw, under the title *Winter Assemblage.* The image reproduced on the poster was part of a collection of photographs taken by Eustachy Kossakowski. Krasiński is shown standing alone against a neutral background, wrestling with a material that is both flexible and uncontrollable and, according to the caption, is blue, thin and long. Linking up with the concept of performance art, the statement 'I have lost the end' means that the artist had no plan to enable him to control this rebellious material or to give it form. He is a clumsy, if not helpless, creature, in total contrast to the spider, which weaves its web with such assurance. The spider follows an instinctive plan, never loses the end, and never gets lost amid the threads. Human beings cannot build according to plans laid down by instinct. Unlike the spider's web, human habitats never emerge directly from our natural equipment or from a stable formula related to the biotope. That is why everything gets tangled up when we pull the threads, and we have to untangle ourselves as best we can.

Untangling ourselves is a primitive, prosaic form of the 'ruse' or *mètis* of which Marcel Detienne and Jean-Pierre Vernant have reconstructed the basic elements and their outcomes in Greek culture. One product of the *mètis* is the trap – especially the net or lobster pot, which, they point out, 'relates to the most ancient techniques for using the suppleness of vegetable fibres'.[12] Here, again, is the motif of the string or rope, as used in basket-weaving. Basketwork, however, is a domestic technique. The net and the trap are methods of fishing and hunting. The ruse may also be used in war – as seen in Odysseus' cunning device of the hollow Trojan Horse. For Detienne and Vernant, the essential features of the *mètis* combine technique and tactic: flexibility and polymorphism, duplicity and equivocation, inversion and reversion – they all imply certain values that we associate with the curve, the supple, the tortuous, the oblique and the ambiguous, in contrast to the straight, the direct, the rigid and the unequivocal.[13]

With the declaration 'I have lost the end', Krasiński drew attention to the equivocal methods of art without a programme. Is this perhaps an echo of philosopher Immanuel Kant's definition of art: 'Zweckmäßigkeit ohne Zweck' ('purposiveness without purpose'). Whether we accept that or not, the lost end is not merely an absence. The 1969 announcement of loss had a particular tactical

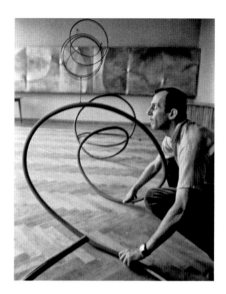

Edward Krasiński with his work *Untitled* (1966, missing work) at *1st Symposium of Artists and Art Scholars. Art in the Changing World,* Kazimierz, Puławy (Azoty), Nałęczów, 1966

significance. In Italy in 1962, polymath Umberto Eco (1932–2016) advanced the concept of *arte programmata* (to describe those artists primarily interested in kinetic art and op art) at an exhibition on the art of movement, held in association with the French group G.R.A.V. (Groupe de Recherche d'Art Visuel/Research Art Group). Krasiński gave a French title to his 1969 performance. He could not ignore the new focus on kinetics, and the performance was a direct challenge to the enthusiastic embrace of programmatic art that was not only unsuited to the situation in Poland but would also inevitably reinforce the normative, repressive impact of the official culture.

The Foksal Gallery in Warsaw had been founded three years earlier in 1966, on the initiative of a group of artists and critics that had gathered round the charismatic figure of Tadeusz Kantor. It was a tiny space of 35m^2, with no space for storage. The artists, therefore, were constrained to prioritise ephemeral events, though photography could capture them for posterity, and *J'AI PERDU LA FIN!!!* was both a photographic and a photographed event. The ambiguity of the *mètis* is echoed here by that of the document. The latter has much in common with the work, but it records an action or activity that lacks the purpose of a work. 'I have lost the end' signifies: 'My action is not intended to produce a work.' This activity is not, however, confined to the time of the performance, because it has been recorded by photographs. So, although it proceeds as a non-work, it is also a permanent record of suspended finality. The ambiguity, therefore, is not an irreconcilable split or a simple negation, it can also be a form of continuity. Furthermore, suspended action does not mean an end, since it can always be restarted.

The split here is actually a diversion: the finality of the work has been diverted in the direction of the photographic document, which has replaced the work. In other words, the document is not the work, because it presents itself as the record of a performance, but it serves as a work. In doing so, it demonstrates that the artistic activity is separate from the domain of any programmatic end, and its status as a non-work allows it to proceed freely without having to conform to the demands of creating something (or 'producing results', as the world of commerce might put it). This diversion is especially significant in a culture that is governed by the demand for social productivity. The artist without artworks is freed from all the restrictive norms of productive labour. This was the position Krasiński adopted to the end of his life. It is that of the aristocrat, and is a fundamental trait of the counterculture. Krasiński's apartment-studio has remained untouched since his death, and it is the place where the distance he created between activity and artworks has been fixed and perpetuated in the absence of the artist himself.

During a trip to Warsaw, I visited the studio and stayed there for several hours, pondering where I was, what I was seeing and what it all meant. The apartment-cum-studio has become a place of memory since the artist's death, producing a time capsule. It is situated at the very top of an eleven-storey building in the centre of Warsaw, close to the old city and the former ghetto. Its location reflects the feeling of suspended time, and is part of this same biographical capsule.

The authorities allocated the apartment to constructivist artist Henryk Stażewski (1894–1988). He was an historical figure, and a living reminder of the great days of constructivism. In the early 1970s, he gave part of the studio to Krasiński, and the two artists lived together until Stażewski died. Krasiński then took it over until his own death in 2004.

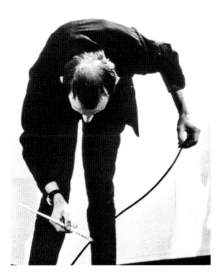

Edward Krasiński at Foksal Gallery, Warsaw, 1969

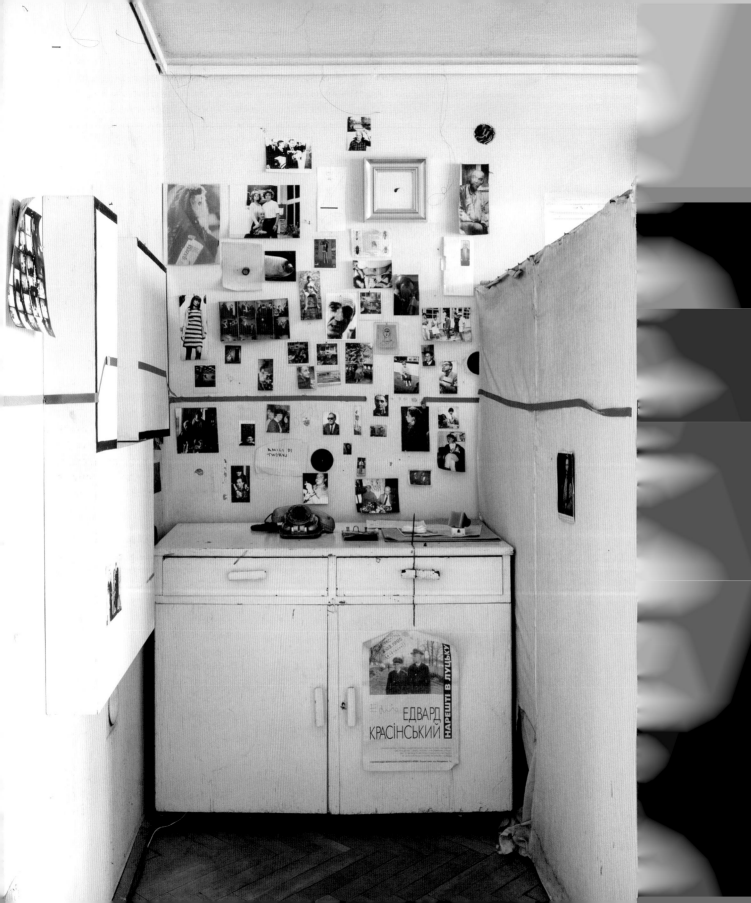

The apartment is spacious and light, consisting of three rooms in alignment. The space is doubled by a huge terrace, now covered, which served as an open-air gallery when the two artists were alive. After Krasiński's death, a panoramic platform was erected on the roof of the building. The view of the urban sprawl contrasts with visitors' close-up perception of the items that occupy the domestic space. This also highlights the rather strange position in which the two artists found themselves: they were at the top of a tower block, up in the sky, and, in keeping with the privileges granted to him, Stażewski was recognised, established and venerated. His flatmate Krasiński, on the other hand, had a totally different lifestyle, and fought shy of all the rites and rituals of the artistic community that had gathered around his elder companion. Contemporaries observed that Krasiński never took part in the gatherings inspired by the convivial Stażewski.

When Stażewski died, one can well imagine that the sole occupant of the apartment would have coexisted with himself like some sort of celestial tramp (or clown), having inherited the role of guardian to the great man's memory – a role he was unsuited to playing. From that moment, the transmission of the constructivist avant-garde took place via the mediation of the 1960s. Krasiński himself became a legendary figure. Today, his lifesize (photographic) image plays ping-pong with that of gallery owner Stefan Szydłowski.

Inevitably, what was once a home has now become a décor (see p.49), but it is a décor without decorum. There is nothing to evoke any sort of dramatic action. One does not think of Kantor's 'bio-objects'.[14] For Kantor, dramatic action unfolded during the time of representation, which itself replaced biographical time, and protagonists – if not heroes – evolved on stage. But the time of the studio is different, between life and death. The artist appears as a protagonist in a written, narrated or exhibited history of art, but the artist who occupied and arranged this apartment-studio was clearly concerned first and foremost with himself, together with various odds and ends from here or there. Kantor's 'bio-objects' were dramatic objects.

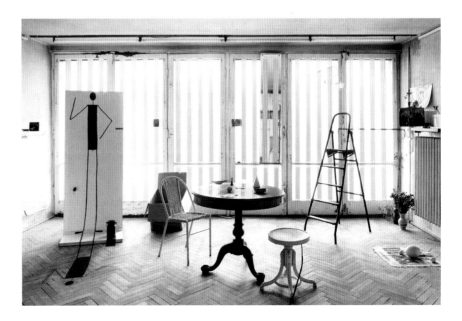

BOTH IMAGES
Edward Krasiński's studio, Warsaw

The apartment-studio is more like a 'dedramatised' work, the setting for a performance without a script and without a programme: life itself. Viewed from the perspective of art, life is a performance that simply goes on from day to day.

The place had been lived in. But it was already haunted by presences, by object-images: enlarged photographs, reproductions, relics and remnants. The construction anticipated a state of ruin – it contained its own memory, both elegiac and burlesque. It is less 'installation' than 'assemblage'. The table, with a shark's fin poking out of the wood, is an assemblage of surrealistic inspiration: the fin transforms the top of the table into a seascape (right). But, in its overall effect, the place is formed by elements that are associated and combined rather than assembled. Yet, one is also struck by a *design of life* that actions have dispersed and reassembled into things, and into configurations of things.

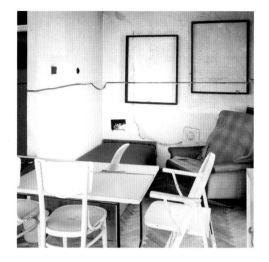

Of all the legendary studios of modern art, the most spectacular is that of sculptor Constantin Brancusi (1876–1957), which might be called a 'total place'. It is a monument to constructive art as a re-creation of the world. The question of art had been resolved and left behind, but here, in Krasiński's studio, it persists. The combination of objects is loose and fluid. It does not constitute a world in itself, or even a family of objects, but creates an ensemble of things with diverse connections, put together according to a logic of variable coexistence. The artist's life is the unbound thread of a genealogy of (and in) things when the things make an image and depend on their image.

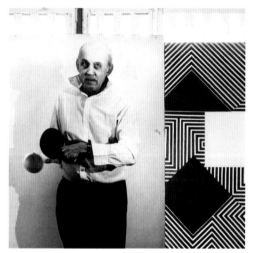

The apartment-studio has become a place of memory or, to be more precise, the place of a particular memory. But who is it for? To whom is this deposit of things addressed, this décor without decorum? Mallarmé gives us the answer: 'À qui veut'[15] ('to whomever'). This is the only target one can attribute to 'dedramatised', non-programmatic art. 'À qui veut' means anybody or everybody who is willing to be addressed, with no one excluded and no one included and no community of any kind.

When all is said and done, Krasiński's work is no more 'comprehensible' in the studio than it is elsewhere. Nevertheless, this is the ambiguous or hybrid place where we find the visible evidence and remains, laid out and assembled, of what I would call the artist's sovereignty. This is comprised quite literally of residues, and indeed historically it could not be anything else. One is reminded of Prince Hamlet, son of a murdered king, subject to the power of the murderer and brought to the very threshold of existence, between being and not being.

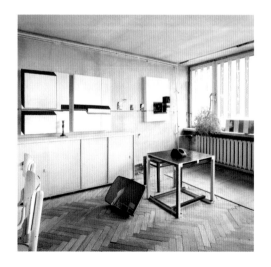

This residual dimension of artistic sovereignty stems from the demand for autonomy that Strzemiński insisted on during the 1920s. An ensemble of constructions made by Krasiński in the early 1960s, recently discovered and exhibited by Andrzej Przywara at the Foksal Gallery Foundation in Warsaw, epitomises the spirit of non-authoritarian constructivism – non-authoritarian rather than anti-authoritarian – that characterises Krasiński's work.

Stażewski had continued the heritage of historical constructivism in the context of the 1960s, but the grace of Krasiński's ethereal constructions is linked to the fact that they are endowed with auto-negation, which had already appeared during the development of unism. As mentioned, we shall see how Strzemiński had been led to negotiate the survival of unism by adopting the necessary postulation of an anti-unism.

Auto-negation is dialectical; it is equivalent to the negative capability in which poet John Keats (1795–1821) saw man's ability to compromise with the uncertainties

of fate. 'Negative capability' allows us to suspend, if not completely abolish, the ineluctable positiveness of terrestrial things transformed into 'facts'. Hamlet, a 'stranger to every place he begins to appear in' (as Mallarmé puts it) is a man who – involuntarily – fulfils this capacity, by setting his own uncertain presence against the false certainty of positive beings who in Shakespeare's play are associated with the criminal illusion of power.[16]

Krasiński, Stażewski and Anti-Unism

As discussed earlier, in 1967 Krasiński acted in Kantor's *Panoramic Sea Happening* as conductor of the waves. Standing in the sea, he raises his arms above the line of the horizon (see p.8). This line may correspond to the thread described as 'blue thin longlonglonglonglonglonglong...' in the 1969 poster. A few months earlier, in 1968, Krasiński – who was living in Zalesie (a village 25km south of Warsaw) – discovered blue adhesive tape. He first used it on trees in the forest. An ensemble of photographs taken in the same year of 1969 shows the Scotch tape stuck to the wall of his house, to acquaintances, to trees and to his daughter, who was three years old at the time (left).

Krasiński used the continuous blue line as an instrument with which to mark out his territory. At the same time, he transposed the line of the maritime horizon into the inhabited or habitable human environment. He invariably fixed this line at 130cm high. He said in 1978 that it allowed him to exhibit the environment, that is to say, to make the environment visible when both it and the place of exhibition generally went unnoticed, giving precedence to things, artefacts and works of art. The blue line springs from the language of painting, but it serves to connect the picture to the wall and to the place; it creates continuity in the secondary, inhabited space, just as the horizon creates continuity in the natural landscape.

Anka Ptaszkowska, Krasiński's partner during the 1960s, thought 1964 was the turning point in his art, when he presented an open-air construction entitled *Spear*, within the framework of *The Second Summer Academy* in Koszalin, near the Baltic Sea, 150km west of Gdansk.[17] It was also within the context of the summer academy that Kantor presented his *Panoramic Sea Happening* three years later, in 1967.

The photographs taken by Kossakowski (c.1963–4, see p.42–3) capture the improvised, choreographic grace of Krasiński's installation in Zalesie (the spear itself was one of the items rediscovered by Przywara). These photographs are like a film shot in a natural, open-air setting. The viewer can see the air passing between the different postures and actions of Krasiński's body and in the progressive course of the suspended line. In French the word 'air', meaning the atmosphere, is linked homonymically to 'aire', signifying the geographical and ethological area. The open air thus denotes total exposure to the 'air' of a particular place.

One is also reminded of writer Fernand Deligny's 'lignes d'erre' ('wander lines'), which redefine territory and territorial intimacy according to the recurrences of an 'erratic' experience.[18] However, the territory marked out by Krasiński is a *directed* space. It is not finalised, or organised to fit in with a particular project or programme, but it is directed by the very action of drawing a route or a line. It must be said that the Beckett epigraph does not fit in well with an action conducted in the open air

OPPOSITE
Edward Krasiński's studio, Warsaw

ABOVE
Edward Krasiński, *Intervention*, Zalesie, 1969

for which the artist has equipped himself with a great spear. One would expect the entanglement of the unravelling string to take place first and foremost in an interior, on the art scene.

In the unism manifesto of 1928, Strzemiński wrote that painting must be freed from the grip of baroque dramatisation perpetuated by Cézanne and cubism: 'The Baroque tradition has been so attractive that even Cézanne, generally regarded as the initiator of modern art, succumbed to it.'[19] Once liberated from this attractive force, painting could become 'weightless'. The picture had to be a unitary surface, freed from the 'dramatic tension' that divides the composition.[20] Strzemiński rejected 'dramatic pathos' and cubist tension:

> Cubist painting is constructed in such a way that vertical and horizontal directions predominate in the center, placed according to the axes of construction. Curves and diagonals, though sometimes found in the center, predominate near the picture's boundaries.... There occurs a contrast of the pictorial form as a whole with the picture's borders, the contrast which does not allow a complete union of the pictorial form with the picture plane and with its boundaries. The form remains unconnected with the [picture's] frame – it has its own center of gravity, unconnected and contrasting with the picture's borders.[21]

Krasiński's suspended forms replaced the dedramatised space of the picture with the open air. The open air is the equivalent of the 'all over' unified pictorial field. The tension is absorbed by and contained within the movement, or the trace, that produces space. According to Mallarmé, the open air had to be the 'almost exclusive medium' for painters.[22] However, the experience of the open air exceeds the capabilities of painting. If the open air can be the equivalent of the unitary picture, the unitary picture cannot be the equivalent of the open air; it cannot be the complete transposition of the atmospheric environment, which is far too mobile and variable.

In some of his unist compositions, Strzemiński succeeded in producing a pictorial surface that conformed to the principle of the dedramatised picture (top right). But he had to acknowledge the limitations of unism. Baroque dramatisation could indeed be removed, but that did not mean the removal of drama, which reappeared in the reality *outside the picture.* With his little post-unist pictures (bottom right), Strzemiński reintroduced the landscape and figure in the form of trembling silhouettes, and these spectral shapes were particularly predominant in the drawings of the late 1930s.

By affirming the autonomy of pictorial space freed from the carriers of baroque dramatisation, unism set out to establish a contemplative mobility that was stripped of all chronological, historical and biographical order. Strzemiński's focus was on the 'organic' unity of the picture. He thought of it as a unitary, centripetal body, and challenged the dynamism of the futurists and suprematists. While Malevich dreamed of forms animated by ethereal dynamism, Strzemiński imagined a universe at rest, animated by a pure internal movement: 'Our aim is an extra-temporal picture, operating within the notion of space.'[23] This opposition of mobility to dynamism, like that of space to time, is common to all the artists who came under the influence of constructivism and who sought to distance themselves from the dynamic belligerence of futurist tropism.[24] Krasiński's suspended linear constructions follow

Władysław Strzemiński (1893–1952)
Kompozycja unistyczna 9 (*Unistic Composition 9*) 1931
Oil on canvas, 48 × 32

Władysław Strzemiński (1893–1952)
Pejzaż łódzki (*Łódź Landscape*) 1933
Tempera on cardboard, 19 × 26

Edward Krasiński B, exhibition view at
Foksal Gallery Foundation, Warsaw, 2013

this trend, but he had also been influenced by Kantor's work in the theatre. The situation of art in Poland during the 1960s was different from that of the 1920s, despite the presence of Stażewski.

For Strzemiński, the unist picture was a form of pacification, with unism the ideal of a space that was both integral and integrated. In a long text that he wrote together with Katarzyna Kobro, he declared that sculpture should be united with space in its totality: 'Space, as a whole, remains in a state of equilibrium. This equilibrium is not the result of some arrangement of forces that are opposed to one another. We always think of space as an element whose existence is independent of the presence of forces.'[25]

This idea finds expression in Krasiński's ethereal constructions and also in his invention of the continuous blue line that links objects and space. However, Strzemiński had realised the limitations of this unitary, all-encompassing concept of space. Since the nineteenth century, the notion of the 'laws of history' had permeated the language of progressive thought. Strzemiński opposed it with the 'fundamental laws of space', but he had to recognise the degree to which history, which cannot be separated from power relations, resisted the principles of unism. And so although the purist concept of pictorial unism was not unfulfillable – as Strzemiński himself proved – it was untenable, to the extent that through the picture itself it tended to produce spatial entity abstracted from history.

Unism's theorist was himself caught up in history and its pathos. He had suffered appallingly during the First World War (he lost a leg and an arm), and no doubt the unist ideal of organic unity and integral space was a response to this ordeal, as well as being a way to exorcise the violence. But social conflict, exacerbated by the Great Depression and the rise of Fascism and Stalinist totalitarianism, created an environment that was hostile to unism. Strzemiński, who had read Adolf Hitler's *Mein Kampf* (*My Struggle*, 1925), was one of the few artists to denounce Nazi biological determinism.[26] His organic pictorial model was his counter to the biological interpretation of the social body.

The organic unity of the picture and of plastic space had to be freed from the theatrical 'plot', but nevertheless drama resurfaced in the totality of outside space. In December 1934, during a discussion with Strzemiński – one of the liveliest debates on the then hot topic of the future of non-figurative art – Leon Chwistek (1884–1944) rejected the 'fiction' of the 'atemporal' unist space in favour of the mass appeal of the cinema.[27] Strzemiński accepted the possibility of 'anti-unism', which he placed alongside typography as a visual formalisation of language. Beyond the functionality of typography, he could see 'a powerful instrument of evocative and emotional action' equivalent to that of the cinema.[28]

The landscapes that Strzemiński painted during the 1930s, followed by the trembling human figures drawn during the war, show a return to the environment and to the figure, but now they have become a kind of floating vision with indeterminate contours. Strzemiński's paintings came closer to surrealism, to a poetics grounded in the subversion of reality by hallucinatory invention.

In Krasiński's work, this surrealist element stems from a sense of the absurd, coloured by Kantor's clownish pathos. The ideal of integral space as promoted by unism could not be restored without an anti-unist approach. Krasiński's infinity is not the integral space of Strzemiński and Kobro. It is a negation of finiteness. But the end was lost. The work of the artist had lost its finality. Unist dedramatisation was revived in the open air, but the entanglement that characterised the confusion of the dramatic 'plot' came back on stage. Krasiński's 1969 declaration of loss set the seal on the restoration of constructivism by starting out with its negation. Before then, the unist project had already been unable to continue without incorporating anti-unism. Now, in the same way, constructivism moved on through its negation by means of performance. The lighting of the studio (the 'sun in the ceiling') may have replaced natural light, but the question of the open air never ceased to re-emerge, especially through performance.

1 Samuel Beckett, *Malone Meurt*, Paris 1951, as *Malone Dies*, trans. Samuel Beckett, Middlesex 1962, pp.64–5.
2 Gene Baro, 'Sculpture made visible', discussion with Barry Flanagan, in *Studio International*, vol. 178, no. 915, October 1969, p.122.
3 Mallarmé identified '*la question du plein air*', combining aesthetics and politics, in 'The Impressionists and Édouard Manet', *The Art Monthly Review*, 30 September 1876; *Oeuvres complètes*, vol. II, Bertrand Marchal, ed., Paris 2003, pp.444–70.
4 The collection was already planned in 1916 and should have been illustrated with engravings by Spanish artist Juan Gris (1887–1927), but the project was delayed by Gris' death in 1927. *Au soleil du plafond* finally appeared in 1955, published by Tériade.
5 Translated from Olivier Boulnois, *Au-delà de l'image. Une archéologie du visuel au Moyen Âge, Ve–XVIe siècle* (*Beyond the Image. A Visual Archeology of the Middle Ages, 5th to 16th Centuries*), Paris 2008, p.165.
6 Samuel Beckett 1962, pp.64–5.
7 Ibid., p.74.
8 Translated from László Moholy-Nagy, *Von Material zu Architektur*, Brunswick, Germany 1929, p.88 (*The New Vision: From Material to Architecture*, New York 1932); quoted by Elodie Vitale, 'De l'oeuvre d'art totale à l'oeuvre totale. Art et architecture au Bauhaus', in *Les Cahiers du Musée national d'art moderne*, no. 39, spring 1992, p.76.
9 Samuel Beckett, *The Unnamable*, in *Three Novels: Molloy, Malone Dies, The Unnamable*, New York 2009, p.236.
10 Samuel Beckett, *Malone Dies*, in *Three Novels* 2009, p.227.
11 See especially Władysław Strzemiński, 'O sztuce rosyjskiej – notatki', in the journal *Zwrotnica* 1922, trans. Wanda Kemp-Welch, 'Notes on Russian Art', in *Between Worlds: A Sourcebook of Central European Avant-Gardes, 1910–1930*, eds. Timothy O. Benson and Éva Forgács, Cambridge, MA 2002, pp.272–80.

12 Translated by the author from Marcel Detienne and Jean-Pierre Vernant, *Les Ruses de l'intelligence: La mètis des Grecs*, Paris 1974, pp.54–5.
13 Ibid., p.55.
14 Kantor's 'bio-objects' are a dramatisation of the *objet trouvé*, resulting from numerous exchanges between sculpture and scenography. More than just a theatrical prop, a bio-object is an extension of a character – his or her emblem. 'Bio' denotes a mixture of life, biography and biology. The bio-object is part of the drama of life.
15 Stéphane Mallarmé, in his response to Leo Tolstoy's question *What is Art?* (concerning Tolstoy's own views on the role of art), *Oeuvres complètes* 2003, pp.670–1.
16 Stéphane Mallarmé, 'Hamlet', ibid., p.169.
17 'Farewell to Spring', Anka Ptaszkowska in conversation with Joanna Mytkowska and Andrzej Przywara, in Sabine Breitwieser, ed., *Edward Krasiński: Les mises en scène*, exh. cat., Generali Foundation, Vienna 2006, p.101.
18 Fernand Deligny (1913–1996) was a teacher and writer, who in 1967 founded a place of residence for autistic children in the Cévennes (a mountainous, sparsely populated region in the south of the Massif Central). This was an alternative to psychiatric institutions, and comprised a network of places to stay, with camps in the hills and on the farms. Deligny got the adults – who lived with the children – to map out their itineraries. The adults drew the *lignes d'erre*, in the sense of wandering but also invoking the idea of the *aire* or area of life and play. A number of these maps have survived: see, *Cartes et lignes d'erre/ Maps and Wander Lines*, Sandra Alvarez de Toledo, ed., Paris 2013.

19 Władysław Strzemiński, *Unizm w malarstwie*, Vienna 1928, 'Unism in Painting' trans. by Wanda Kemp-Welch in *Between Worlds* 2002, p.651.
20 Ibid., p.652.
21 Ibid., p.651.
22 Stéphane Mallarmé, 'The Impressionists and Édouard Manet', *The Art Monthly Review*, 30 September 1876; *Oeuvres complètes* 2003, pp.444–70.
23 Ibid., p.655.
24 One should make special mention of Sophie Taeuber-Arp (1889–1943), who between the 1930s and early 1940s followed a path similar to that of Strzemiński, although her lines were always more solid. While they gained in flexibility and mobility, they never reached the stage of trembling.
25 Translated by the author from the French: Władysław Strzemiński and Katarzyna Kobro, 'La composition de l'espace. Les calculs du rhythme spatio-temporel' 1931, trans. Antoine Baudin in Strzemiński and Kobro, *L'Espace uniste. Écrits du constructivisme polonais*, eds. A. Baudin and Pierre-Maxime Jedryka, Lausanne 1977, p.102. Extracts from this text were translated in Wanda Kemp-Welch, *Between Worlds* 2002.
26 Biological determinism is the belief that human behaviour is determined solely by biological attributes.
27 'Discussion L. Chwistek – W. Strzemiński' (*Forma*, 1935, no. 3), Strzemiński and Kobro, *L'Espace uniste* 1977, p.158. This text is not translated in *Between Worlds*.
28 Ibid., p.157.

EARLY 1960S

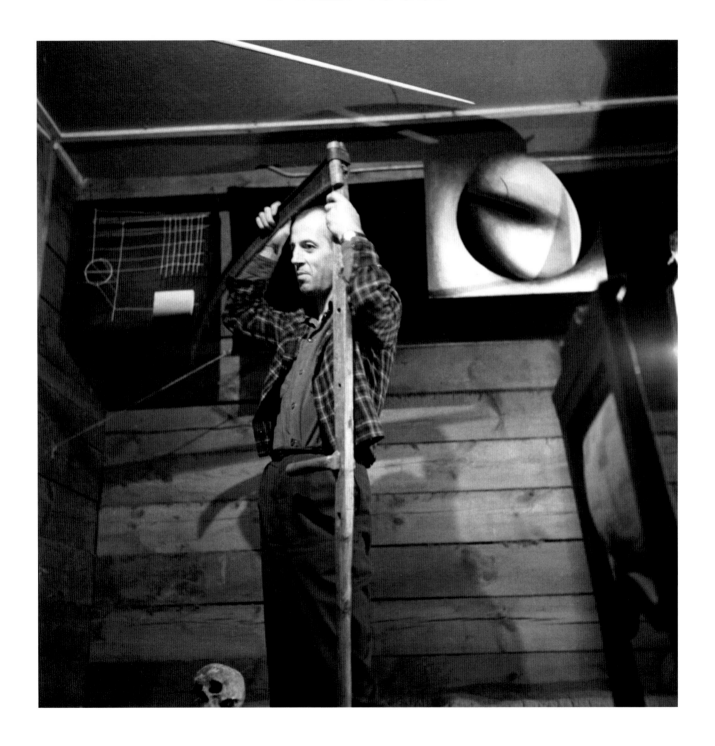

Edward Krasiński at his house in Zalesie, 1960s

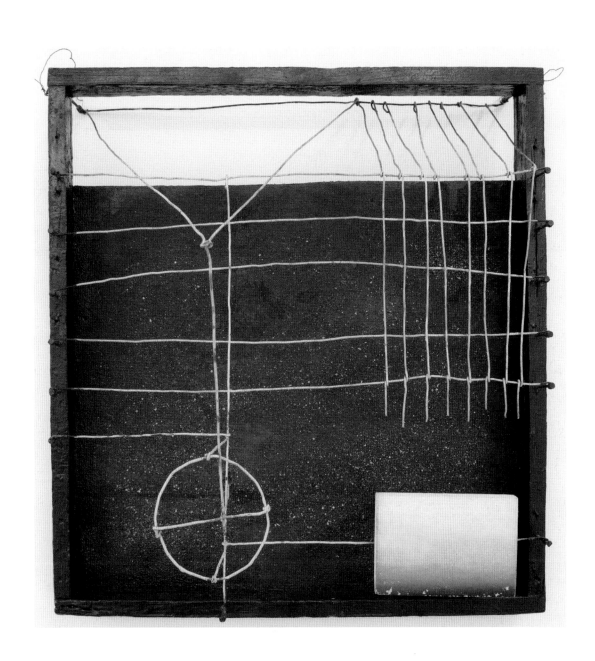

Untitled c.1960
Wood, metal, roofing felt and acrylic paint, 58 × 56 × 41

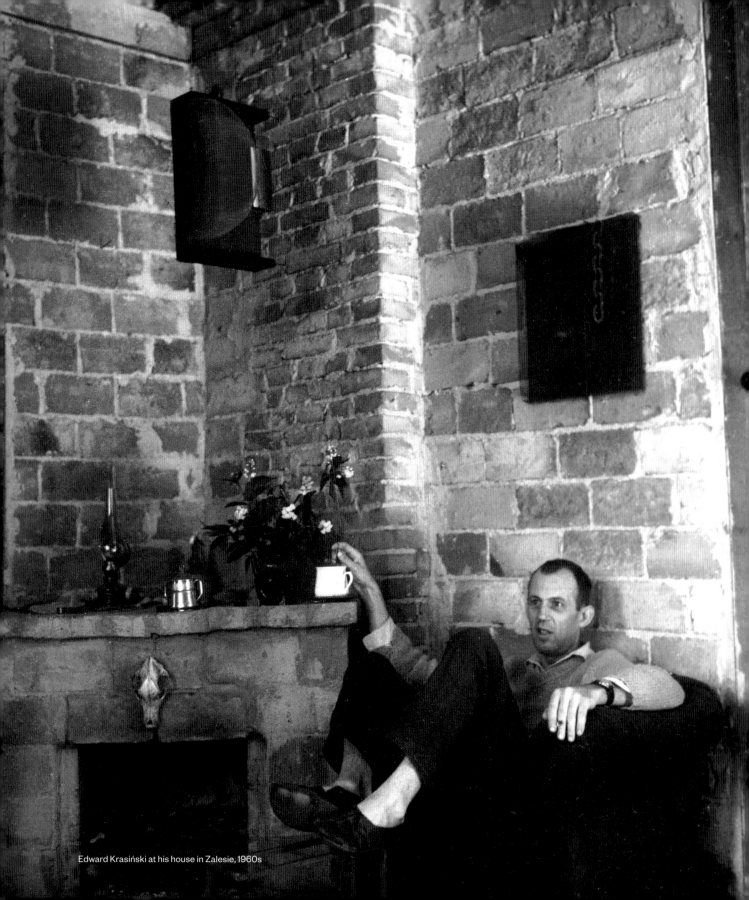

Edward Krasiński at his house in Zalesie, 1960s

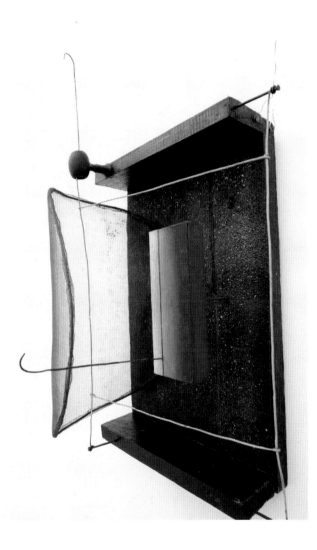

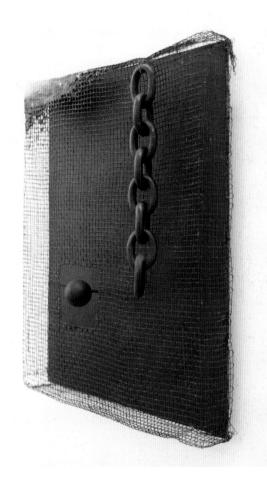

Untitled c.1960
Wood, metal, roofing felt and acrylic paint, 60 × 37 × 31

Net I 1962
Wood, metal, plastic and acrylic paint, 49 × 39 × 10

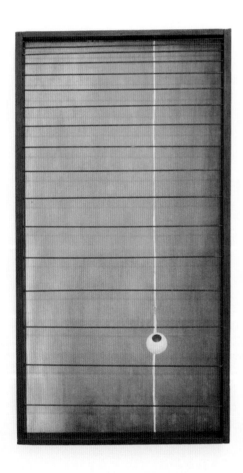

Untitled 1962
Wood, metal, plastic and acrylic paint, 85.5 × 44.5 × 32.5

Composition in Space 1964
Wood, canvas, metal and acrylic paint, 81.5 × 40 × 15

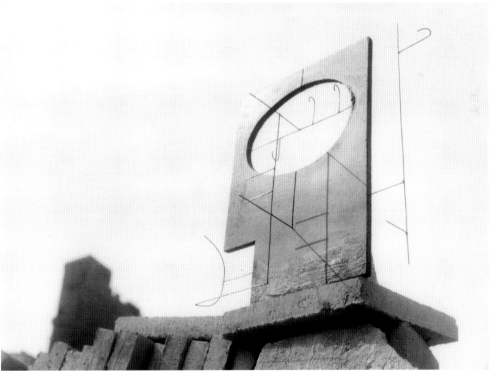

TOP
Composition in Space VIII 1963
Wood, metal and acrylic paint, 51 x 29 x 20.5

BOTTOM
Composition in Space IX 1963
Wood, metal and acrylic paint, 53 x 54 x 15

29

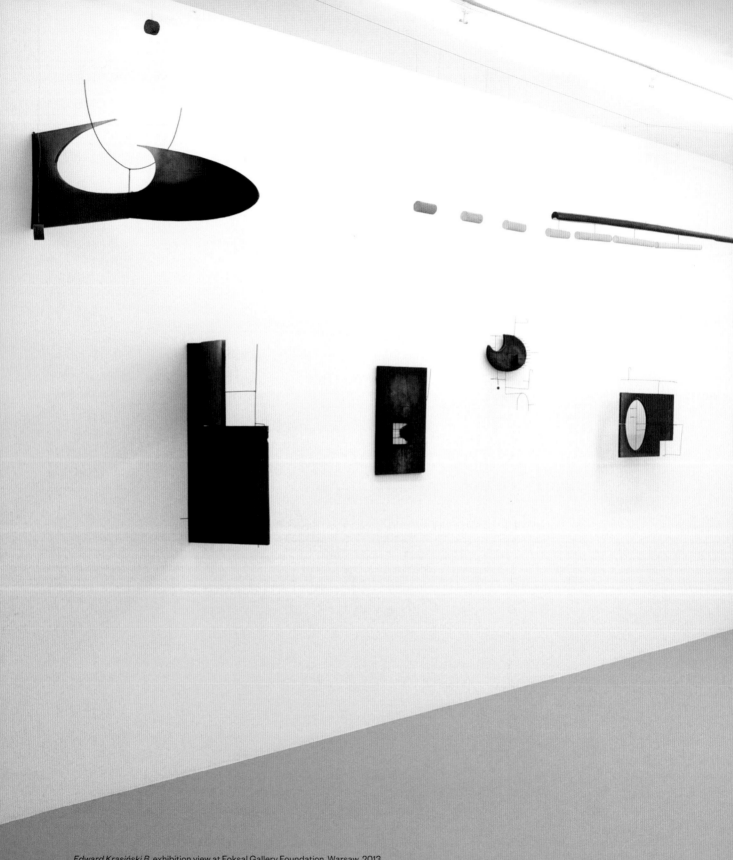

Edward Krasiński B, exhibition view at Foksal Gallery Foundation, Warsaw, 2013

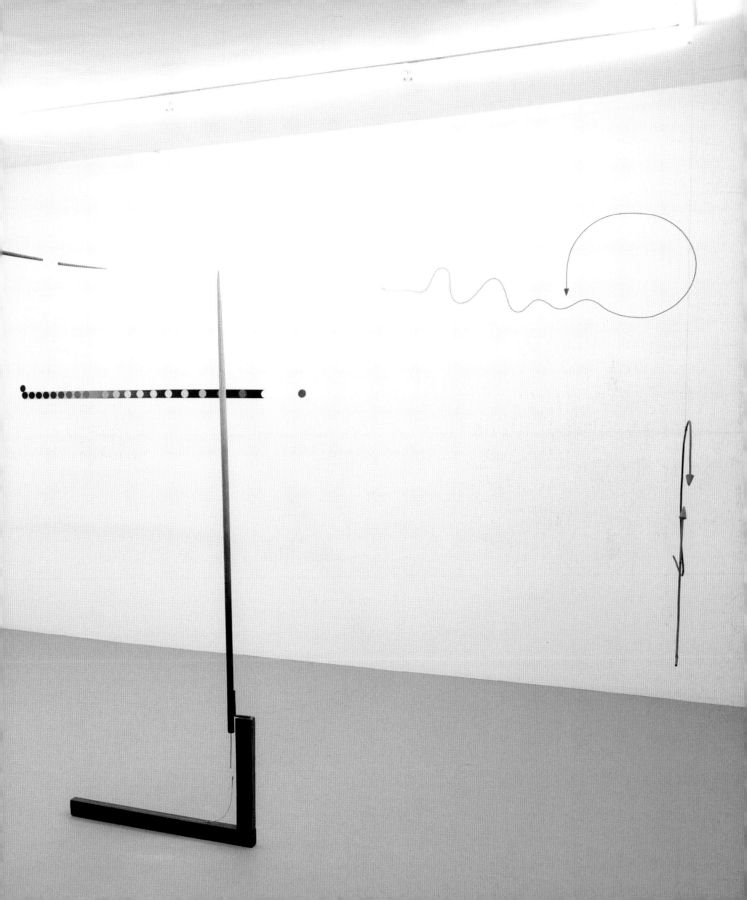

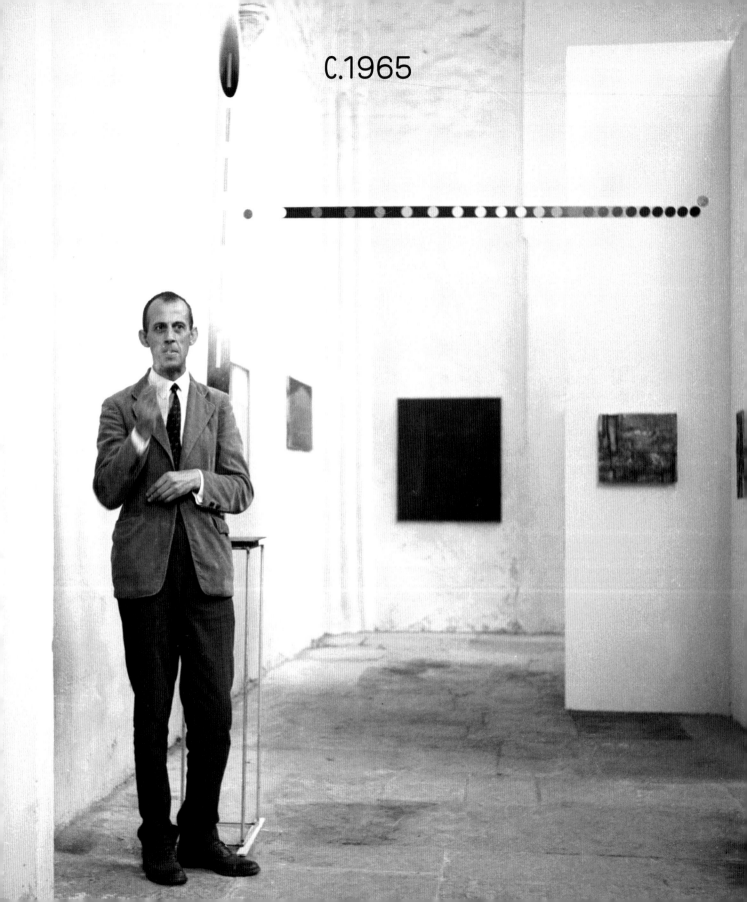

C.1965

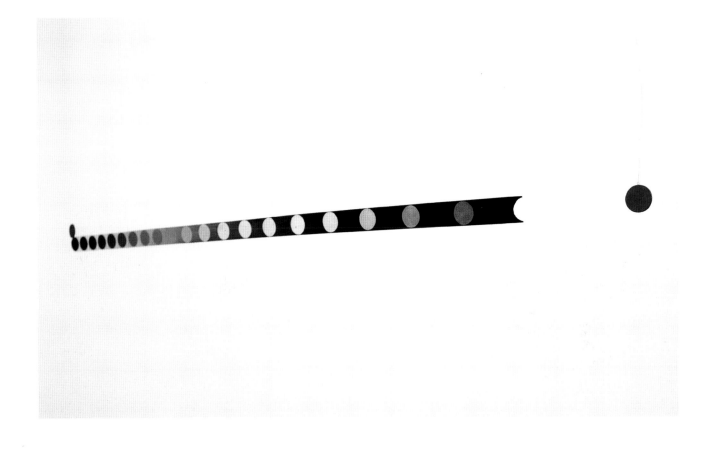

LEFT
Edward Krasiński in front of his works at *Confrontations 1965*.
1st Biennale of Spatial Forms, EL Gallery, Elbląg, 1965

ABOVE
Untitled 1965
Wood, metal and acrylic paint, 10 × 192

33

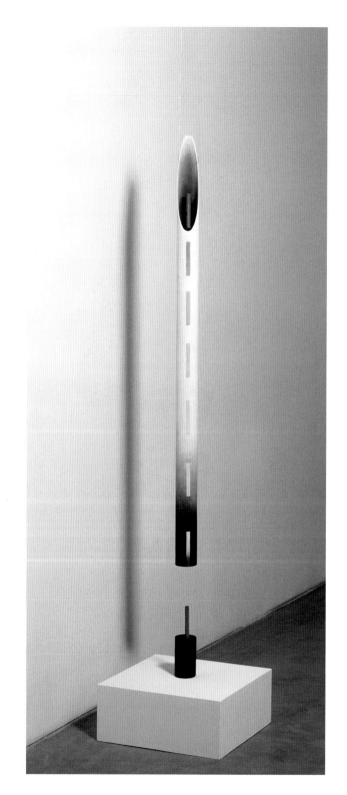

Untitled 1965
Wood, cardboard, metal and acrylic paint,
189.9 × 8.2 × 8.2

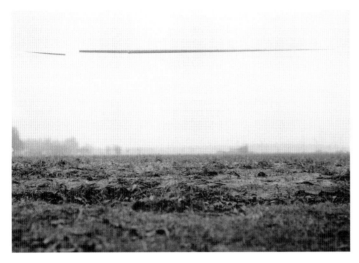

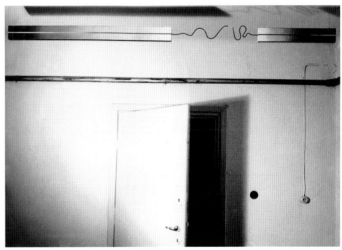

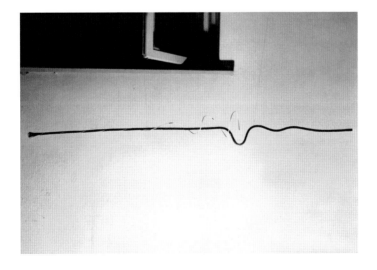

FROM TOP TO BOTTOM

Spear 1965
Wood, metal and acrylic paint, 45.5 × 240

Composition in Space 1965
Wood, metal and acrylic paint, 12 × 132 × 2.3

Untitled c.1964
Metal and acrylic paint, 14 × 157 × 5

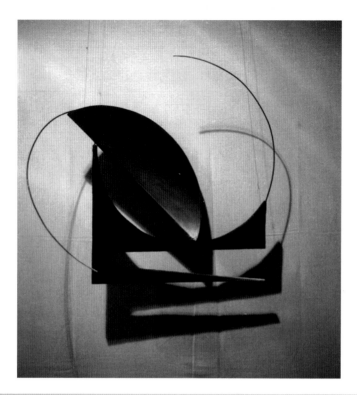

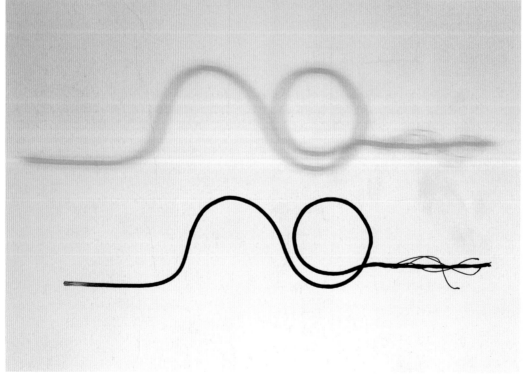

TOP
Composition in Space 1964
Wood, metal and acrylic paint, 59.5 × 71 × 1.5

BOTTOM
Untitled 1964
Metal and acrylic paint, 23 × 105 × 5

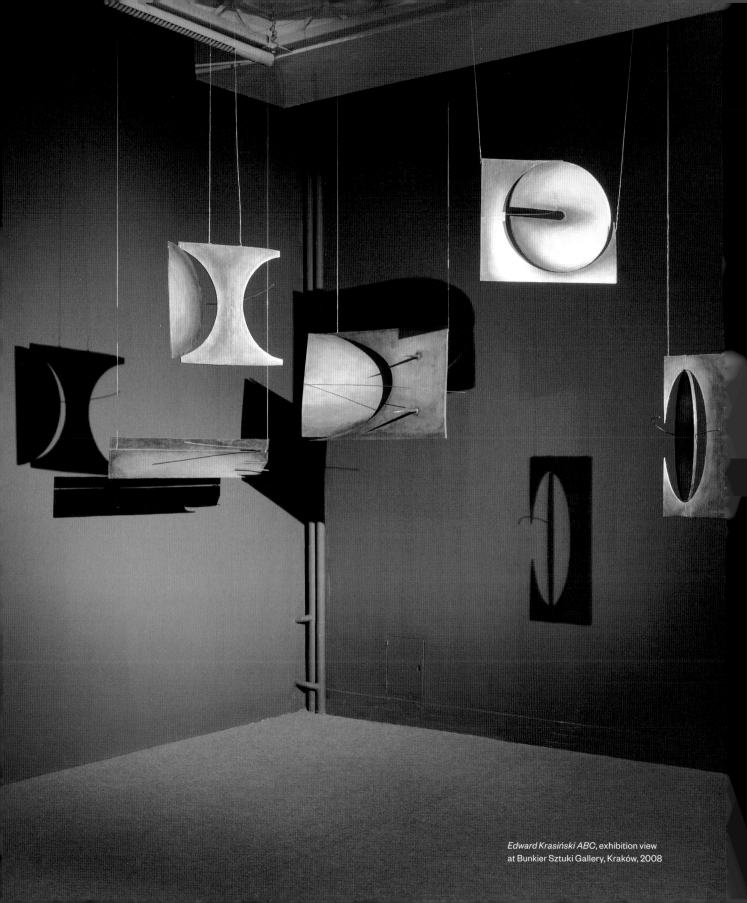

Edward Krasiński ABC, exhibition view
at Bunkier Sztuki Gallery, Kraków, 2008

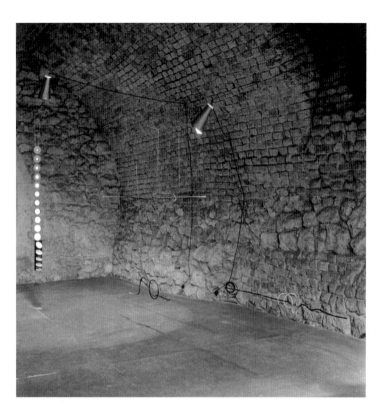

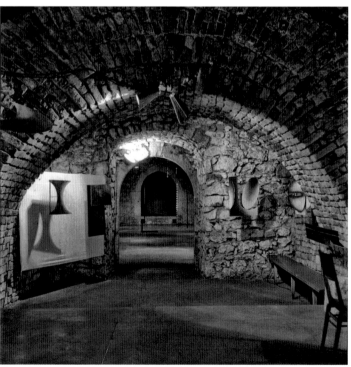

Edward Krasiński, exhibition views at Krzysztofory Gallery, Kraków, 1965

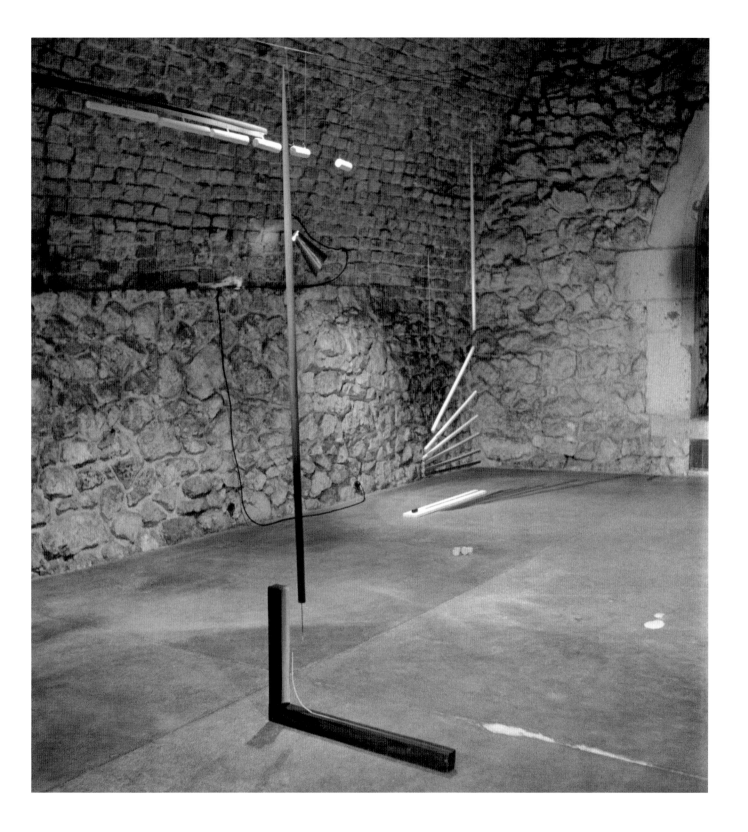

Untitled 1965
Metal and acrylic paint, 210 × 260

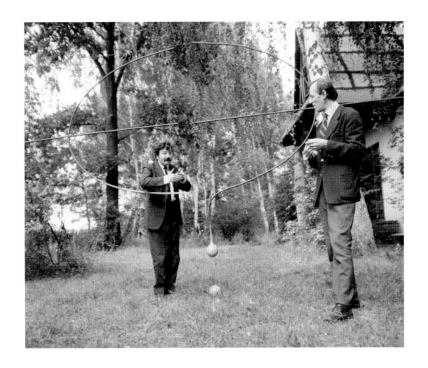

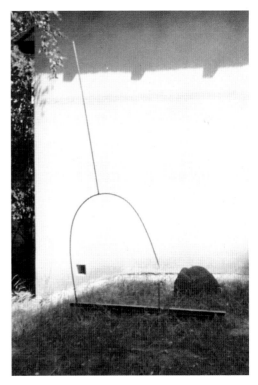

TOP
Edward Krasiński and Pierre Restany
in Zalesie, 1966

BOTTOM LEFT
Untitled 1965
Wood, cardboard, metal, plastic and acrylic
paint, 195 × 41 × 41

BOTTOM RIGHT
Untitled 1966
Wood, metal and acrylic paint,
233 × 89 × 8

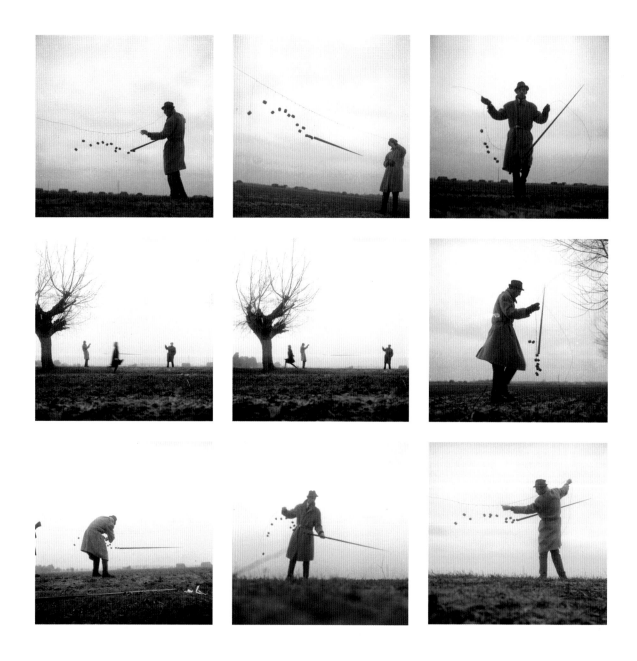

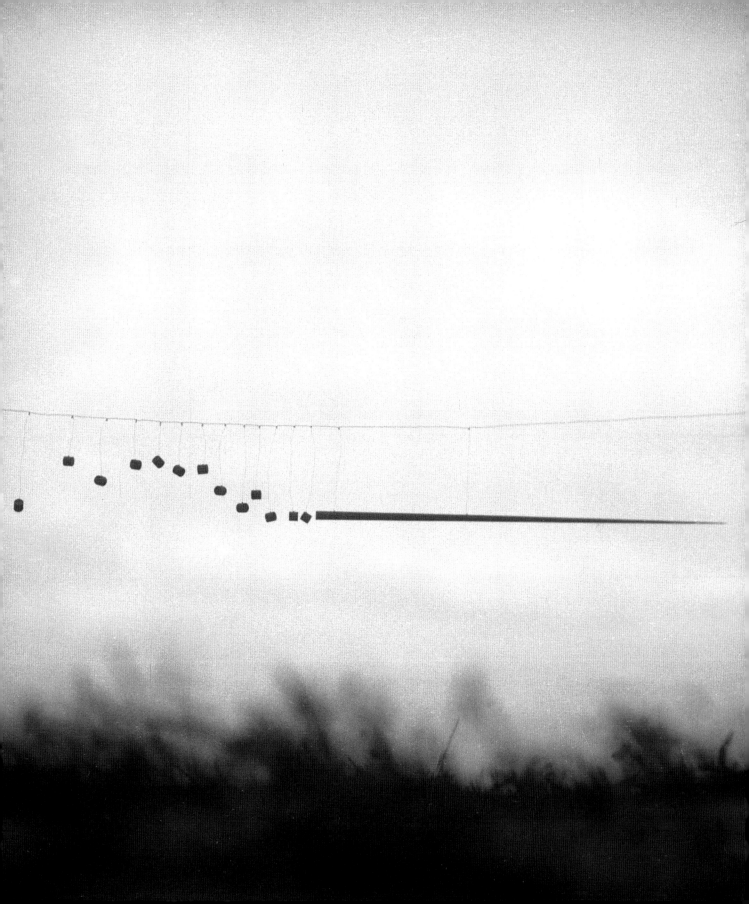

Kasia Redzisz

SCULPTURE FOR PERFORMANCE

Edward Krasiński and his Props

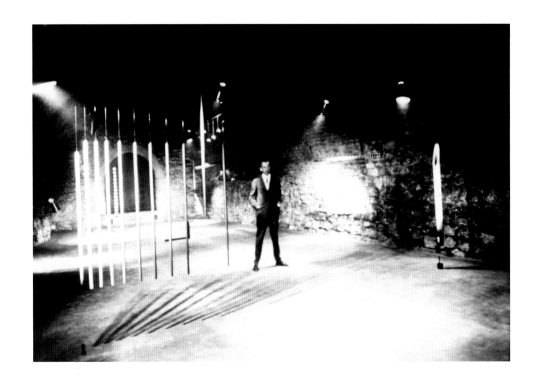

The line between art and life should be kept as fluid, and perhaps indistinct,
as possible. The reciprocity between the man-made and the ready-made
will be at its maximum potential this way.
Allan Kaprow, *Assemblages, Environments & Happenings*[1]

The Show

In 1965, Edward Krasiński staged his first solo exhibition. The show, which took place at the Krzysztofory Gallery in Kraków, was a late debut. Already 40 years old by the time it opened, the artist had left Kraków, where he had studied, and had been living in Warsaw for over a decade. There, he became acquainted with a group of young critics, future founders of the Foksal Gallery and Henryk Stażewski, a forefather of Polish constructivism, with whom Krasiński went on to share his now-famous apartment-cum-studio. At the time of the show, Krasiński was making his living by executing various public commissions, such as painting murals or stage designs for theatre. He also drew illustrations for magazines. They were similar in style to his early surrealistic paintings – works that were nothing like the ones displayed at the Krzysztofory. Nevertheless, the atmosphere evoked by the objects in the gallery had something of a surreal reverie.

Photographs of the exhibition taken by Eustachy Kossakowski present a mysterious, dark space with raw stone walls (opposite). A group of geometric sculptures – forms cut out of wooden squares with mobile parts on hinges – are suspended from the ceiling. Illuminated with theatrical spotlights, they cast elaborate shadows on the walls. One image shows a white rectangular screen installed in the corner to serve as a backdrop for the works and to enforce the dramatic effect of the interplay between light and shadow (see p.38). Floating in the air is a vertical sculpture – a slim wooden tube, painted black and white, with thin pieces of cardboard in various shades of red marking its axis or, perhaps, the vector of movement. It seems to be frozen in motion, as do mysteriously levitating wooden sticks and sixteen flat circles threaded on to a thin, almost invisible string and hovering just above the floor, their fall suspended in time.

Photographed among the works, Krasiński, immaculately dressed in a dark suit, a white shirt and an elegant tie, poses like the director of a spectacle rather than 'merely' a sculptor. A master of ceremony, an illusionist deceiving our eyes, a conductor responsible for harmony of experience, Krasiński was no stranger to theatre and performance. (Indeed, an iconic photograph taken in 1967 shows him conducting an absurd orchestra of waves standing on a proscenium immersed in the sea, as the protagonist in Tadeusz Kantor's *Panoramic Sea Happening* [see p.8].) Kossakowski's camera captures the viewers circulating in the dimly lit gallery. Their encounter with the works is uninterrupted; no visual barriers – vitrines, display cases, pedestals – separate them from the sculptures. In this precisely arranged setting, Krasiński's objects are less the visual focus and more an integral part of the overall scene. They play a role in a theatrical scenario.

Three years later, in 1968, Krasiński had a second show at the Foksal Gallery. The script for the viewers' interaction with his works was radically reversed. A small, neutral interior, evenly and brightly lit, was filled with large plinths on which the artist displayed a diverse group of sculptures made of wire and rubber cable (see pp. 56 and 58). The entrance to the gallery was narrowed and almost entirely blocked by

Edward Krasiński at the opening of his first solo
show at Krzysztofory Gallery, Kraków, 1965

one of the pedestals. Navigating through the labyrinthine space was a complicated undertaking, a paradox for the interior measured no more than 35m^2. The experience of the works was defined by prescribed choreography: pedestals determined the route and convoluted metal rods swirling across the space, unifying all its components, guided the gaze of spectators. As visitors moved through the room, the light, seen from various angles, shifted slightly, creating the illusion of movement, described by Alexander Alberro in his phenomenological reading of Krasiński's practice, as a feature inherent to his static objects.[2]

With these early shows, Krasiński introduced an approach to exhibition- and object-making that came to mark his entire practice, notwithstanding the changing styles and experiments with various media that occurred in later years. Playing tricks on perception, leading and misleading the senses, precisely directing the viewers' encounter with objects remained his guiding principles. The meaning of his work is defined by the relationship between the object, space and the beholder. In this sense, his art, often seen as a local incarnation of minimalism, embraces Michael Fried's critique of the trend and his idea of the theatricality of an artwork manifested in the necessity of engagement with the physicality of the spectator.[3] The meaning of Krasiński's works does not unfold in the act of contemplative looking but rather in the potential for the works to be performed, activated or animated. 'It was always objects in action for him… in potential action.'[4]

The Magic Act

Commenting on Krasiński's collaboration with photographers such as Eustachy Kossakowski, who documented many of his works, Anka Ptaszkowska spoke of the 'happening' character of his sculptures.[5] Indeed, these objects seem to happen rather than to simply be, an observation that finds its fullest articulation in the series of photographs showing the artist interacting with *Spear* (see p.42). The action takes place in an open field in Zalesie, c.1963–4. Krasiński and his partners in crime hold the spear up in the air, suspended on thin wires. Its fragmented end suggests that the object is falling apart while cutting through the space with great speed. The impression of movement is so strong that it overshadows the very obvious presence of the support structure. Seduced by the lightness and finesse of the work, the viewers of the scene suspend their disbelief. They see the spear flying, even after it has been entrapped in a gallery space.

As in the case of *Spear*, it is, to a large extent, through photographic documentation that we recognise the performative nature of Krasiński's works. Take the sequence of images in which the artist is shown with *N…, (Intervention 4, Zig-Zag)* c.1970, a work consisting of a number of 70cm-long blue wooden sticks hinged together, so that they can be folded and unfolded. Krasiński places the folded piece flat on the floor in the long corridor of his apartment (see pp.74–5). He grabs its end and gradually stretches out the work. *Zig-Zag* looks as if it is following its creator. Another photograph shows three *Zig-Zags* laid out next to each other in various positions (folded, partly unfolded and elongated, see pp.80–1). Seeing the sculptures on a low plinth as part of an installation made for the 1970 Tokyo Biennial, *Between Man and Matter*, one almost expects them to change position every day. The works have no fixed shape and call for manipulation, as do other objects made from metal

Lygia Clark (1920–1988)
Caminhando (Walking) 1963
Paper, glue, scissors, dimensions variable

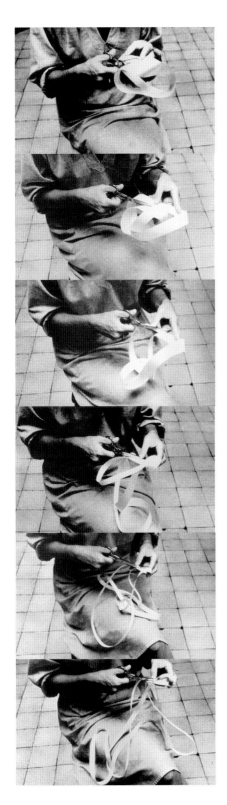

and rubber cables that form part of the same installation. Scattered around gallery spaces, writhing and unravelling on pedestals and floors, they remind visitors of organic forms living their own lives.

In spite of the temptation of interaction inscribed in their ever-changing shapes, Krasiński's works from the 1960s were never meant to be interacted with. The artist took his interrogation of the modernist category of sculpture far enough to question its objecthood and stability, but he never gave away control of its final form (installation instructions drawn by the artist for the Tokyo Biennial are striking in their precision, see p.130). His works change shape backstage; the act of manipulation is concealed. In this sense the zig-zags or cable sculptures stop at the threshold transgressed by Krasiński's contemporaries such as Lygia Clark (1920–1988). This seemingly distant comparison is triggered by the fact that both artists shared constructivist heritage. Their experiments with sculpture are rooted in the theories of such avant-garde predecessors as Katarzyna Kobro (1898–1951), who considered her sculptural compositions in relation to the movement of the body in space.[6] Clark's *Bichos* (Creatures) 1959–66, manipulative sculptures made from hinged metal planes, explicitly intended to be handled by the viewer, go one step further than Krasiński's objects. Animating her metal creatures is a possibility; animating his crawling zig-zags is a desire.

There is, however, no doubt that Krasiński considered the public as active participants of his exhibitions. The most direct call for participation was expressed on the occasion of his show at the Foksal Gallery in 1969. The poster for *Winter Assemblage* features a portrait of the artist entangled in a convoluted cable, accompanied by a desperate and comical appeal (see p.62):

J'AI PERDU LA FIN!!!
Je la cherche!
Qui la trouvera
est pri[é] d'ECRIRE! de TELEPHONER!
de TELEGRAPHIER![7]

At the end of the 1960s, Krasiński was looking for an end, which Clark consciously lost in her first truly participatory piece *Caminhando (Walking)* 1963, a paper Möbius strip, which participants were supposed to cut over and over again to create the finest possible line with no end (left). Clark's later investigations into the nature of a line resulted in participatory works made with the use of rubber bands or threads, which constituted physical lines connecting the bodies in space. In a similar way, Krasiński's endless (*J'AI PERDU LA FIN!!!* seemed to be lost forever in 1969) blue line, which became his signature motif from the beginning of the 1970s, integrates the components of the space and delineates the area of sensual experience of the works.

Observing Krasiński in action with his sculptures – enveloped helplessly in plastic cable, taking wooden sticks for a walk, or later, persistently sticking blue adhesive tape on everything within his reach and placing eggs on museum plinths – calls for considering them in performative terms and, as a consequence, allows one to approach them as props of sorts: objects that convey meaning and enhance our understanding of fictional narrative. Everyday objects and materials employed in Krasiński's scenarios are used in unconventional ways, removed from their original function. Reflecting upon her relationship to objects, Joan Jonas (b.1936), whose

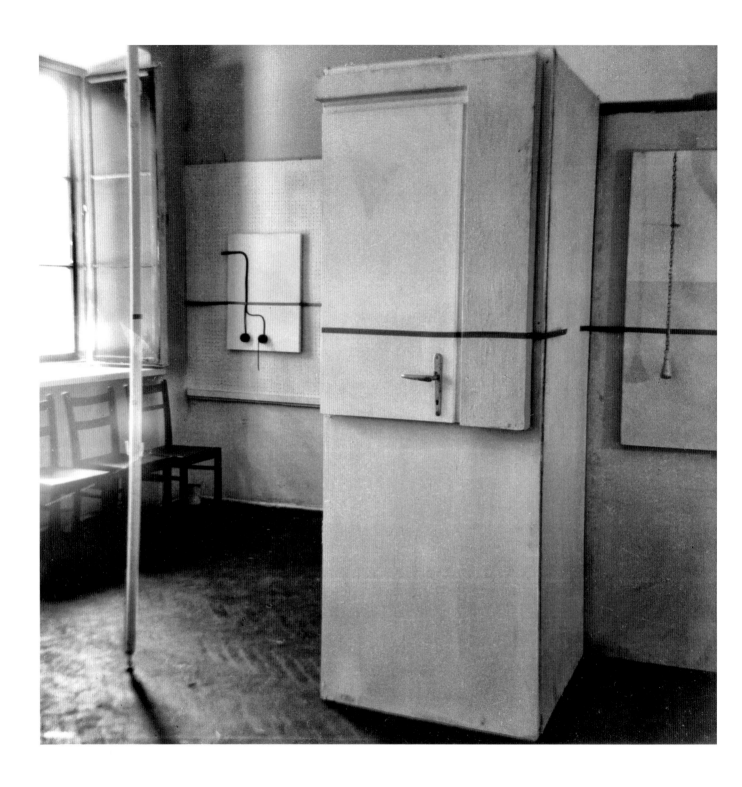

Edward Krasiński, exhibition view at Repassage Gallery, Warsaw, 1974

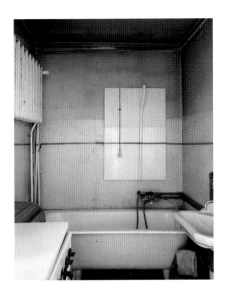

Edward Krasiński's studio, Warsaw

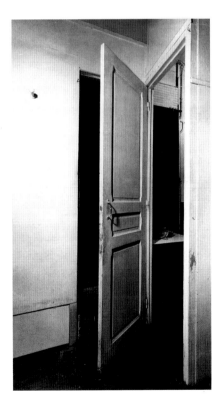

Marcel Duchamp (1887–1968)
Door: 11 rue Larrey, Paris 1927
Reconstruction by Pontus Hultén
and Daniel Spoerri 1961

experimental practice since the late 1960s has been marked by the frequent use of props, recalls her childhood experience of watching magic shows and her memory of conjurors using eggs, hats, handkerchiefs and coins in an 'inappropriate' manner to produce an illusion of magic. She assigns this inadequate manipulation of things to the realm of performance, explaining also that in her works she started to employ props thinking of them as 'objects that are capable of generating movement, [which] partly comes from the prop in relation to the body and the space'.[8]

Trip Hazard

Krasiński's 'inappropriate' approach to the everyday and its attributes manifests itself fully in the décor of his studio-cum-apartment in Warsaw.[9] Walking through its doors results in confusion. The interior is full of little traps and visual pranks. The coat rack in the hallway is replaced by a pitchfork sticking out of the wall, hanging too high for anyone to reach it. The envelope lying on the floor is glued there, so no one can pick it up. There is a dry branch sprouting out of the wooden parquet and little artificial mice hidden in the corners of the rooms (the mouse traps are real, though). A power socket may be functional but it hangs on two thin threads, a metal fin cuts through the table, a water tap is installed purposelessly in the living room at eye level. On closer inspection, the bookshelf appears to consist of a large photograph of the original item of furniture, which stands behind its photographic reproduction (see p.122). In the bathroom, there are two flush pulls: one functional and one an artistic relief, a dummy (top left). The border between reality and its crooked mirror image is perplexingly blurred, and navigating through the space is a risky undertaking. Everything here hangs by a single thread, supported only by a narrow strip of blue Scotch tape skirting the walls at the height of 130cm.

Motifs and elements from Krasiński's apartment were frequently repeated in his works. *Intervention 10* 1974, for instance, contains a large fragment of an ordinary door (opposite). Installed on a wall, it tempts the viewer to reach for the handle, yet, by virtue of artistic gesture, the door will remain closed forever. The handle is useless. Famous for his aphorisms, the artist once said: 'I very much like doors because they open on to something, and close behind something.'[10] The relief is a tribute to a favourite object, questioning its very favourite function. Krasiński's comment, disarming in its simple logic, brings to mind another set of doors, namely Marcel Duchamp's paradoxical *Door: 11 rue Larrey* 1927 (left). Serving two adjacent doorways, the door opened one route while blocking the other, never fulfilling its original role. When discussing the somewhat Dadaistic décor of Krasiński's apartment, Duchamp proves a useful analogy in the reading of the space.[11]

Taking off his hat, a visitor to Duchamp's New York apartment, as photographed by Henri-Pierre Roché c.1918 (overleaf), notices that the hat rack is positioned at a height beyond his reach. Confused, he moves back and almost hits his head against a snow shovel dangling from the ceiling. He fails to keep his balance after tripping over the coat rack nailed to the floor. And then comes the worst: the urinal hangs over the doorway. Inverted! The guest is struggling, as he begins the awkward dance between the oddly positioned props. The interior is infamously dusty and messy. Yet, Duchamp's ready-mades, the mundane objects of everyday life – the snow shovel, the urinal, the coat rack (entitled *In Advance of the Broken*

Arm, *Fountain* and *Trap*, respectively) – are positioned in the space with thoughtful precision. It was not until after the Second World War that they came to be widely exhibited; at the time when the photographs were taken, the flat on 33 West 67th Street was their main field of perception. As in the case of Krasiński's works in the studio, they were carefully put on display.[12]

The absurd arrangement of seemingly ordinary things unveils their subversive character, undermining functionality as their raison d'être. In the era of Taylorism – the practice of scientific management and work efficiency – (for Duchamp) and the communist worship of productivism (for Krasiński), the mass-produced, purely utilitarian things are staged in useless poses. What a waste! Disrupting the efficient flow of movement, they call for slapstick choreography. Their meaning lies in their relationship with a performer. It is easy to imagine Charlie Chaplin (1889–1977) in the interiors described above, repeating the erratic sequence of movements from the opening scenes of his film *Modern Times* (1936), which ridicule the effects of rationalised work on the body.[13] The comedian's irrational behaviour, his jerky gestures and strange hand manoeuvres ironically reflect his (but also Duchamp's, his contemporary) critical view of the efficiency and utilitarianism of the everyday. Can the dysfunctional character of Krasiński's studio be interpreted in the same way – as a subtle act of resistance towards the socialist propaganda of work?

In photographs showing Krasiński, he is never seen at work. He is usually immersed in some kind of futile activity: chatting, drinking or vainly looking for the end of a long cable. In fact, Krasiński did not even like the word 'artwork'. He did not want to associate his practice with any kind of effort.[14] The blurring of domestic and work functions in his studio/apartment was a reflection of this approach. The artist never seemed to actually make art in the flat, and to regular visitors his interventions in the space always seemed to emerge out of nowhere. He generally made works in his bedroom, an area conventionally associated with rest and relaxation. Art and life coexisted there in blissful symbiosis uninterrupted by even the slightest symptom of pragmatism, suggesting the notion of the decadent figure of the dandy, which stood in profound contradiction to the state-approved ideal of socially and politically engaged artist.

This position was not unpopular among fellow artists on both sides of the Iron Curtain. Consider Alighiero Boetti (1940–1994) tellingly sunbathing in winter Turin, Italy's most booming industrial city *(Io che prendo il sole a Torino, il 19 gennaio 1969 [Me sunbathing in Turin, January 19, 1969]* 1969); photographs of Mladen Stilinović (1947–2016) napping in his bed, provocatively titled *Artist at Work* 1977; and Marc Camille Chaimowicz (b.1947), whose non-activities (sleeping, sitting at the table, drinking tea, gazing out of the window), performed in his immaculately elegant apartment, penetrate the field of art, escaping the binary opposition of private and public or art-making and living (right). In the case of Chaimowicz, the interior of his apartment, filled with his installations and objects, mirrors a personage he adopted. His house, and by comparison Krasiński's apartment, is an arena for artistic creativity, a stage where performance takes the place of reality. This tension between the place and reality is crucial in understanding Krasiński's treatment of not only domestic but also exhibition spaces.

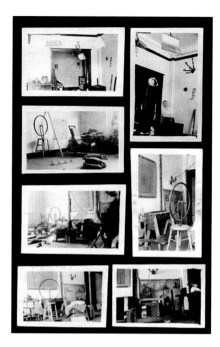

The apartment of Marcel Duchamp (1887–1968), 33 West 67th Street, New York, c.1918

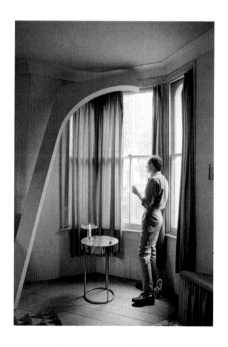

Marc Camille Chaimowicz (b.1947)
Man looking out of window (for SM) 2006
Photograph on aluminium, 193 × 121

The Place as Illusion

I've turned the floor into a work of art – excuse the expression.
The floor is no longer redundant.

– You've raised the floor

It's like the floor rears up to meet a drunk. I gave the floor the same
treatment as I did to walls when I fixed them with the strip. That is,
I exposed the wall, unmasked walls. Now, I'm unmasking the floor
with floorboards. The floor with the floor. Pig on pork.

Joanna Mytkowska and Edward Krasiński in conversation[15]

Krasiński's comment about his 1997 exhibition at the Foksal Gallery, in which he
raised pieces of the wooden parquet above floor level (below), unveils how similar his
relationship is to the space he inhabited and to the space where he showed his works
to the public. He approached both with an acerbic humour intended to challenge the
conventional ways of seeing art.

As mentioned above, Krasiński conceived his exhibitions as total scenarios in
which the viewers' encounters with the works were carefully orchestrated yet removed
from any institutional routine.[16] With time, the relationship between objects and bodies
in space became increasingly complicated. From the mid-1980s onwards, viewers
often needed to negotiate their path through the space, finding their way through
labyrinths and narrow corridors (overleaf, top), losing orientation while navigating
mirrors that reflect the space and the artworks installed within it (see p.124). The
vertigo effect generated by the installations went hand in hand with the confusing

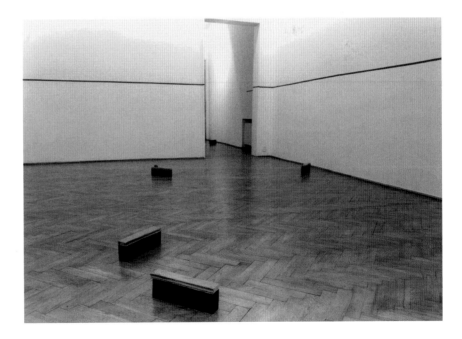

Edward Krasiński, exhibition view at
Foksal Gallery, 1997

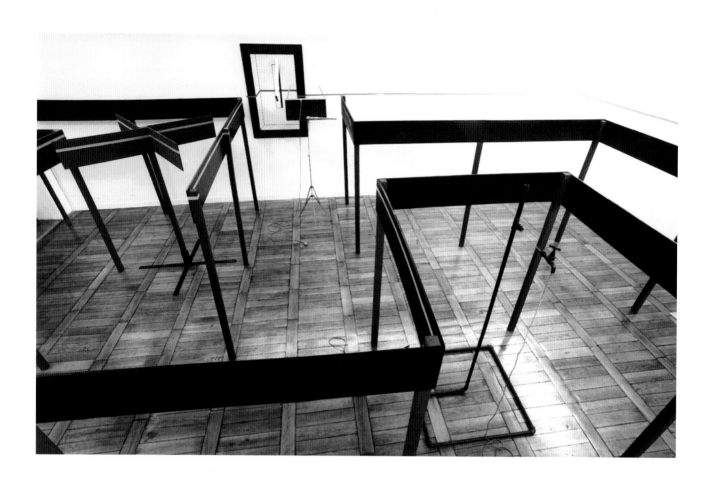

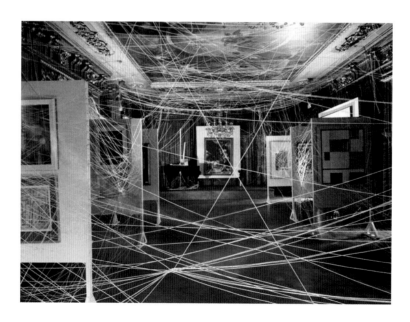

disrespect for chronology and the blurring of borders between the artworks and their photographic reproductions.

Krasiński's strategy was to tease and frustrate the gaze, an approach that can be traced back to Duchamp and his determination to undermine the status of museum displays, as shown in his design for the exhibition *First Papers of Surrealism* 1942 (opposite, bottom). Duchamp used white string to create a dense web across the historical interiors of Whitelaw Reid Mansion – a visual barrier between spectator and exhibited works.[17] What can be made of a combination of Duchampian legacy, the slapstick embedded in Krasiński's installations and Krasiński's aspiration to physically challenge perception?

Analysing walking practices as a performative act of individualising public space, scholar Michel de Certeau (1925–1986) reads Charlie Chaplin's exaggerated manipulation of his cane (a ready-made object, a truly Duchampian prop) as extending its role beyond conventional use, and, therefore, as an action that subverts the logic of social space.[18] In his book *The Practice of Everyday Life* (1980), he discusses movement within an efficiently organised urban environment as a means of negotiating individual position and expressing one's relationship to the surrounding scenery. Embarking on a discourse on narratives expressed through topography and motion, he contrasts the public sphere, in which elements coexist according to a 'proper', stable order, with an individualised space defined by movement and change and articulated by 'operations' and the individual 'practicing' of objects.[19]

Based on numerous photographs documenting Krasiński's projects, it is clear to see that the spaces he 'articulated' were ruled by subjective logic. The fixed principles of the external world stayed outside the walls of his exhibitions and apartment. This division echoes a key belief noted in the *Programme of the Foksal Gallery* (the artist was among the gallery's founding members), which claimed that 'the PLACE is an area that arises by virtue of setting aside all and any principles in the universe'.[20] For Krasiński, what separated the two realities was the blue stripe of Scotch tape, a mass-produced, ready-made object, which when applied to trees, walls, doors, windows and artworks gained a new life, while putting in parentheses the space it encompassed. The gesture of placing the tape 'everywhere and on everything' is an exemplary case of individual 'practicing' of an object as per de Certeau. Grotesque in its stubborn repetition, it undermines the functional status of the material – and, as a consequence, the standard order of space – that it delineates and the one that it excludes.

The notion of heterotopia – a concept that describes a world misaligned with respect to normal or everyday space – inherent to Krasiński's treatment of his surroundings, however, constitutes only one aspect of his elaborate exhibition-making practice. Drawing from theatre in their discreet engagement of props and choreography, his immersive installations operate as stage sets, which not only transform physical aspects of space, isolating them from the external world, but also evoke mental images of places and temporalities beyond the casual here-and-now. This poetic result is achieved through the consideration of a multisensory experience and a meticulous attention to detail. 'An hour before the opening have the floor polished and waxed, so it smells like a floor. The floor is revealed in its smell,' explains Krasiński in an interview with Joanna Mytkowska.[21] The smell, like the taste of Proust's madeleine, sends the viewer on a journey elsewhere.

In the majority of cases, this effect of displacement results from the use of photography as a substitute for the real or the authentic. The most explicit example of this mechanism is perhaps the 1985 show at Foksal Gallery, for which the artist wallpapered the interior with photographic images of a forest and filled it with birches, generating a highly artificial yet, by virtue of poetic licence, somehow believable illusion of being in nature (see p.125). This mode of operating reached its emotional peak four years later in the exhibition entitled *Hommage* à *Henryk Stażewski* at the same venue (see p.122). Following Stażewski's death in 1988, Krasiński made the symbolic decision to move the studio they shared to the gallery. He used large-scale photographs to create the illusion of one space inside another. Fake furniture, doors, walls and artworks mixed with ones that were real. Filling the space with objects from the original flat and inviting guests to visit the scenographic incarnation, Krasiński re-enacted the space as it functioned. In this way, he bridged the space between something that had been there and that which was no longer there – a poignant gesture from a sensitive trickster.

Detaching himself and the viewer from the world outside, Krasiński's practice assumed the role of an alibi, offering the possibility of being 'somewhere else' at any given moment. Rather than denying reality, however, Krasiński constructed its parallel version – a method that originated, perhaps, with an event he organised with his circle in the turbulent summer of 1968. *Farewell to Spring*, a ball that took place in Zalesie, was a carnivalesque assembly of friends, who met despite the official ban on gatherings following student protests and political turmoil. Krasiński designed the ball as a tableau vivant, with decorations based on *The Land of Cockaigne* by Pieter Bruegel the Elder (below right). The idyllic landscape was in stark opposition to the events of the time.[22] On the evening, he wore a tailcoat and top hat – the quintessential attributes of an illusionist (below left). From that moment on, Krasiński masterfully dedicated himself to transforming the scenery around him.

LEFT
Edward Krasiński at the ball *Farewell to Spring*, Zalesie, 1968

RIGHT
Edward Krasiński's installation at the ball *Farewell to Spring*, Zalesie, 1968

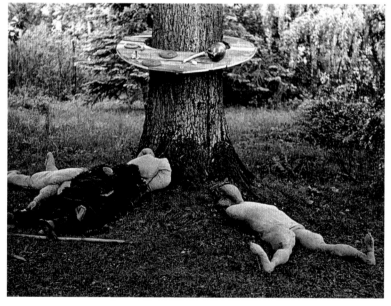

1 Allan Kaprow, *Assemblages, Environments & Happenings*, New York 1966, in Mariellen R. Sandford, ed., *Happenings and Other Acts*, London 1994, p.235.

2 Alexander Alberro, 'Edward Krasiński's Dynamic Line', in *Avant-Garde in the Bloc*, Gabriela Świtek, ed., Warsaw and Zürich 2009, p.373.

3 Michael Fried, 'Art and Objecthood', in *Artforum*, vol. V, no. 10 (Summer 1967), pp.12–23.

4 'Farewell to Spring', Anka Ptaszkowska in conversation with Joanna Mytkowska and Andrzej Przywara, in Sabine Breitwieser, ed., *Edward Krasiński: Les mises en scène*, exh. cat., Generali Foundation, Vienna 2006, p.102.

5 'Happening Sculptures and Documentary Photographs, Anka Ptaszkowska talks to Andrzej Przywara', in: Paweł Polit, ed., *Edward Krasiński ABC*, exh. cat., Bunkier Sztuki Gallery, Kraków, 2008, p.95.

6 In 1966, Julian Przyboś linked Krasiński's spatial explorations with ideas of movement and continuity of space discussed in Kobro's writings, see Julian Przyboś, 'Rzeźba napowietrzna' ('Sculpture Overhead'), *Poezja* (*Poetry*) magazine, no. 1, 1966, p.75. The relationship between Kobro and Lygia Clark was explored in the exhibition *Kobro/Clark* at the Muzeum Sztuki in Łódź, 21 November 2008 – 1 March 2009. The show was curated by Jarosław Suchan in collaboration with Paulo Herkenhoff.

7 Poster published by the Foksal Gallery, Warsaw, April 1969.

8 Joan Jonas, 'Some Reflections on a Practice: Mirrors, Hoops and Organic Honey', *The Showroom Annual 2006/7*, London 2008, p.35.

9 Décor is a French term for stage set. I am using it after Rachel Haidu, who linked Krasiński's late installations and his studio to works from the 1970s by poet Marcel Broodthaers in her essay 'The Time of the Instytut Awangardy', in Świtek 2009, pp.204–16. See also Haidu, 'Set Piece: Décor – A Conquest by Marcel Broodthaers', in *Artforum*, vol. 45, no. 10 (Summer 2007), pp. 434–41; and the conclusion of Haidu's book *The Absence of Work. Marcel Broodthaers 1964–1976*, Massachusetts 2010, pp.265–84.

10 Edward Krasiński quoted in Breitwieser 2006, p.115.

11 The discussion about Krasiński's studio in relation to Duchamp is based on my essay 'The Studio as Stage Set. The Stage Set as Portrait or Can the Prop Talk', in *Pavilonesque*, no. 1, September 2005, pp.27–9.

12 Helen Molesworth, 'Work Avoidance: The Everyday Life of Marcel Duchamp's Readymades', in *Art Journal*, vol. 57, no. 4 (Winter 1998), pp. 50–61.

13 Ibid.

14 See Adam Szymczyk, 'Shot at Breast Height', *Parkett*, no. 81, 2007, pp.195–7; and Karol Sienkiewicz's essay in this volume, pp.108–19.

15 Joanna Mytkowska, 'Interview with Edward Krasiński', in Joanna Mytkowska, ed., *Edward Krasiński*, Foksal Gallery Foundation, Warsaw 1997, p.69.

16 The designs of Krasiński's most important solo exhibitions were re-created in a major retrospective of his work: *Edward Krasiński: Les mises en scène*, Generali Foundation, Vienna, 12 May – 27 August 2006. The show was curated by Sabine Breitwieser.

17 Elena Filipovic, 'A Museum That Is Not', *e-flux Journal*, no. 4, March 2009, www.e-flux.com/journal/a-museum-that-is-not/, accessed 17 June 2016.

18 Michel de Certeau, *The Practice of Everyday Life* (1980), Steven F. Rendall, trans., California 2011, p.98.

19 Ibid., p.124.

20 Mariusz Tchorek et al., 'An Introduction to the General Theory of Place', in *Program Galerii Foksal PSP*, exh. cat., Foksal Gallery, Warsaw 1967, n.p. (introduced in Pulawy in 1966).

21 Mytkowska 1997, p. 69.

22 Luiza Nader interpreted the ball in Zalesie through the Foucauldian notion of heterotopia and the theory of trauma. See her essay: 'The Zalesie Ball. Other Spaces in the Polish Avant-Garde', www.springerin.at/dyn/heft_text.php?textid=1936&lang=en, accessed 19 June 2016.

C.1968

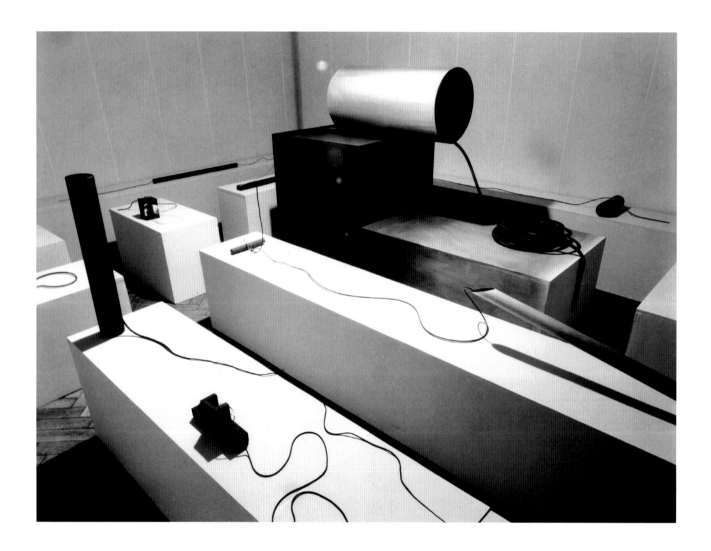

ABOVE
Edward Krasiński, exhibition view at Foksal Gallery, 1968

RIGHT
Untitled 1968 (missing work) in the garden, Zalesie

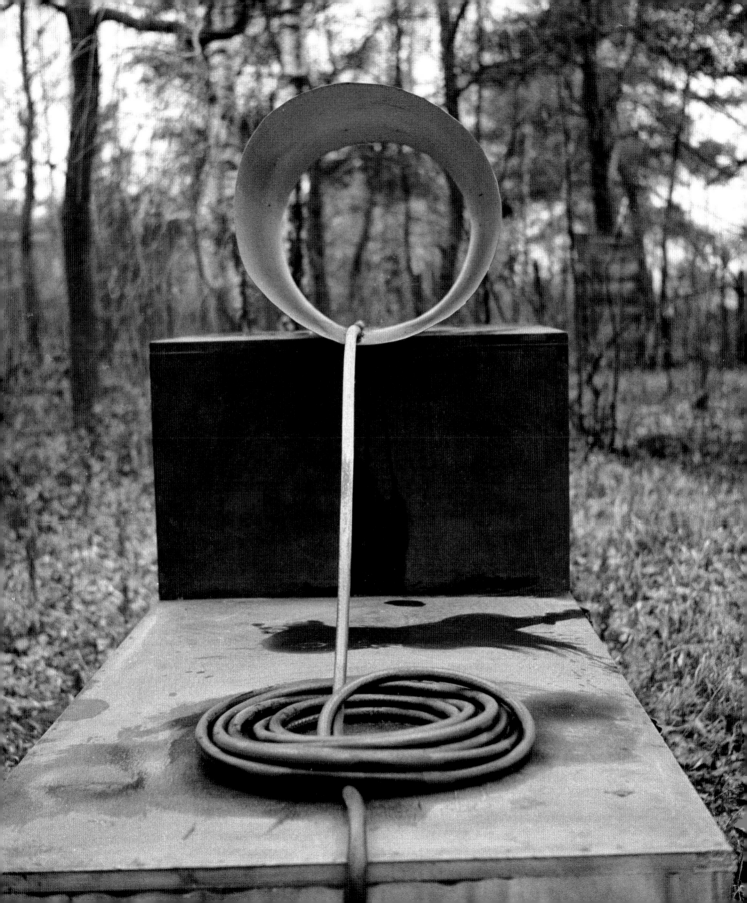

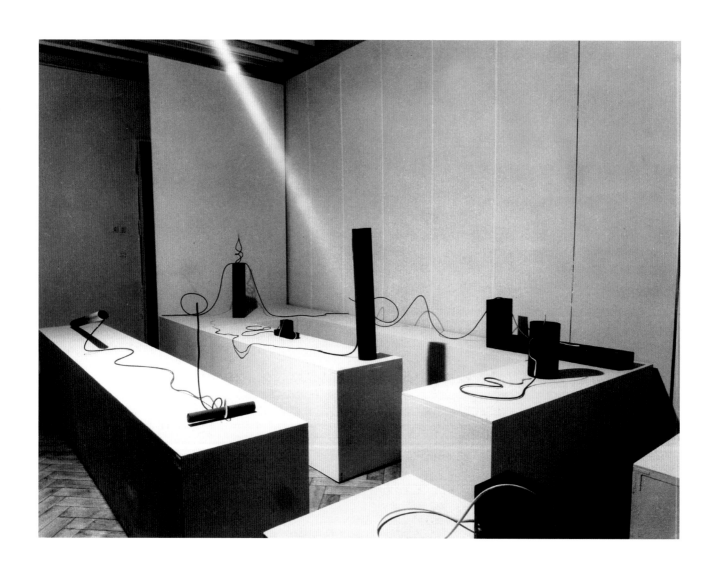

Edward Krasiński, exhibition view at Foksal Gallery, 1968

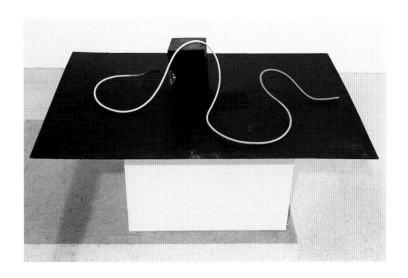

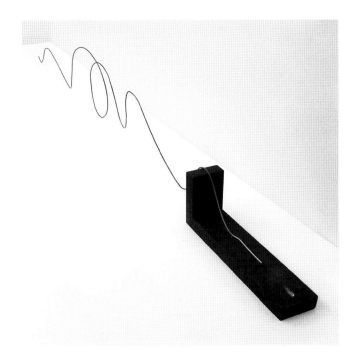

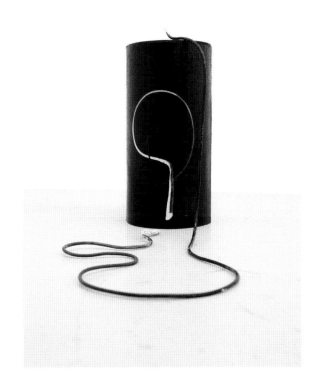

CLOCKWISE FROM TOP
Untitled 1968
Wood, steel, photograph and acrylic paint, 18 × 71 × 58.3

Untitled 1967
Wood, metal, photograph and acrylic paint, 28 × 37 × 15

Bar 7 1967
Wood, steel and acrylic paint, 30.5 × 425.5 × 19

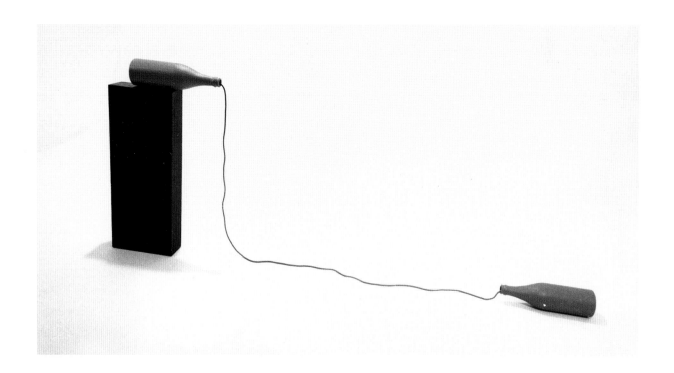

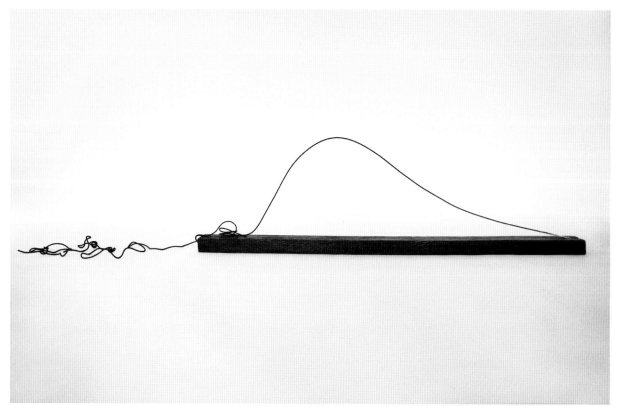

TOP
K. 1 1968

60 Glass, plastic, wood and acrylic paint, 54 × 125 × 7

BOTTOM
Untitled 1967

Wood, metal, plastic and acrylic paint, 34 × 260 × 8

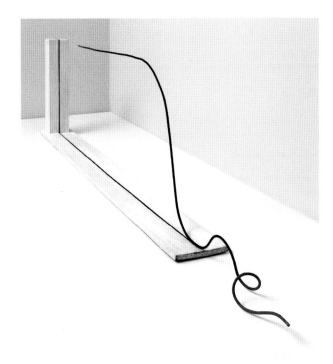

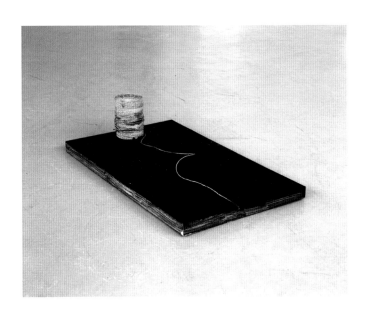

CLOCKWISE FROM TOP LEFT
i-4 1968
Aluminium, metal, plastic and acrylic paint,
27 × 114 × 9

Untitled 1967
Wood, metal and acrylic paint, 52.5 × 227 × 17

Untitled 1969, reconstructed 1978
Wood, string and cardboard, 11.5 × 49 × 30

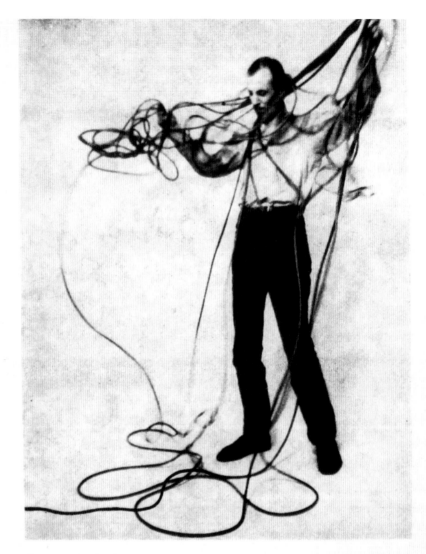

bleu mince longlonglonglonglonglonglonglonglonglonglonglonglonglonglonglonglonglonglo
nglonglonglonglonglonglonglonglonglonglonglonglonglonglong...

J'AI PERDU LA FIN!!!

Je la cherche!
Qui la trouvera
est prié d'ECRIRE! de TELEPHONER!
de TELEGRAPHIER!
à l'adresse suivante: Edward Krasiński
Galeria Foksal PSP, Varsovie, rue
Foksal 1/4, tel. 27 62 43

publié par la Galerie Foksal PSP Varsovie. avril 1969

J'AI PERDU LA FIN!!! poster, published by the Foksal Gallery within the framework of *Winter Assemblage*, 1969

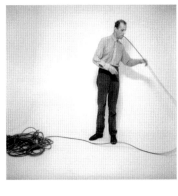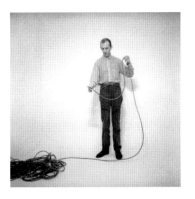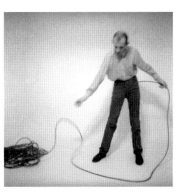
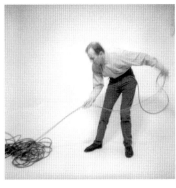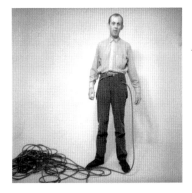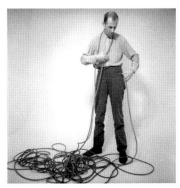
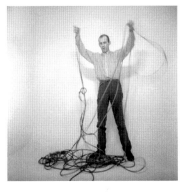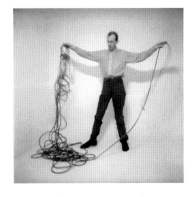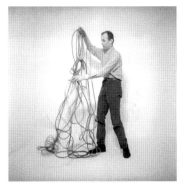
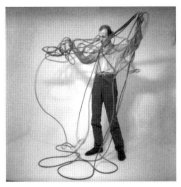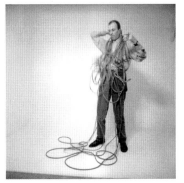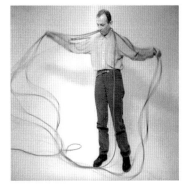

J'AI PERDU LA FIN!!! 1969

Stephanie Straine

A KIND
OF CIRCUIT

Edward Krasiński and Minimalism

If one is not too sure what has happened in sculpture since 1960 and if one wants to see an absorbing, if conservative, selection of works by primarily well-known figures, then one ought to stroll down the bright spiral of the Guggenheim…. Edward Krasiński of Poland, one of the few unknowns, presents a modest, anti-material column of colour-graduated balls rising on a nylon line.
Robert Pincus-Witten, *Artforum*[1]

These remarks are taken from art critic Robert Pincus-Witten's ambivalent review of the 1967 *Guggenheim International Exhibition: Sculpture from Twenty Nations* (opposite). They hint at the fresh, distinctive role of Edward Krasiński's art in what Pincus-Witten later refers to as the 'United Nations-like' nature of such group survey shows, which attempted to summarise the global state of art, in this case sculpture since 1960. This fifth Guggenheim International Exhibition was the result of a three-year undertaking by curator Edward F. Fry, whose final checklist included, according to the press release, 'over one hundred works of the 1960s by eighty artists from twenty nations…. As Curator of the exhibition, Mr. Fry devoted three years of study to recent developments in modern sculpture, a reconnaissance which took him around the world and involved him in consultations with collectors, artists, dealers and museum officials in the many countries he visited.'[2] Established figures like Pablo Picasso (1881–1973), Alberto Giacometti (1901–1966) and Barbara Hepworth (1903–1975) rubbed shoulders with younger artists more readily associated with the current American art scene, including John Chamberlain (1927–2011), Claes Oldenburg (b.1929), Donald Judd (1928–1994), John McCracken (1934–2011) and Robert Morris (b.1931), in an exhibition that was decidedly inter-generational and trans-continental. Alongside Krasiński, Jerzy Jarnuszkiewicz (1919–2005) was the only other Polish artist to be featured.

This staged institutional encounter can be understood not only as an occasion potentially fraught with overtones of cultural imperialism, but also as a productive discursive moment within the global advancement towards what was, in this very year, beginning to be framed as the 'dematerialization of the art object'.[3] Krasiński's participation in this major exhibition in New York shed light on his practice's dialectic relationship to minimal and post-minimal sculpture, and the emerging field of conceptual art, in the same year that the theoretical base of minimalism was consolidated thanks to the publication of Michael Fried's watershed text 'Art and Objecthood'.[4]

For the last decade or so, Krasiński has been rightly included in the proliferation of new-generation surveys of global conceptualism, mounted as part of the collective effort to correct the Western Euro-American bias of earlier narratives of that much-analysed art-historical moment of the late 1960s and early 1970s.[5] It is instructive, therefore, to return to the presentation of this artist within a group exhibition from that time, which was specifically framed as 'international' for its American audiences, and treat it as an archival case study that helps to explain the present curatorial re-positioning and historicisation of Krasiński's practice. This essay argues not for the wholesale detachment of Krasiński from his formative and critically important local, national and regional contexts, but rather for a simultaneous consideration of those moments in the 1960s and 1970s when his practice physically, materially and theoretically intersected with other global centres of minimal and conceptual tendencies.[6] The influential figure of Ryszard Stanisławski,

Installation view of *Guggenheim International Exhibition: Sculpture from Twenty Nations*, 20 October 1967 – 4 February 1968

Director of the Muzeum Sztuki in Łódź between 1966 and 1990, looms large over many of the connections forged between Poland's contemporary art scene and other countries, a feat achieved under often difficult political circumstances.[7] An early supporter of Krasiński, Stanisławski acted as Edward Fry's curatorial advisor in Poland and ensured the inclusion of Krasiński's sculpture *No.7* 1967 at the Guggenheim (right).[8]

The global remit of the 1967 Guggenheim International Exhibition contrasts with the resolutely US/UK axis of the previous year's most-talked-about New York survey show, *Primary Structures*, curated by Kynaston McShine at the Jewish Museum (bottom right). This exhibition is often credited with ratifying minimalism's key players and theories, and is an important contextualisation for the broader thematic and stylistic range of the Guggenheim show, which also chose to foreground artists featured in *Primary Structures*, positioning Robert Morris's vast nine-part steel sculpture *Untitled* 1967 in the ground-floor atrium space. In his introductory text for the 1966 exhibition catalogue, McShine attempted to summarise what was then, and remains now, a highly differentiated and heterogeneous field:

> Most of these works contain irony, paradox, mystery, ambiguity, even wit, as well as formal beauty, qualities which have always been considered positive values in art. Recent characterizations such as 'minimal,' or 'cool,' are inadequate; they are not descriptive of the experience and only partially of the means. Simplicity in structure allows for maximum concentration and intensity, and does not necessarily imply vacuity; it usually, in fact, connotes a rich complexity of formal relationship and of experience.[9]

This essay traces some of Krasiński's points of correspondence and overlap, and aspects of contradiction and refusal, within the context of minimal art as it was articulated and debated during this period. The artist's appearance in the 1967 Guggenheim exhibition is a lens through which to view his latent engagement with minimalism, his American debut occurring the year after minimalism's critical apogee in New York, in the context of a reorientation towards those diverse post-minimal practices that would collectively be termed anti-form or process art. As critic Lucy Lippard later reflected, minimal art was 'the failed attempt at a clean slate', and the year 1967 announced the advent of the messier 'process art'.[10]

Krasiński's wider project – from the wall-mounted reliefs that mark the beginning of his mature practice in the early 1960s through to his final installation works of the late 1990s and early 2000s – consistently undermines the certainties of our knowledge and understanding of the material world. By foregrounding a sensation of deep strangeness (verging on disorientation) during our encounters with his objects, he opens up a space of productive doubt, revealing the very instability of ostensibly fixed terminologies such as minimalism.

> *I don't want it to sound too scholarly, but there is a kind of animating force involved that puts motion into a seemingly static object. But there is always some kind of inner dynamic to the object.... There's a mystery and a kind of circuit.*
> Edward Krasiński[11]

No.7 1967 (missing work) in the *Guggenheim International Exhibition: Sculpture from Twenty Nations*, 20 October 1967 – 4 February 1968

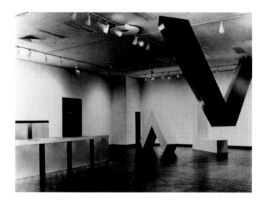

Installation view of the exhibition *Primary Structures* at The Jewish Museum, New York, 27 April – 12 June 1966. Works included Donald Judd, *Untitled* 1966 and *Untitled* 1966; Robert Morris, *Untitled (2 L beams)*; and Robert Grosvenor, *Transoxiana* 1965

Krasiński's articulation of his objects' 'animating force', although uttered in 1993, strongly resonates with the suspended sculptures he produced in the mid-1960s, one of which was sent to New York to represent his practice. This loose collective of sculptures, which use thin wire to suspend some or all of their constituent parts, was shown at Krasiński's 1965 solo exhibition at the Krzysztofory Gallery in Kraków (see pp.38–9 and 44). The gallery's windowless spaces of arched stonework appear in documentary images as if plunged into darkness, with the exception of intense spot-lighting on the objects themselves: a dramatic, borderline theatrical, staging that minimised the viewer's reading of the wires supporting or suspending the sculptures. By visibly erasing their sleight-of-hand realisation, Krasiński imbues these delicate, lightweight constructions of cardboard, aluminium and wooden rods with the 'inner dynamic' and 'mystery' he later reflected on.

Edward Krasiński, exhibition view at Foksal Gallery, 1966

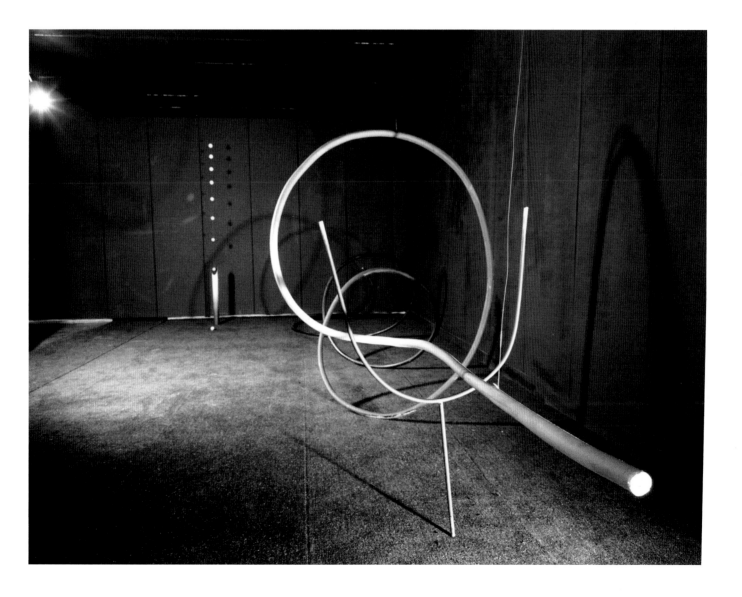

The artist continued this presentation strategy for his first solo show at the Foksal Gallery, Warsaw, in 1966 (the year the gallery was founded by a group of critics and artists including Krasiński). Once again, dramatic lighting and strongly cast shadows determine the viewer's experience and negotiation of the objects and their surrounding space: a high-contrast environment that frames and illuminates the views of a narrow vertical column, positioned at the back of the small, panelled, carpeted space (see pp.67 and 71). This slender sculpture later became the artist's contribution to the New York show in the following year. As is clearly revealed, its columnar structure is composed of eight descending (although they could equally be *ascending*) ping-pong balls threaded to form a precise vertical line, with irregular spaces between them, increasing downwards from small to large gaps. They meet a short wooden cylinder sliced open on the elliptical, painted to graduate from white to a dark colour at its base (no colour images of this work exist, but other objects from the series use a palette of white, black and grey with flashes of red). The final ping-pong ball just touches the opening of the cylinder, which actually contains a black-painted recessed surface, signifying infinite depth and continuity. An additional, ninth, ball rests some distance away from the column on the gallery floor, as if to suggest its mischievous escape from this monument to geometry and alignment.

Another photograph from this series of Foksal installation shots was used to illustrate the work in the Guggenheim's exhibition catalogue (see p.66), cropped even closer to heighten the play of contrasts between a backdrop drenched in darkness and the emphatic lightness (tonally, optically and materially) of the tiny, gravity-defying spheres. In the first invitation that the artist received to participate in the Guggenheim International Exhibition, an untitled vertical construction in steel, over three metres tall, is listed as the museum's chosen work.[12] Two months after this missive from director Thomas M. Messer, in a letter from the museum's registrar to the Polish exporters, there is a new title listed – a series of ellipses,, no date – with a note that 'this is the actual title', and the medium changed to polychromed wood.[13] This new material plus the equivalence between the string of ping-pong balls and the meandering line of ellipses suggest that this was the moment the work from Foksal 1966 was substituted to show in New York. In the final checklist for the Guggenheim's sculpture survey, the title has been finalised as *No.7*, the way it also appears in the publication.[14] It is unclear whether the artist purposefully re-dated his sculpture for the American exhibition, or whether an administrative error led to this change. Although regrettably no installation photographs showing Krasiński's work in the Frank Lloyd Wright rotunda seem to exist, from the wall list document we know that the artists shown alongside Krasiński in Bay VIII were Andrea Cascella (1919–1990), Masakazu Horiuti (1911–2001) and Karel Malich (b.1924), exhibiting geometric and biomorphic abstract sculptures in marble; bronze; and plastic, wood and aluminium, respectively.

In 1966, poet and theorist Julian Przyboś (1901–1970) formulated the concept of 'Aerism', a phenomenon in Polish art that was particularly inspired by Krasiński's installation of works at the 1965 outdoor sculpture exhibition, *The Third Summer Academy*, in Osieki, Koszalin, many of which were shown at the Krzysztofory Gallery in November that same year. Przyboś later commented that, of all the sculptors present, 'only Krasiński had taken into account the entirety of the air – from the ground to the sky'.[15] This description, while specific to the 'en plein air' situation of Osieki, also holds true in an indoor context for *No.7*, where each space between the eight ping-pong balls

Edward Krasiński, *Untitled* 1966 (missing work), exhibition view at Foksal Gallery, 1966

Letter to Edward Krasiński from the curator of Nelson A. Rockefeller's collection enquiring about the possibility of acquiring work *No.7* 1967

is accounted for as part of the work. When space plays an active role in determining a sculpture's totality of experience as encountered by the physical body of the viewer, we veer close to the conditions that heralded minimalism's emergence in mid-1960s New York, as a stylistic tendency rather than a cohesive school or movement. Art historian James Meyer has written extensively on minimalism and its most closely associated artists, including Donald Judd, Anne Truitt (1921–2004), Dan Flavin (1933–1996) and Robert Morris, on whom he comments:

> Integral to Morris's sculptural conception was a reciprocity of perception and production, of the viewer's bodily encounter with the work and the activity of making. "An object has a lot to do with [the spectator's body] because it was made by a body," Morris observed.... Morris's concern was the process of making, a making motivated by the physical qualities of the material.[16]

These sculptural motivations of bodily encounter, perception and physicality provide a distinct set of characteristics that the American minimal scene, led by Morris's discourse, shares with Krasiński's work at this time.[17] Minimal sculpture relentlessly focussed on three-dimensional geometric shapes (shapes that were realised in materials as diverse as plywood, neon tubing, sheet metal and firebricks), often arranged in repeating units or progressive sequences. This concentration speaks directly to the geometric structures and serial alignment of industrially produced objects that characterise many Krasiński works of the mid-1960s, with their uncanny material fusion of the handmade, the readymade and the manufactured. However, as art historian Anne Rorimer notes: 'Judd and [Carl] Andre contributed to an understanding of sculpture as an object that exposes its immediate and incontrovertible relationship to material and spatial reality.'[18] This articulation of the dominant minimal position points to a particularly pertinent fault-line with Krasiński's endeavour: the demand that a sculpture deals directly with the objective reality of space and matter.

In his summary of Krasiński's sculpture of this period, writer and lecturer Alexander Alberro invokes a rhetoric deeply associated with minimalism for an important observation regarding the artist's suspended sculptural forms: 'His was a dynamic art that did not literally move; a *virtual* [my emphasis] or imperfect dynamism that uses movement not as an isolated element but as a whole structure that openly interacts with its surroundings and the phenomenology of the beholder.'[19] Alberro's appraisal of what he posits as the phenomenological (i.e., experiential; subjective) nature of Krasiński's mid-1960s work points to the internal paradox at its core. Fundamentally, the sculpture is conditioned by its own *virtual reality* that simultaneously invites and repels the literalist, grounded associations of minimal art. Krasiński gives his viewer an experience of sculpture that is not tied to rational logic and the rules of gravity. It requires a leap of the imagination: the possibility and openness to shift into a different understanding of space. A statement by Robert Morris from his now-canonical two-part 1966 text 'Notes on Sculpture' reads: 'One of the conditions of knowing an object is supplied by the sensing of the gravitational force acting upon it in actual space.'[20] Krasiński's work counter-intuitively disobeys this gravitational force, in favour of sculptural acts of suspension, collective moments frozen in time that work *against* the physical force and smooth motion of gravity. What we have instead, in works like *No.7*, is the inverted physicality of one object (a prosaic ping-pong ball, multiplied) travelling through space, but not time. His work unravels our sense of 'knowing an

object'. Rather, it offers up the object as a container for the fleeting sensation of movement, in all its volatility.

Returning to Alberro, he, too, read this particular work, as documented in the 1966 Foksal Gallery exhibition, in terms of sequencing and movement: 'When traced by the eye of the spectator, the vertical sequence of balls, combined with the loose ball on the floor, gave rise to impressions of animated movement.... Form was thus deprived of its material qualities, with the use of light on the balls functioning as one of the principal methods of "formation".'[21] This echoes Pincus-Witten's brief assessment of the sculpture in his Guggenheim review, with which this essay began. His chosen adjectives 'modest' and 'anti-material' upend the implicit minimal agenda of monumental material presence, and anticipate Alberro's suggestion that Krasiński's sculpture somehow negates its intrinsic materiality in favour of a staged virtuality. If the sculpture's animation derives (even in part) from its synthetic lighting conditions and its illusory construction of guide wires, then the self-containment so favoured by the minimal object here finds itself splintered, and reconfigured as an object opening itself out to the world.

Published during the exhibition run of the Guggenheim International, Jack Burnham's 1967 article charting a contemporary taxonomy of sculpture concludes with the category of 'air-borne sculpture', and a description that seems particularly appropriate for Krasiński: 'Now, with sculpture completely liberated from its base it becomes a different animal! Its *raison d'être* is no longer that it embodies formal qualities, but that it exists as a physical system including invisible forces. The duality between matter and energy enters a new phase.'[22] This dichotomy between the visible and invisible, and between matter and energy, is an embodiment of precisely the 'mystery' and 'circuit' of which Krasiński spoke. His sculptures are a rebuke to the necessity of heft and physical bulk; an affirmation that weight does not equal presence. In their slightness, these works are willing to move with the barest of air currents. They are engineered as if to acknowledge the atmospheric conditions around them, rather than presenting a sculptural surface of resistance and immovable mass.

This leads to a proposition: should we consider Krasiński's work as a pseudomorphic manifestation of minimalism? It is surely only lightly tethered to the variant explored and expounded in New York. His work instead takes something of the earlier 1960s kinetic art moment and blends this lineage with minimal-industrial overtones, as seen most clearly in his factory-produced contribution to the *1st Biennale of Spatial Forms* in Elbląg, 1965, which corresponds neatly to the industrial fabrication aspect of minimalism (see p.113). As Paweł Polit acknowledges: 'Krasiński's relationship with Minimalism is not unequivocal; he was one of the first artists in Poland to use industrially produced materials, such as metal rods, electric cables, rubber cables, and industrial technologies, such as forging and welding.'[23] In the face of this necessarily ambiguous position, it is instructive to look at one of the most important artists associated with the post-minimalist undoing of geometry, industrial perfection and standardisation. Eva Hesse's insistence on the role of 'absurdity' within her sculptural practice is analogous in many ways to Krasiński's approach to object-making around 1967 (overleaf). Absurdity, for Hesse, had 'to do with contradictions and oppositions',[24] a statement that also underlines Krasiński's dialectic relationship with minimalism, as he strived to disobey several laws of physics. Hesse pursued the undoing of the single, sculptural object, as did Krasiński in his solo exhibition configurations by the end of the 1960s, with his installation for the 1970 Tokyo Biennial displacing the notion of sculpture in favour of environment. Hesse's interest in pushing an object towards a dissolving

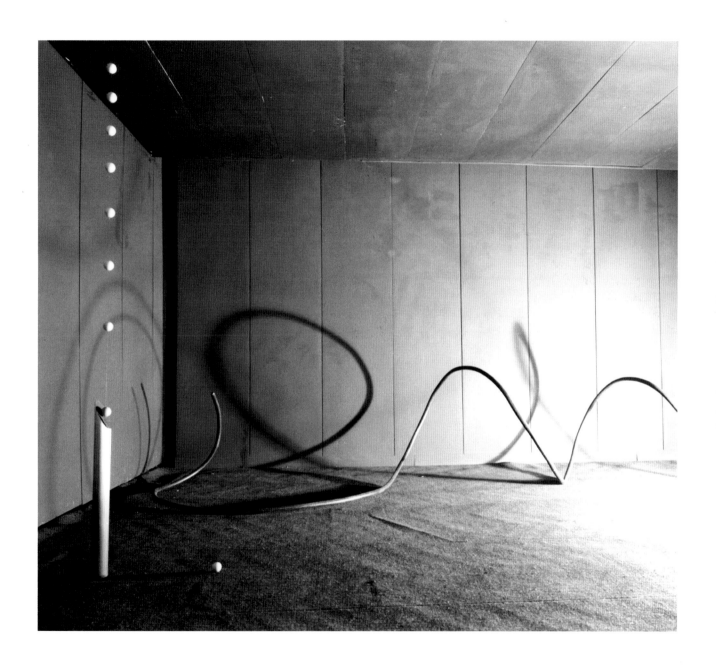

Edward Krasiński, exhibition view at Foksal Gallery, 1966

state of irrationality is also expressed in Krasiński's ceaseless use of the blue line, first employed in 1969.

What artist Dennis Oppenheim (1938–2011) described as the 'minimal syndrome' – the 'displacement of sensory pressures from object to place'[25] – is minimalism's clearest legacy for conceptual art, and a good description of Krasiński's trajectory towards the vitally important Tokyo installation, and eventually the fusing of object and environment in his *Interventions*. It has been argued that Krasiński is a deeply material artist who never sought to privilege idea over object, and therefore cannot be considered a figurehead for the emergence of conceptual art in Poland.[26] However, was conceptual art ever truly interested in extricating itself from the object, instead preferring to challenge what an object could come to mean? As an artist Krasiński clearly was interested in complicating the polarity established between idea and object, thanks to his emphasis on activity, animation and action – motion over stasis, verbs rather than nouns – all of which falls in line with wider conceptual-art frameworks of the early 1970s. It is precisely because the Guggenheim International Exhibition did not attempt to summarise minimal art that it succeeded in revealing the tensions (both literally and theoretically) that Krasiński could offer to this set of affinities predicated on materials of industrial manufacture, experiential encounters, and repeating units of numerical and geometric persuasion. In Krasiński's work, there is a dual stress on spatial and temporal sequencing that offers a path if not to 'dematerialization' in its strictest sense, then to a proto-conceptual unfixing of the object as a static point in time and space.

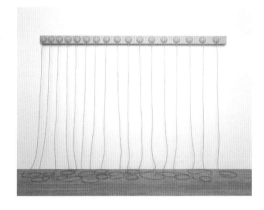

Eva Hesse (1936–1970)
Addendum 1967
Papier mâché, wood and cord, 12.4 × 302.9 × 20.6

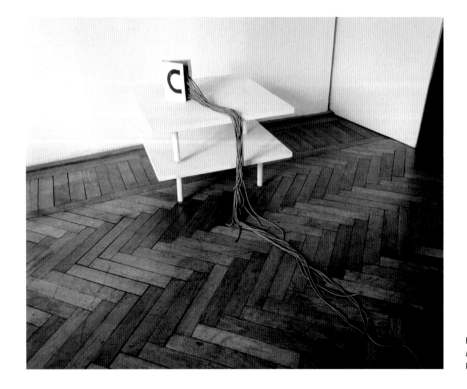

Edward Krasiński
L3 1969, photographed at the artist's studio, Warsaw
Paper, plastic and acrylic paint, 17.5 × 13.5 × 9

1 Robert Pincus-Witten, 'Review of *Guggenheim International Exhibition. Sculpture from Twenty Nations*', in *Artforum*, vol. VI, no. 4 (December 1967), p.55.

2 Solomon R. Guggenheim Museum Archives, Archive: GIE 1967, Press Release (10/9/67), *Guggenheim International Exhibition 1967: Sculpture from Twenty Nations*, 20 October 1967 – 4 February 1968.

3 Lucy Lippard and John Chandler started writing their *Studio International* article 'The Dematerialization of the Object of Art' in 1967, although it was not published until 1968. Sol LeWitt published his 'Paragraphs on Conceptual Art' also in 1967 in a special summer issue of *Artforum*, vol. V, no. 10 (Summer 1967), pp.79–83.

4 Michael Fried, 'Art and Objecthood', in *Artforum*, vol. V, no. 10 (Summer 1967), pp.12–23.

5 See, for example, the artist's recent inclusion in the exhibitions *On Line: Drawing through the Twentieth Century*, The Museum of Modern Art, New York, 21 November 2010 – 7 February 2011; *Transmissions: Art in Eastern Europe and Latin America, 1960–1980*, The Museum of Modern Art, New York, 5 September 2015 – 3 January 2016; and *Other Primary Structures*, The Jewish Museum, New York, 14 March – 3 August 2014.

6 As art historian Blake Stimson observed: 'When you start to think about the canonical work from the US and Europe in the conceptual art tradition in the late 1960s, and then you put them into dialogue with the work from Latin America or another context, it suddenly opens up new meanings and complicates the existing sense of the neo-avant-garde tradition in a way that would not be available otherwise. Krasiński's work is very much part of this tradition, in coming out of happenings and anything else that was happening in the 1960s, but then it emerges in a specific milieu that gives it a distinct historical articulation.' Stimson in 'Discussion of the Papers by Sabine Breitwieser and Blake Stimson', in Gabriela Świtek, ed., *Avant-Garde in the Bloc*, Warsaw and Zürich 2009, p.125.

7 Stanisławski also engineered the unveiling of Polish conceptual art within the British art scene, establishing a collaboration between Muzeum Sztuki in Łódź and Edinburgh gallerist Richard Demarco for the group exhibition of forty Polish artists including Krasiński, *Atelier 72*, held at the Demarco Gallery during the Edinburgh Festival in the summer of 1972.

8 A letter from the Guggenheim's registrar to Polish traders DESA explains that: 'The selector of this sculpture exhibition, Mr. Edward F. Fry, has informed me that his very good friend Mr. Ryszard Stanisławski, who worked with him in the selection of these works, is connected with DESA and that it would be very helpful if DESA could supervise the export of these works.' Solomon R. Guggenheim Museum Archives, Archive: GIE 1967_Krasiński, A0003 Box 1109, Folder 6, Loans: Letter from David Roger Anthony, Registrar, Solomon R. Guggenheim Museum, to DESA Arts, Warsaw, dated 22 May 1967.

9 Kynaston McShine, 'Introduction' in facsimile reproduction of *Primary Structures*, New York 1966, in Jens Hoffmann, ed., *Other Primary Structures*, exh. cat., The Jewish Museum, New York 2014, unpaginated.

10 Lucy Lippard, 'Escape Attempts', in *Six Years: The Dematerialization of the Art Object from 1966 to 1972*, Berkeley and London 2001, p.viii.

11 Edward Krasiński, 'Drôle d'interview: Edward Krasiński in conversation with Eulalia Domanowska, Stanisław Cichowicz, and Andrzej Mitan' (1993), in Sabine Breitwieser, ed., *Edward Krasiński: Les mises en scène*, exh. cat., Generali Foundation, Vienna 2006, p.29.

12 'The example of your work which we have chosen is (Vertical Construction in Steel, height 350 cm), 1966, for which we have as yet no title.' Solomon R. Guggenheim Museum Archives, Archive GIE 1967_Krasiński, A0003 Box 1104, Folder 14, Correspondence – Artist: Letter dated 29 March 1967 from Thomas M. Messer, Guggenheim Director, to Edward Krasiński, Mickiewicza 25/82, Warsaw.

13 Solomon R. Guggenheim Museum Archives, Archive GIE 1967_Krasiński, A0003 Box 1109, Folder 6, Loans: Letter from David Roger Anthony, Registrar, Solomon R. Guggenheim Museum, to DESA Arts, Warsaw, dated 22 May 1967.

14 Solomon R. Guggenheim Museum Archives, Archive GIE 1967_Krasiński, A0003 Box 1108, Folder 13, document 'Wall List'.

15 Julian Przyboś, 'Rzeźba napowietrzna' ('Overhead Sculptures'), in *Edward Krasiński*, exh. cat., Muzeum Sztuki in Łódź, 1991, quoted by Sabine Breitwieser, 'Edward Krasiński: Les mises en scène', in Breitwieser 2006, p.17.

16 James Meyer, *Minimalism: Art and Polemics in the Sixties*, New Haven and London 2001, p.116.

17 Meyer has explained the fundamentally intertwined nature of Morris and Fried's texts, writing that: 'despite Morris's claim that he was not establishing "an environmental situation," "Notes on Sculpture" did propose a notion of sculpture as *mise en scène*, a sculpture that existed in relation to its surroundings. His argument came to have a tremendous impact. In "Art and Objecthood" (1967), Fried drew much from Morris's account, describing all minimal practice as the bodily encounter of a viewer and work within a gallery, an encounter he described as "theatrical." The influence of this essay was such that Morris's views, rehearsed by Fried, came to be seen as representative of minimalism as a whole... minimalism was an art centered on the relationship of a mobile spectator and work within the gallery ambience, and this experience occurred in time. In other words, the dominant account of the perceptual experience of minimalism was the one proposed by Morris in "Notes on Sculpture."' Meyer 2001, p.166.

18 Anne Rorimer, *New Art in the 60s and 70s: Redefining Reality*, London 2001, p.20.

19 Alexander Alberro, 'Edward Krasiński's Dynamic Line', in Świtek 2009, p.372.

20 Robert Morris, 'Notes on Sculpture', in *Artforum*, vol. IV, no. 6 (February 1966), p.43.

21 Alberro in Świtek 2009, p.374.

22 Jack Wesley Burnham, 'Sculpture's Vanishing Base', in *Artforum*, vol. VI, no. 3 (November 1967), p.55. The article was excerpted from Burnham's forthcoming book, *Beyond Sculpture: The Effects of Science and Technology on the Sculpture of this Century*, New York 1968.

23 Paweł Polit, 'Unbearable Porosity of Being', in Breitwieser 2006, p.64. Polit also notes that: 'quite early on, he developed a body of work which seems related to Carl Andre's version of Minimalism rather than Judd's'.

24 Eva Hesse in Cindy Nemser, 'An Interview with Eva Hesse', in *Artforum*, vol. VIII, no. 9 (May 1970), p.60.

25 Quoted in Lippard 2001, p.xxi.

26 'He never got rid of the objects he produced in favor of only the line.... I do not believe that Krasiński with his blue line, the blue stripe, or Scotch-Blue, as it has been variously termed, could serve as the father of Polish conceptualism. Each of these names for the blue line reveals the complexities of the ways we speak of the artwork, from which we cannot extricate ourselves.' Adam Szymczyk, 'Discussion of the Papers by Sabine Breitwieser and Blake Stimson', in Świtek 2009, p.118.

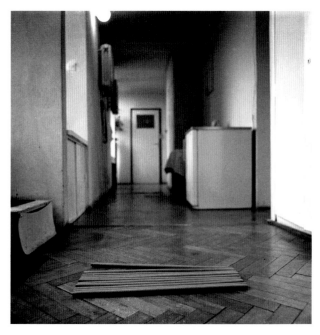

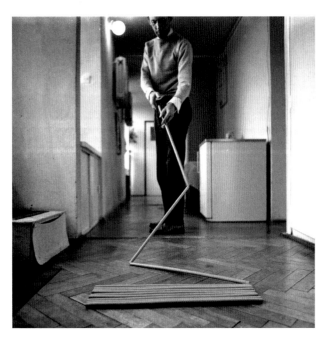

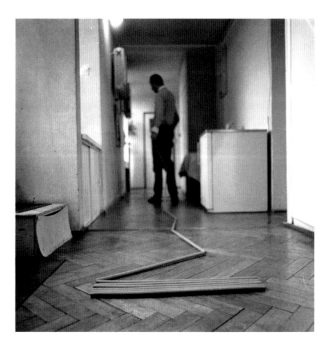

ALL IMAGES
N..., (Intervention 4, Zig-Zag) 1969, photographed at the artist's studio, Warsaw

Wood, plastic and acrylic paint, dimensions variable

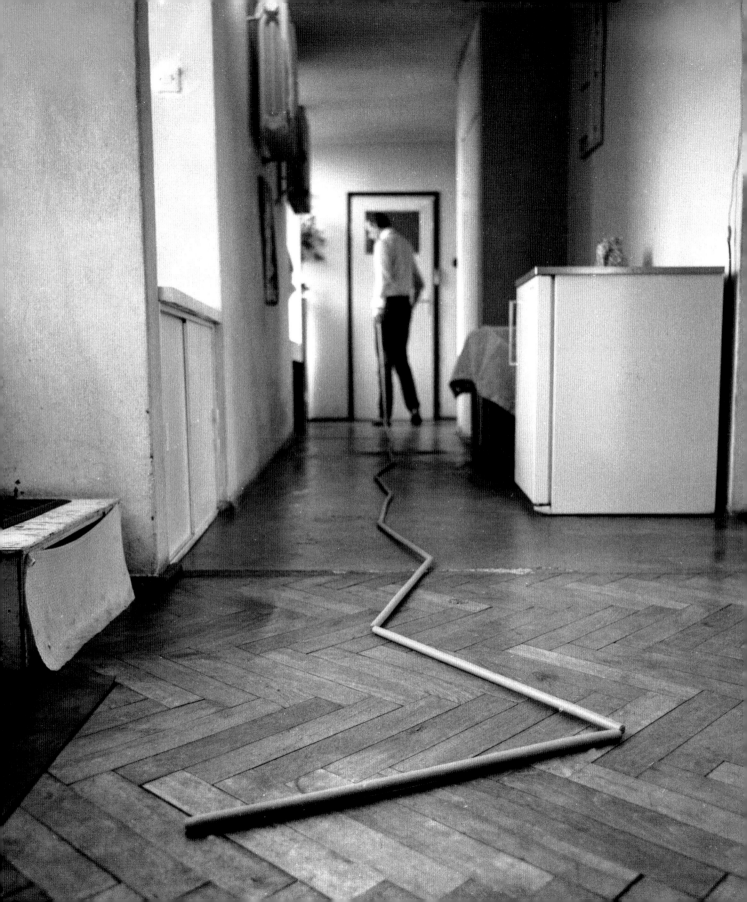

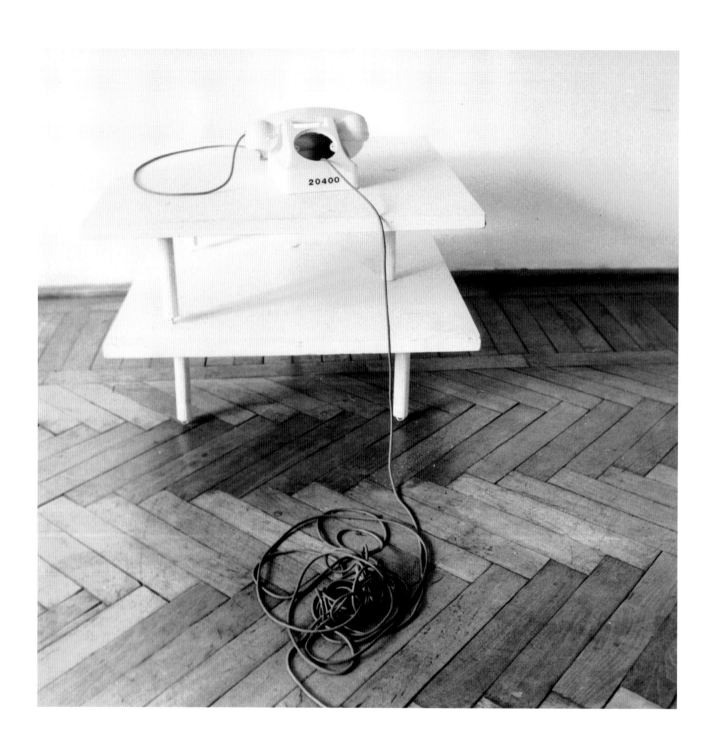

L-Untitled 1969, photographed at the artist's studio, Warsaw

Plastic and acrylic paint, dimensions unknown

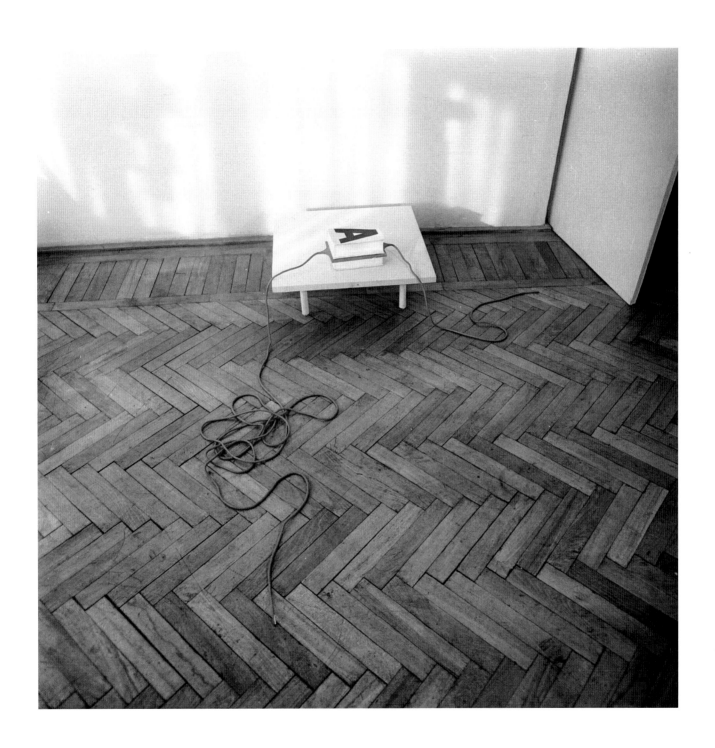

L Composition with a Book 1969, photographed at the artist's studio, Warsaw
Paper, wood, plastic and acrylic paint, 12 × 16 × 30

LEFT
K 6 1968
Wood, plastic, rubber and acrylic paint,
300 × 12 × 2.6

MIDDLE
K 5 1968
Wood, plastic and acrylic paint,
155 × 16 × 12

RIGHT
K 3 1968, photographed at the artist's studio
Wood, plastic, metal, plaster, canvas and acrylic
paint, 55 × 46 × 2 (cable length c.450)

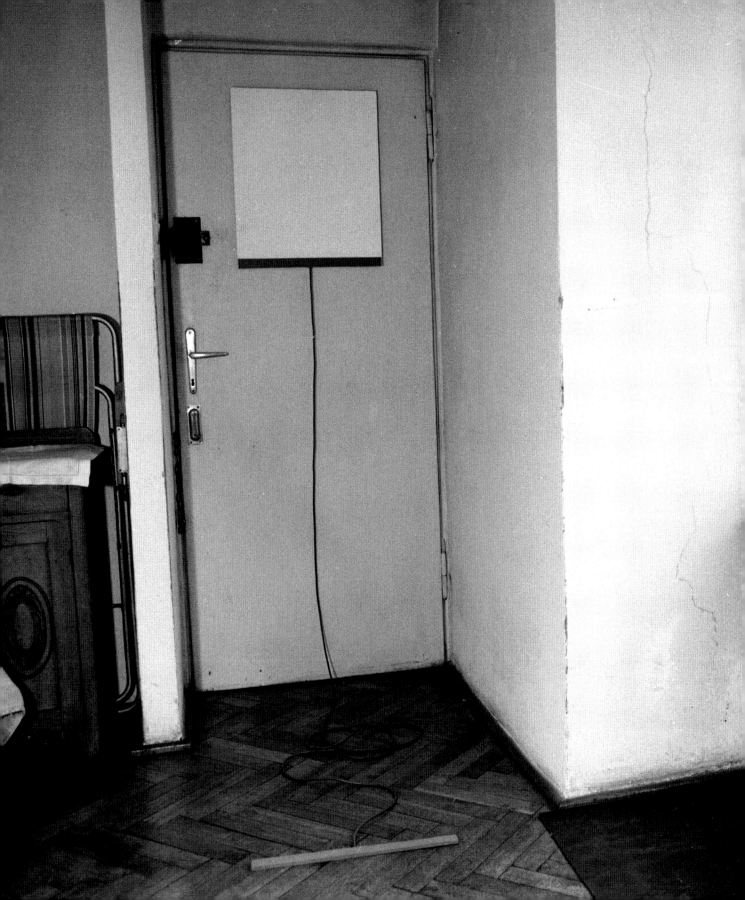

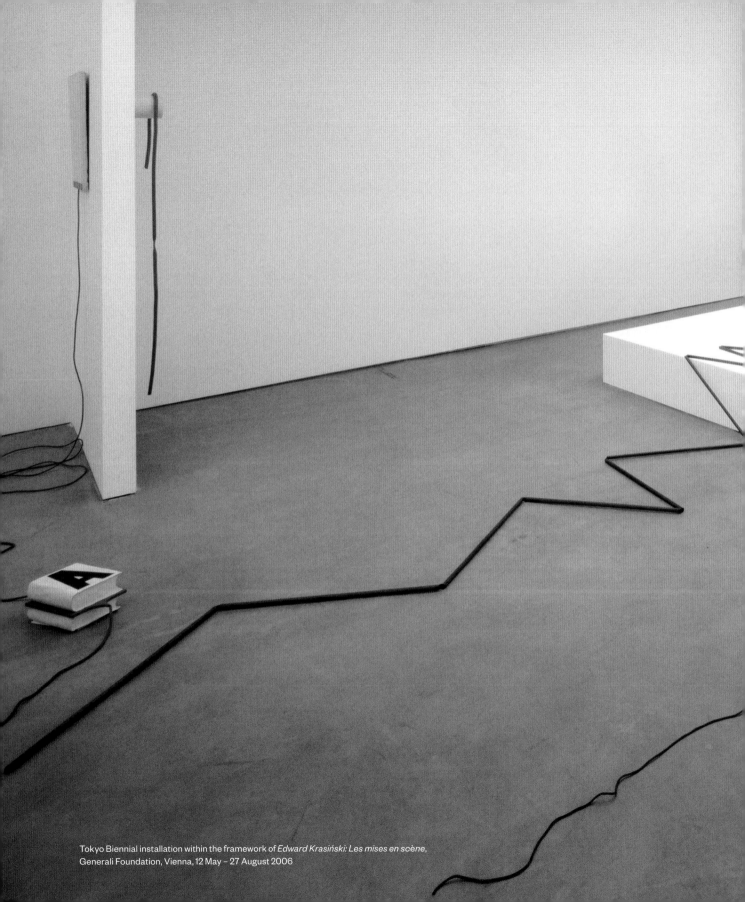

Tokyo Biennial installation within the framework of *Edward Krasiński: Les mises en scène*, Generali Foundation, Vienna, 12 May – 27 August 2006

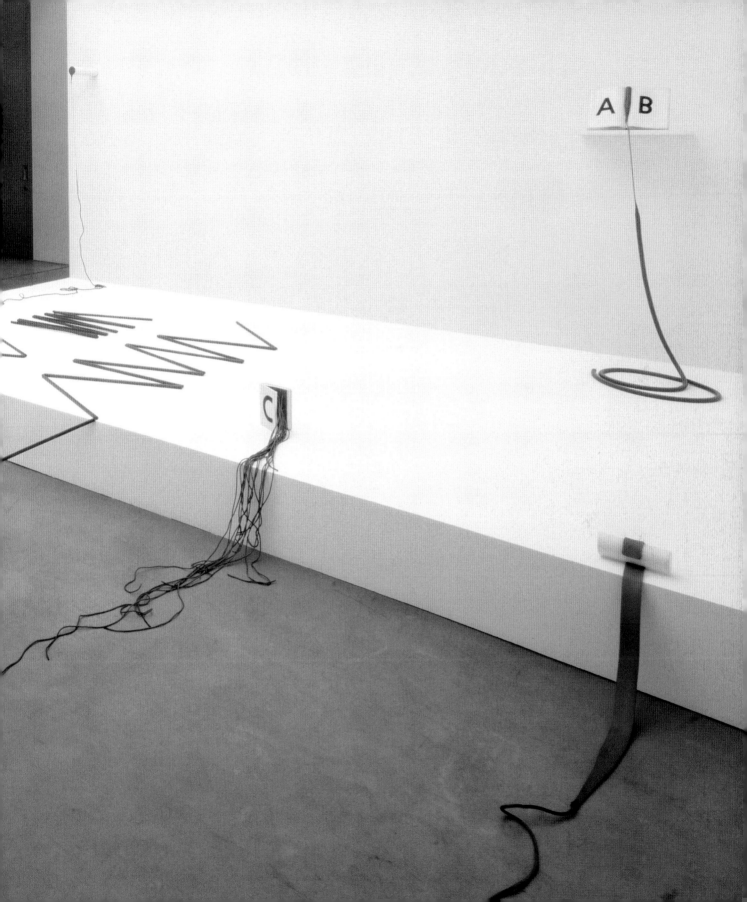

INTERVENTIONS

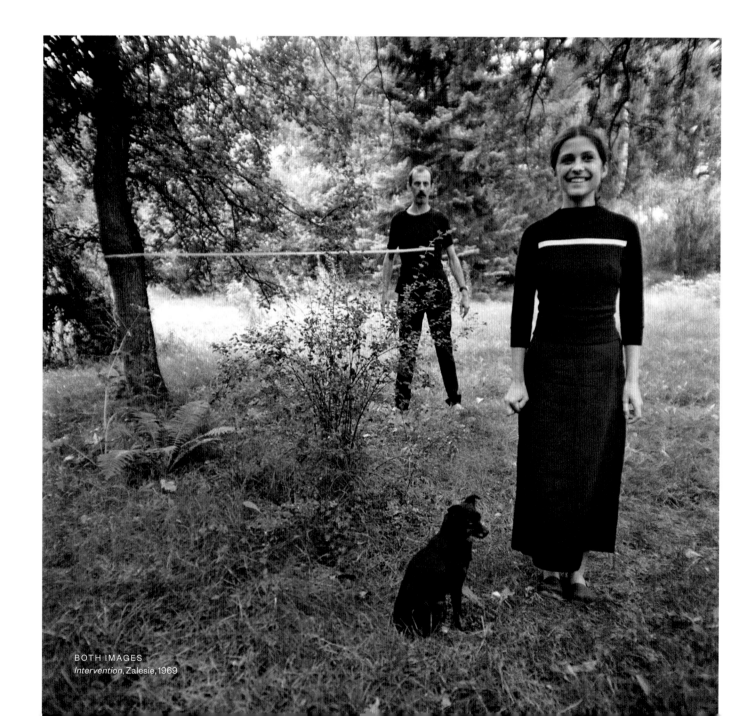

BOTH IMAGES
Intervention, Zalesie, 1969

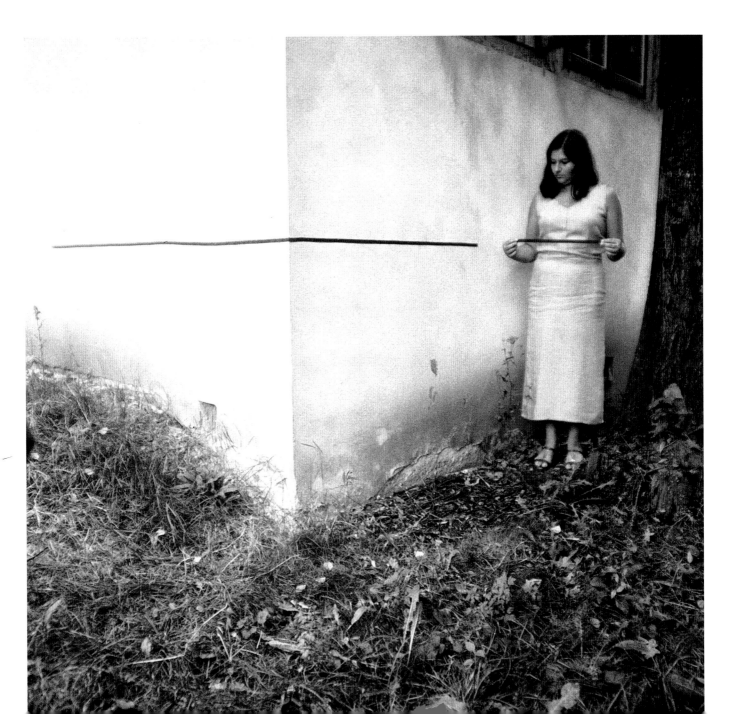

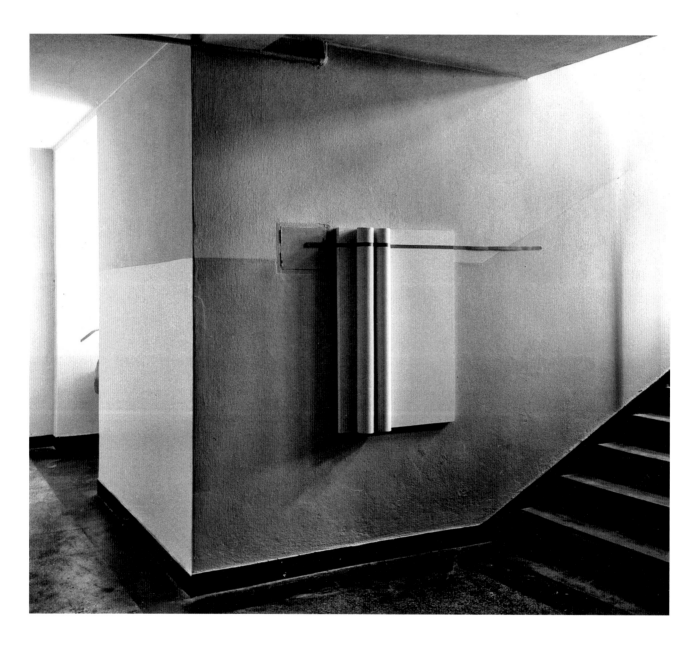

ABOVE
Intervention 7 1975, on the staircase to the artist's studio, Warsaw, 1975
Plywood, metal and acrylic paint, dimensions unknown

RIGHT
Intervention 25 1975
Hardboard, adhesive tape and oil paint, 100 × 70 × 3

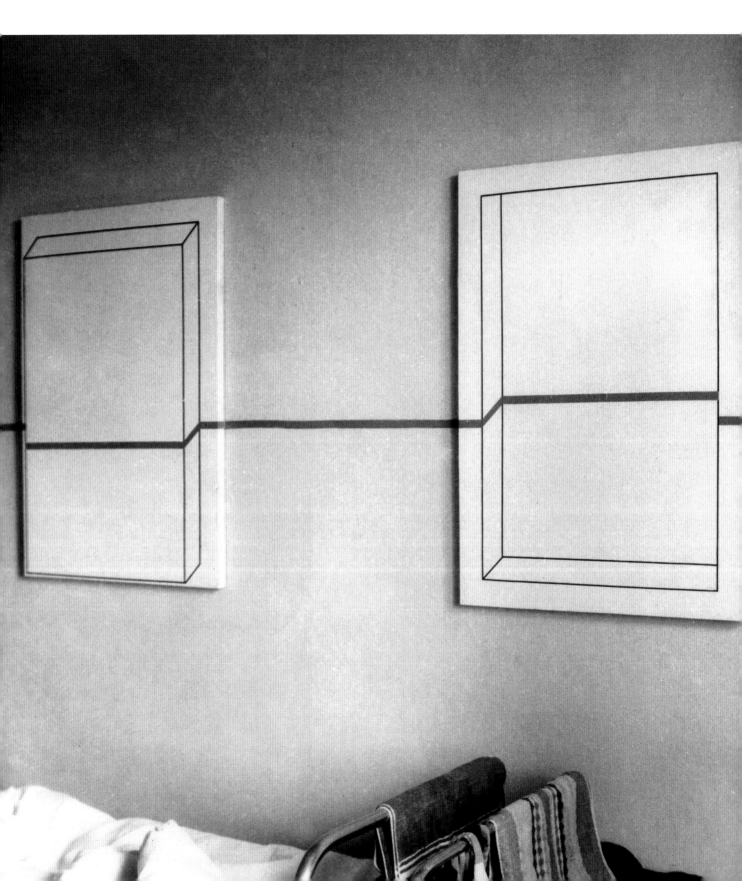

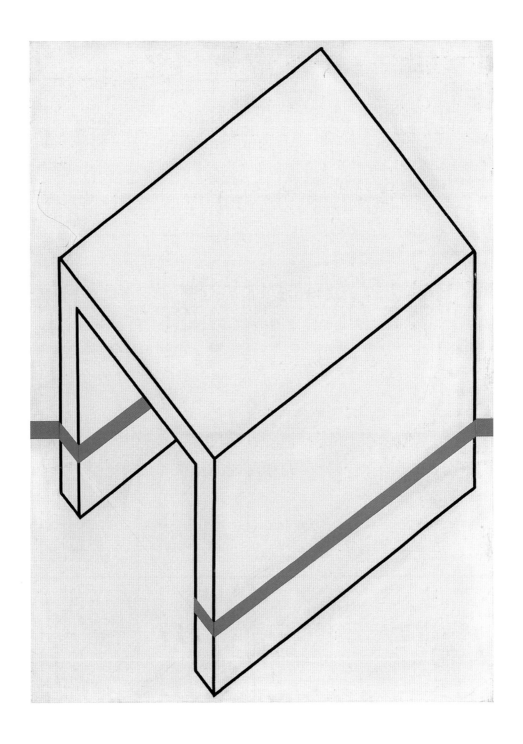

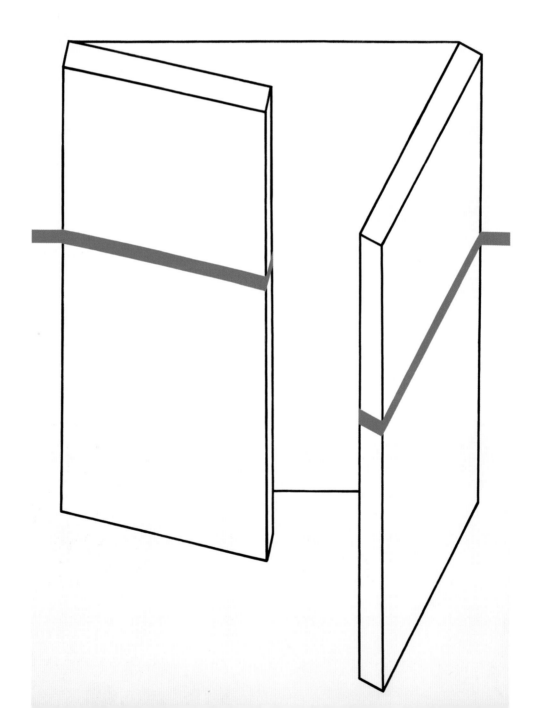

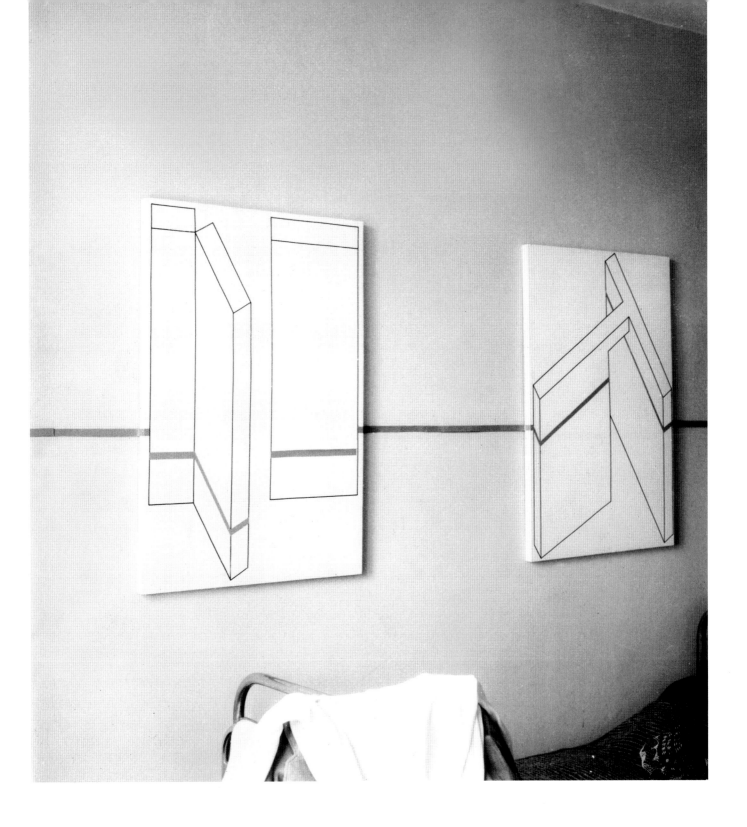

LEFT
Intervention 10 1975
Hardboard, adhesive tape and oil paint, 100 × 70 × 3

ABOVE
Interventions at the hospital in Komorów, c.1973–5

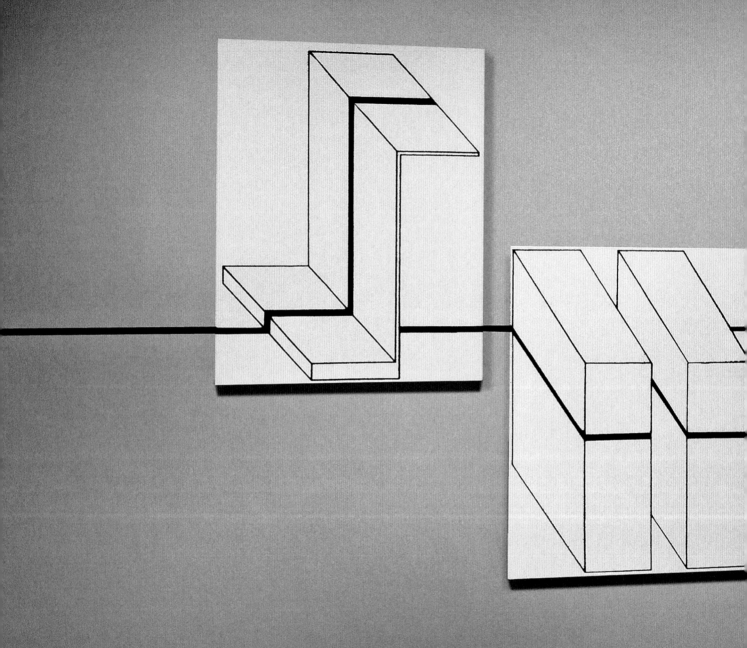

Europa, Europa, exhibition view at Kunst- und Ausstellungshalle
der Bundesrepublik Deutschland, Bonn, 1994

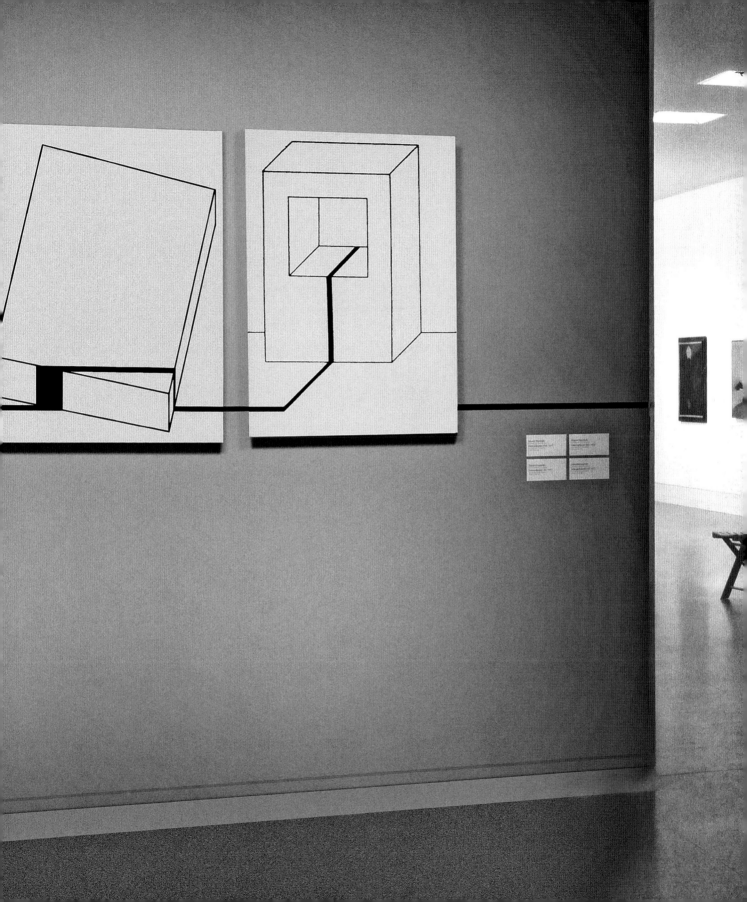

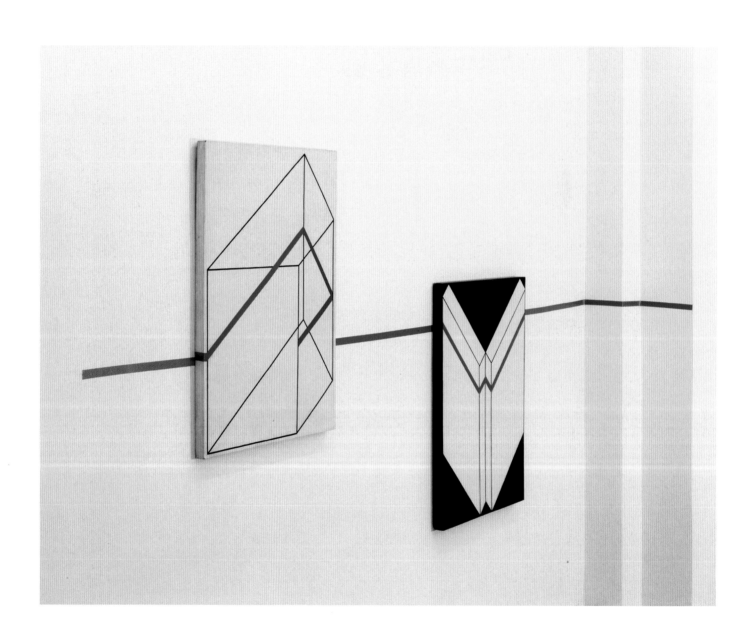

ABOVE LEFT
Intervention 27 1975
Hardboard, adhesive tape and acrylic paint,
69.9 × 50 × 2.8

ABOVE RIGHT
Intervention 15 1975
Hardboard, adhesive tape and acrylic paint,
69.9 × 50 × 3.3

RIGHT
Intervention 1975, photographed at Edward
Krasiński's exhibition at Galerie 30, Paris, 1975
Hardboard, adhesive tape and oil paint, 70 × 50 × 3

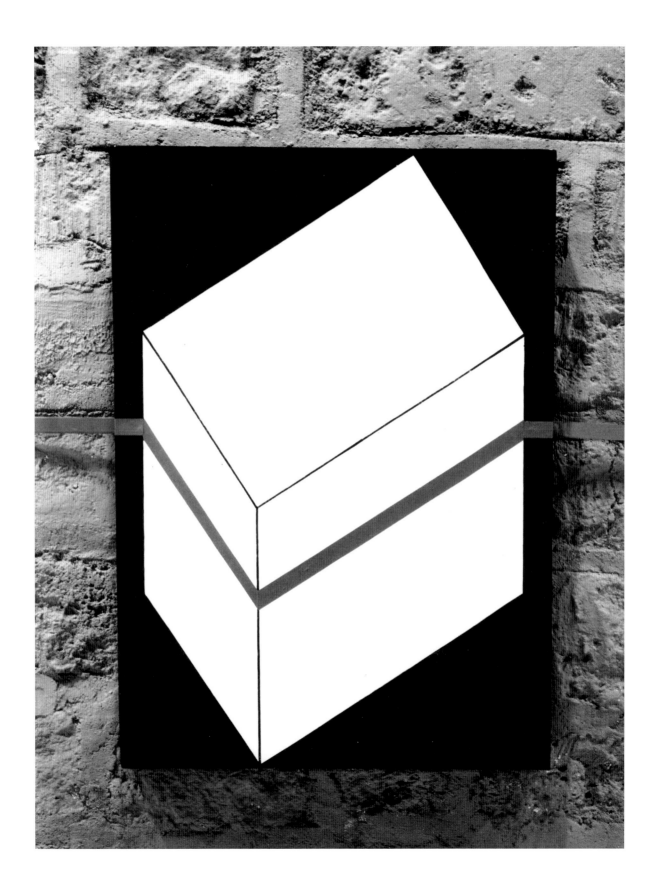

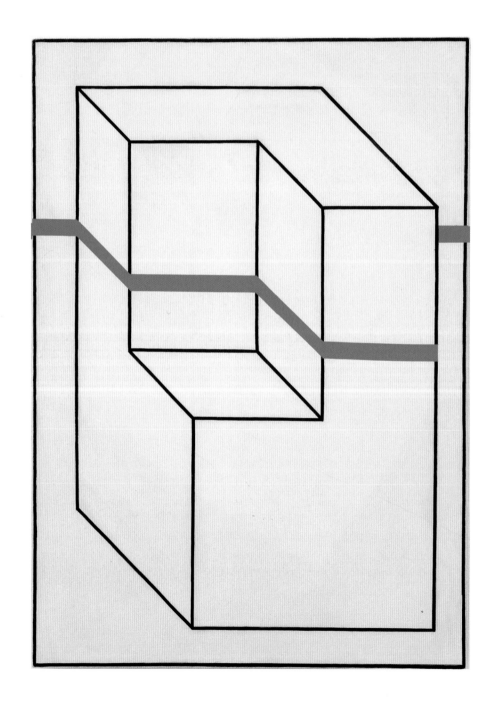

LEFT
Intervention 3 1975
Hardboard, adhesive tape and acrylic paint, 70 × 50 × 4

ABOVE
Intervention 11 1975
Wood, plywood, adhesive tape and acrylic paint, 99.7 × 70 × 3.3

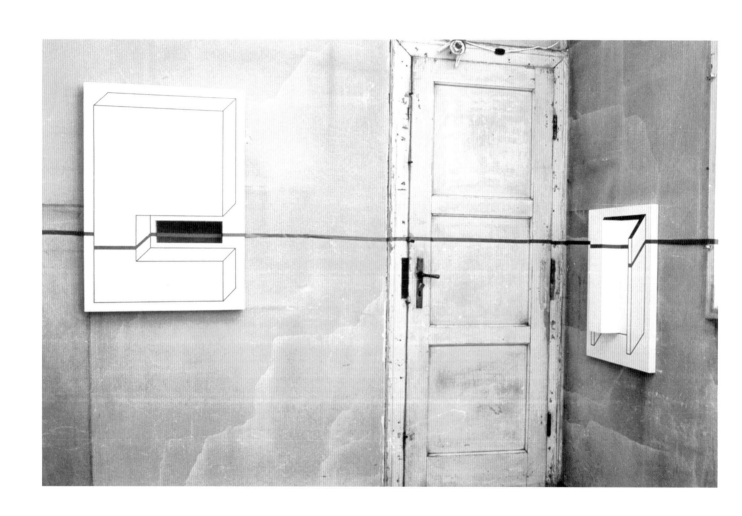

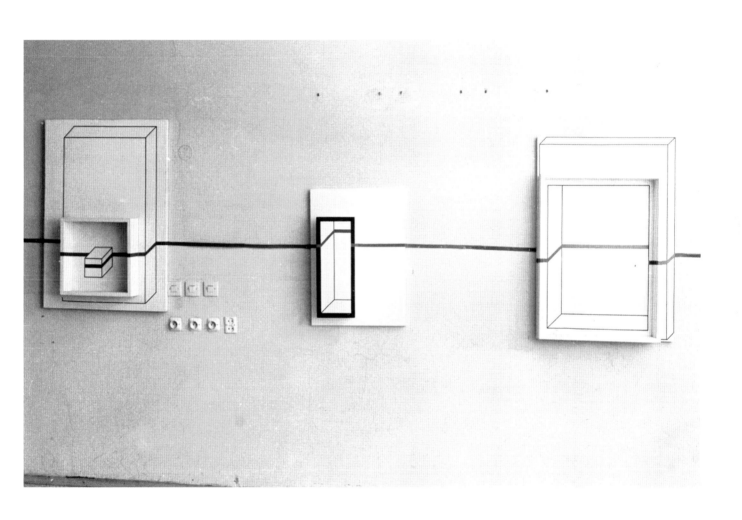

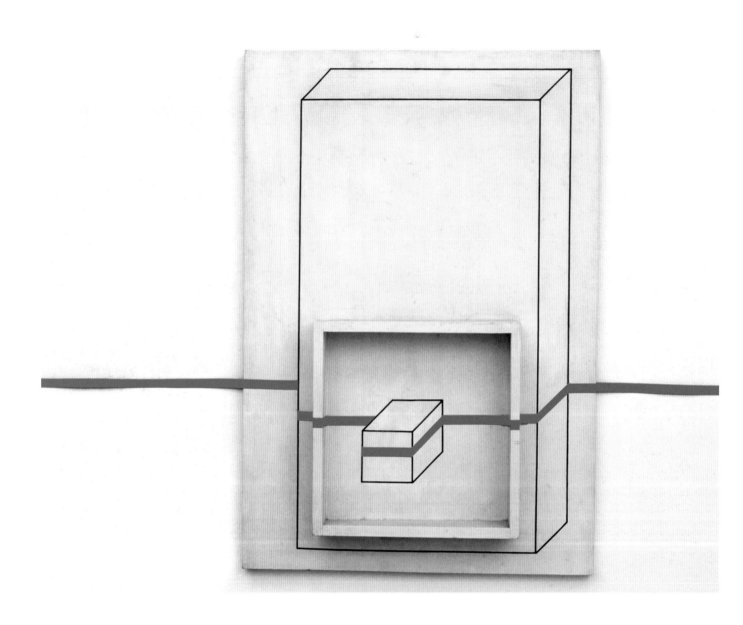

Intervention 1978
Fibreboard, adhesive tape and acrylic paint, 100 × 70

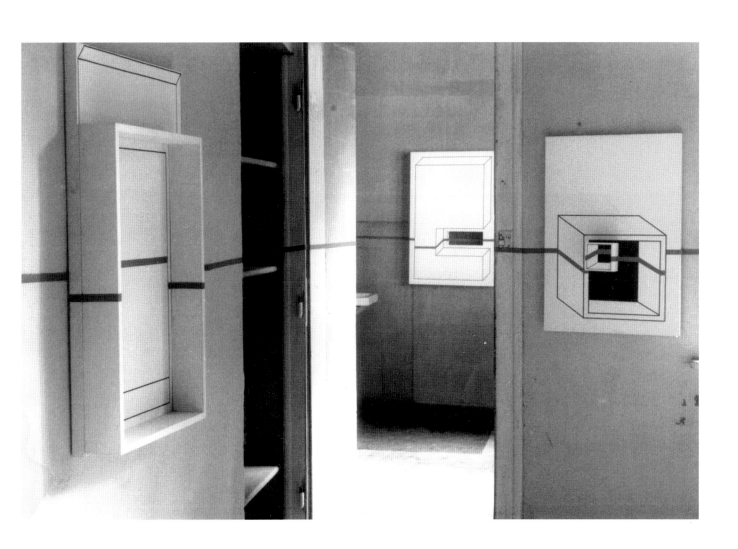

Edward Krasiński, exhibition view at Pawilon Gallery, Kraków, 1978

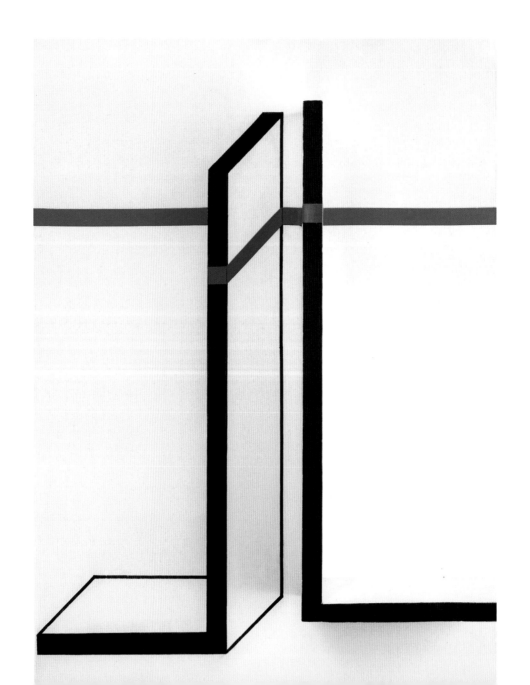

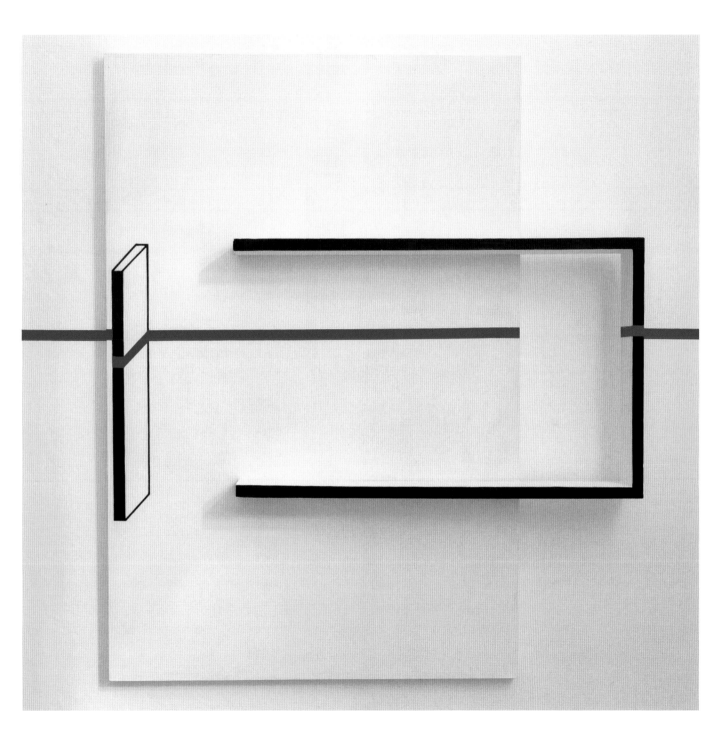

LEFT
Intervention 1978
Hardboard, adhesive tape and acrylic paint, 40 × 30 × 13

ABOVE
Intervention 1974
Plywood, adhesive tape and acrylic paint, 110 × 95.5 × 12

101

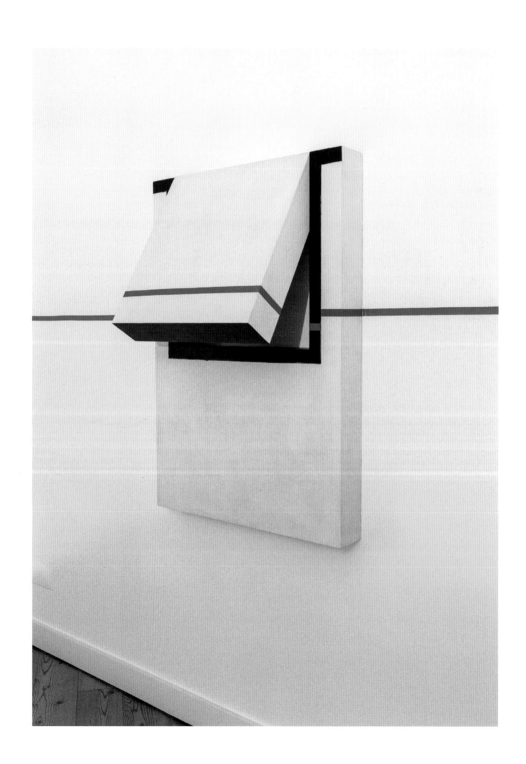

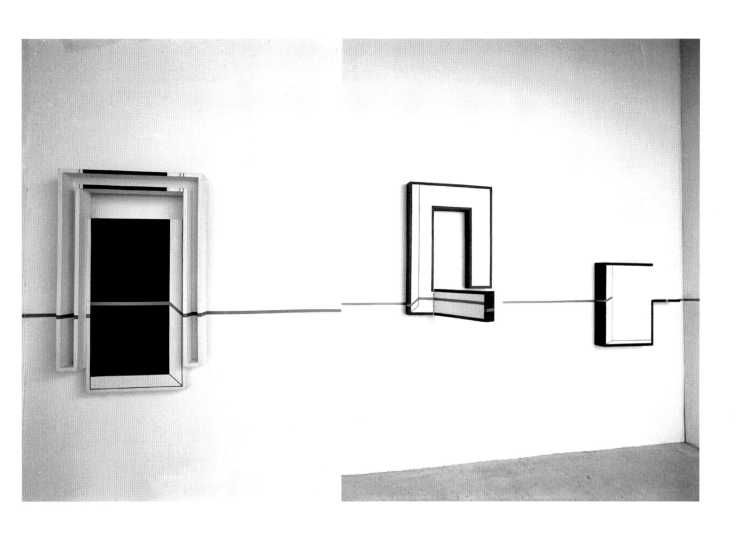

LEFT
Intervention 1981
Plywood, adhesive tape and acrylic paint, 100 × 70 × 42

ABOVE
Edward Krasiński, exhibition view
at Galerie J&J Donguy, Paris, 1988

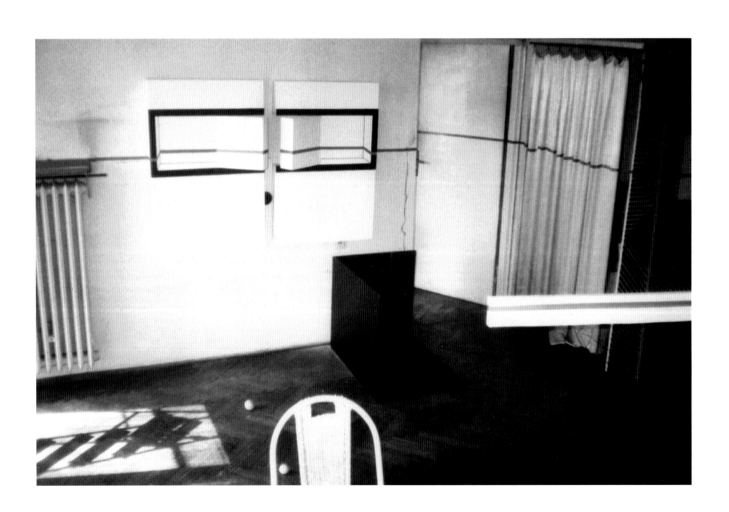

104 View of Edward Krasiński's studio, Warsaw, 1990s

Plastic Tape Scotch blue; szerokość 19 mm, długość niewiadoma.
Nalepiam ją wszędzie i na wszystkim, horyzontalnie na wysokości 130 cm.
Pojawia się ona na wszystkim i wszędzie z nią docieram.
Nie wiem, czy jest to sztuka.
Ale jest to na pewno Scotch blue; szerokość 19 mm, długość niewiadoma.

 E. Krasiński

Blue plastic Scotch Tape; the width of 19 mm, length unknown.
I stick it everywhere and on everything, horizontally at the height of 130 cm;
It appears everywhere and I pet with it everywhose.
I don't know whether it is art.
But certainly it: Blue Scotch, width of 19 mm, length unkown.

 E. Krasiński

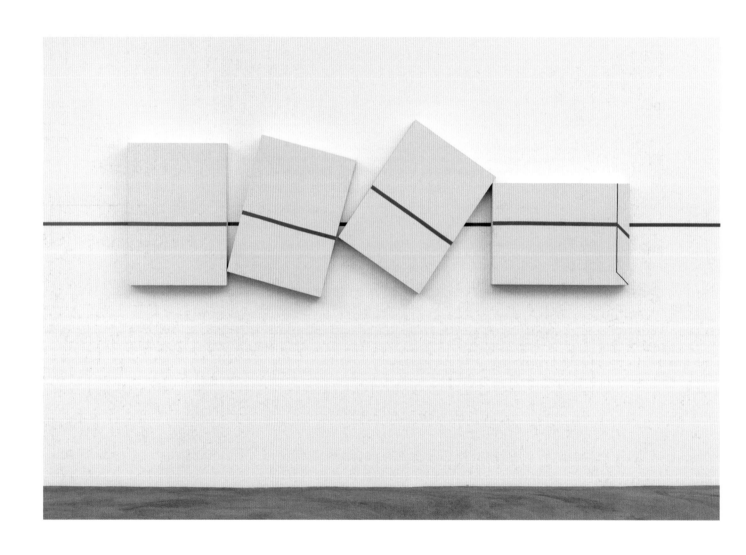

Intervention 1988

Plywood, adhesive tape and acrylic paint; four objects, each 70 × 50 × 10

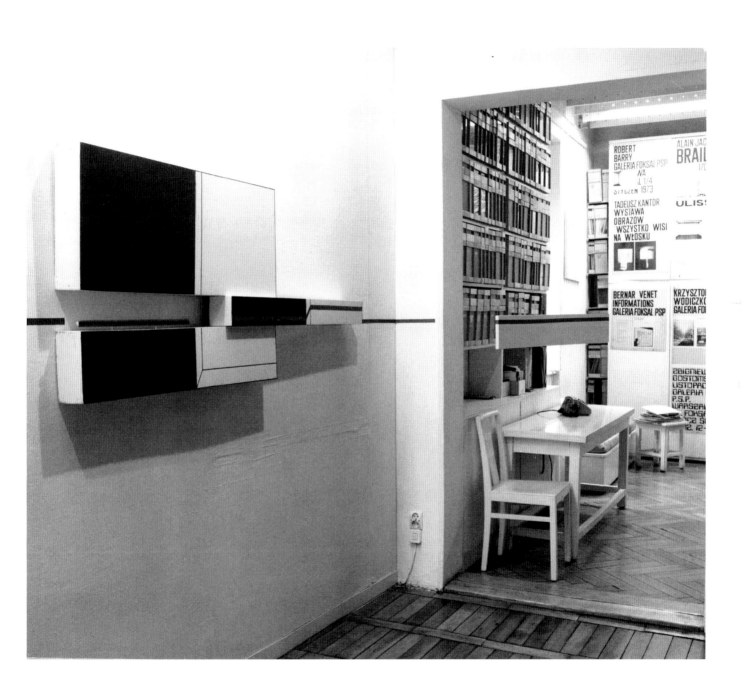

Intervention 1989, photographed at the exhibition *Hommage à Henryk Stażewski,* Foksal Gallery, Warsaw, 1989
Plywood, adhesive tape and acrylic paint, 71 × 100 × 10, extended part 10 × 68 × 10

Karol Sienkiewicz

THE VISIT[1]

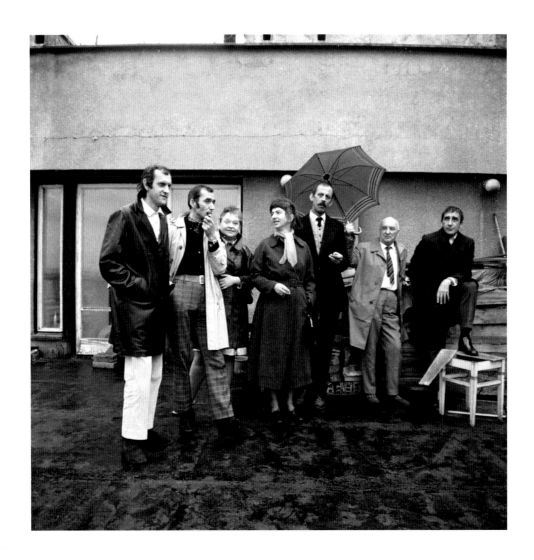

1998

It is 6 May 1998. Young curator Adam Szymczyk (b.1970) and artist Paweł Althamer (b.1967) are going to visit Edward Krasiński. Althamer, who is often seen with a camera in his hand, turns it on. The film starts inside KFC fast-food restaurant in Bankowy Square, one of many portents of the new capitalist democracy established in Poland after 1989. They leave KFC and go to the nearby Gruba Kaśka Café, an old-style bar. Szymczyk looks around. Krasiński is a regular visitor here, but they cannot see him so leave. They buy three Okocim beers in the grocery store and enter Krasiński's building. Address: Solidarność Avenue 64. A few years earlier, it had been called Świerczewski Avenue, but was rechristened to commemorate the movement that brought to collapse the communist system in Poland. Another sign that times have changed. They take the tiny elevator to the 11th floor. There, Szymczyk attaches two pieces of paper to the wall and Althamer focusses the camera lens on them. On these are written the opening credits of the film: 'A visit to Edward Krasiński Studio in Warsaw. Camera: Paweł Althamer. Concept: Adam Szymczyk'.[2]

The door to Krasiński's flat features a photo of him with a welcoming smile and a gesture that resembles Pope John Paul II's blessings. And, of course, there is blue adhesive tape attached to the wall at the height of 130cm. Szymczyk knocks loudly. Krasiński, clad in a green gown, unassumingly opens the door and returns to his chair by the round table inside. He complains about his health: he feels dizzy and nauseous, he cannot sleep at night. 'If only I could throw up.' But, he offers them something to drink and has a shot of vodka himself. They light up cigarettes. They talk for a while about the current exhibition at the Foksal Gallery.

Krasiński is an old man, thin, almost wiry, and he talks with a lisp. He seems tired. He says he has to lie down for a while and goes to his bedroom next door. Althamer follows him with the camera. There is a small bed, a television set, an ashtray filled to the brim with cigarette butts and a plastic bowl by the bed. The small table is cluttered with lots of small objects: medicines, jars, plates, packets of cigarettes, scissors, newspaper clippings, tubes of paint, glue, coins and, of course, rolls of blue adhesive tape. This is where he works.

Althamer looks around the apartment, not knowing where to focus his attention. Sometimes he just follows the blue line. The rooms are filled with unassuming artworks, but they do not overwhelm the living space. There are fake mice and hard-boiled eggs all over the place. A dry twig grows out of the wooden floor, as if a seed had fallen between the boards, germinated, grown and then dried up. A few pieces of the parquet floor are elevated on black pedestals, a cigarette butt atop one of them. On the table in the living room are small vodka glasses with a drop of red paint inside each of them, and one of Krasiński's aphorisms jotted down in his childish handwriting: 'Art is too serious a thing to be made by artists'.

The camera examines the books on the shelf and stumbles upon a picture of painter Henryk Stażewski, with a real tie attached to it (see p.122). In another room, there are life-size photos of Krasiński and gallerist Stefan Szydłowski playing ping-pong, and a table with a shark's dorsal fin cut into it like the blade of a table saw (see p.18). A globe with a blue line marking the equator hangs in the air. Then, there is a toilet and a bathroom, which also serves as a kitchen. Above the bath hangs a painting with an old-style flush pull attached to it and, of course, a blue line (see p.49).

From left: Zbigniew Gostomski, Wiesław Borowski, Maria Stangret, Anka Ptaszkowska, Edward Krasiński, Henryk Stażewski and Tadeusz Kantor on the studio's terrace, Warsaw, 1970

Karol Sienkiewicz

When Szymczyk and Althamer go on to the terrace – a piece of roof covered with bituminous waterproofing – they look at the Warsaw skyline, the Palace of Culture, the Old Town, the traffic congestion on Solidarność Avenue. 'What is your impression of the apartment?' Szymczyk asks. 'I feel unreal. But I feel at home, I must say,' replies Althamer. They say goodbye and leave. On the way out, Szymczyk rips off the two pieces of paper from the wall.

After Krasiński's death in 2004, his daughter Paulina Krasińska and Foksal Gallery Foundation decided to leave the space untouched. Everything but Krasiński's private room remains as it was the day he died. It is not a museum about the artist, however. It is a complete work of art, framed by a new pavilion built on the terrace. Christened the Institute of the Avant-Garde, it reflects the uncanny contradiction between avant-garde art and the very idea of an institution. For decades it was a private home, but also the place where art ideas were born.

1986

The same place, 1986. It is 5pm. Guests are arriving. In the big armchair sits an old man. He looks tiny. Two women on either side of him are chatting, but it is obvious that he is the epicentre of this world. At 91 years old and surrounded by his artworks in his apartment, Henryk Stażewski (opposite) is the doyen of the Polish and European avant-garde movement. The walls are covered with his geometrical paintings: mesmerising, fluorescent, bright with colour.

Suddenly a guy steps in from the other room and Stażewski announces like a butler: 'Count Krasiński!' Krasiński, tall and handsome, has holes burnt by cigarettes in the sleeves of his jacket, but nevertheless looks very elegant. He is going to the opening at the Foksal Gallery. Stażewski asks him to convey his apologies: he does not feel strong enough to go.

Stażewski connected younger critics and artists, such as poet Andrzej Partum (1938–2002), with a pre-Second World War avant-garde sensibility. When Russian painter Kazimierz Malewicz (1878–1935) visited Warsaw in 1927 for his exhibition at Hotel Polonia, Stażewski was his guide. Those who knew Stażewski often said that they shook the hand that had shaken Malewicz's hand. Stażewski had his own table in a café on Foksal Street

Edward Krasiński in the studio, Warsaw, 1980s

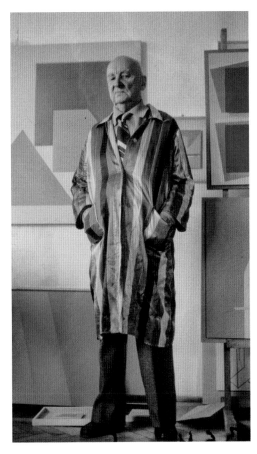

Henryk Stażewski in the studio, Warsaw, 1980s

at which he appeared every day at 1pm after spending the morning painting. At 5pm, he greeted guests at his apartment. That was his daily routine. Every artist who exhibited at Foksal Gallery, like Christian Boltanski (b.1944), Lawrence Weiner (b.1942), Sol LeWitt (1928–2007) and Michael Craig-Martin (b.1941), visited his studio/apartment.

Stażewski was allocated the apartment at Świerczewski Avenue by the authorities in the early 1960s. He moved there with painter Maria Ewa (Mewa) Łunkiewicz-Rogoyska (1894–1967) and her husband Jan Rogoyski (previously the three had shared an apartment on Piękna Street). Their friendship had started long before the Second World War and they were inseparable. She was an avant-garde, purist painter with great pre-war manners and impeccable French. The coexistence of the three is difficult to figure out. Their mutual friend, Professor Jan Żabiński, Director of Warsaw Zoo, used to say that in the animal world there are couples and boars. Within couples, there is a type A and a type B. Type A always overwhelms with energy. Mewa was type A and Stażewski was the lonely boar.

Poet Miron Białoszewski (1922–1983) once described how he climbed to the top floor of the block and found the door closed. 'Mewa ["seagull" in Polish] flew with Henio,' he wrote.[3] When Rogoyski died in 1967, Białoszewski's friend Le. (Leszek Soliński) said, 'Now Henio is a half-widower.' But Mewa, suffering from lung disease, joined her husband only weeks later. In 1977, ten years later, Białoszewski jotted down a short discussion with Le. during an exhibition opening:

'Did Henio leave?'
'Yes.'
'With Mewa?'
I looked at him.
'But Mewa is dead.'
'Exactly. When Henio is gone, she'll be gone too.'[4]

Krasiński moved into the smallest room of Stażewski's apartment in 1970, and they lived together for almost two decades, until Stażewski's death in 1988. Stażewski's family cleared the apartment of his works and Krasiński was left by himself in a half-empty space. There were only the outlines of Stażewski's paintings and the wires on which they used to hang.

Later, in 1989, Krasiński dedicated his exhibition at the Foksal Gallery to Stażewski. He moved the studio to the gallery through the use of photography. For the first time, he used large-scale photographs to give the illusion of one space inside another. He included some objects from the studio but mainly he created faux furniture, cubes containing photos of the original items. After the exhibition, the cubes were moved to the studio, and since then most of the shelves and cabinets sit alongside their doubles. They seem to reflect each other like mirrors. This is how Krasiński started to take over the space, creating the *Gesamtkunstwerk* as Szymczyk and Althamer visited it in 1998, and as we know it today.

Krasiński worked at night in his tiny bedroom, usually by himself, so new interventions seemed to appear out of the blue. Guests were always surprised by something new: the wig, the mice, or the socket to which Krasiński attached a wire and a small nail, turning it into a tiny painting. The interventions revealed an unusual sense of humour, a predilection for gags and a hint of the surreal. An old man living in his eerie world.

Something remained after each of Krasiński's shows, for example, the black-and-white reproductions of historical paintings cut by his blue line. Invited to exhibit at Zachęta Gallery, Krasiński reminded visitors of the origins of the gallery. The building originally hosted a collection of nineteenth-century historical paintings and landscapes, including the gargantuan *Battle of Grunwald* 1875–8 by Jan Matejko (1838–1893), kitschy but patriotic (in 1410, Polish and Lithuanian knights were victorious over the Teutonic order). Krasiński made photocopies of the paintings, creating ghosts from the past, and added his blue line to them. He cut a door into the copy of Matejko's canvas, which on opening revealed a photograph of himself greeting onlookers with a glass of wine in his hand (below).

In the studio, the blue line revealed its all-encompassing power.

1950s

Early 1950s, the doorbell rings. Who is that? It is Edzio. Hanna Rechowicz (b.1926) is surprised. She lives with her husband Gabriel (Gaber) Rechowicz (1920–2010) in a basement on Lekarska Street. Edzio Krasiński is their friend from Kraków, but they were not expecting him in Warsaw. He claims that he arranged to meet his fiancée from Gdańsk here – they are going to marry. They wait, but the girl does not show up.

The story is neither refuted nor confirmed. What we know is that Krasiński stayed with the Rechowiczs for almost a decade.

Edward Krasiński, *Intervention* 1997, *Edward Krasiński* exhibition view at Zachęta Gallery, Warsaw, 1997

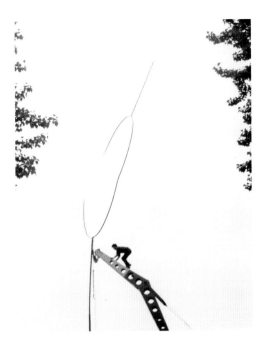

Installation of Edward Krasiński's work,
Untitled 1965 at *1st Biennale of Spatial Forms*,
EL Gallery, Elbląg, 1965

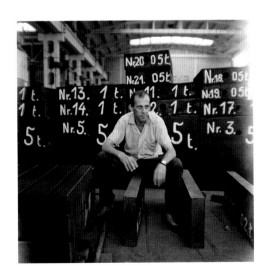

Edward Krasiński at the *1st Biennale of Spatial Forms*,
ZAMECH factory, Elbląg, 1965

Krasiński rarely had a space of his own. During the war in Kraków, while attending the Kunstgewerbeschule, he lived with the Branicki family. After the war, he studied at the Academy of Fine Arts and worked in the Traveling Exhibitions Bureau at the National Museum in Kraków. He met such artists as Tadeusz Kantor and Jerzy Nowosielski (1923–2011) and the painter Tadeusz Brzozowski (1918–1987).

The Rechowiczs and Krasiński lived in two small rooms in the basement of Hanna's father's house on Lekarska Street, sleeping on mattresses on the floor. Krasiński's place was by the furnace. He made drawings for magazines and surreal paintings, one of which was Hanna's portrait. He depicted her as a half-skeleton, with a decorative pelvis, thin ribs and one breast – a light circle with a red dot for the nipple. Her head is faceless, but Krasiński attached her real hair to the painting. She was suffering from the notorious winter cold at the time it was made.

Later, in an interview, Krasiński said that 'Polish surrealism was superficial, it existed only on canvas…. One's whole life and attitude makes somebody a surrealist.'[5] Hanna remembers the wooden jewelry Krasiński made for her and the toys that he and Gaber concocted out of everyday objects for their daughters. She also recalls their trips to Kazimierz Dolny, a small town in central Poland, where they rented a house and Krasiński staged his suicide, hanging himself in a hazelnut tree and thus breaking the branches.

The Rechowiczs were true Warsaw bohemians, a fact reflected in their house. The damage to the façade from bombing during the Second World War was filled with stones, turning the destruction of war into an amusing decoration. Inside, there was a plethora of objects, artworks and interventions, such as the wooden tomb, designed by Hanna for her family, but which never ended up in a cemetery and instead lurked behind the sofa. As a piece of furniture, they bought a decorative sleigh. No wonder film director Andrzej Wajda (b.1926) restaged the house in a film studio as a bohemian interior in his film *Everything for Sale* (1968).[6]

The Rechowiczs worked on architectural decoration and stage sets for theatres, over the years specialising in abstract, quasi-surreal mosaics. Krasiński sometimes helped them, but he quickly became a well-known patron of Warsaw bars. Part of that life was vodka. When Krasiński and Gaber got into trouble because of drinking, they switched to beer for a while. Among Krasiński's friends were film writer Marek Nowakowski (1935–2014) and the poet Miron Białoszewski. Jur Wańkowicz took him to a party in Wiesław Borowski's apartment. It was there that he met artists and critics, some of whom went on to establish the Foksal Gallery, including his future wife Anka Ptaszkowska and Henryk Stażewski. It was the end of one chapter of his life and the beginning of the next.

1960s

They marry in 1962. During the first few years of marriage, they live in a number of different places, but the most important is the house of Ptaszkowska's mother in Zalesie Górne on the outskirts of Warsaw. It is *the* place to visit, and Krasiński displays his new pieces among the trees for visitors to see. His art changes radically. He makes abstract sculptures from metal wire and painted wooden compositions, revealing the tensions and dynamics, playing with gravity. In Zalesie in 1969, Krasiński makes his first interventions with the blue adhesive tape, which a friend brought him from Rome. The tape cuts the space inside and outside the house, and the

bodies of several models, including the couple's young daughter Paulina Krasińska, as evidenced in the photographs taken by Eustachy Kossakowski (see pp.82–3). Krasiński came back to Kraków as a fully fledged artist and his artistic debut took place in the Krzysztofory Gallery in 1965. There was little left of him as a surrealist painter; instead, he was questioning the genres of painting and sculpture in a series of dynamic works.

Foksal Gallery, however, became Krasiński's place for decades. Borowski, Ptaszkowska and critic Mariusz Tchorek (1939–2004), along with a group of artists including Stażewski, Kantor and Krasiński, established the gallery in 1966 in the former Marxist library of the Pracownie Sztuk Plastycznych (the Laboratory of Visual Arts). In the same year, Krasiński had his first solo show there, exhibiting a huge spiral sculpture and a composition with ping-pong balls (see pp.66, 67 and 71). The gallery brought him closer to the mainstream of Polish art, and he participated in the most important art events of the 1960s, such as the *1st Biennale of Spatial Forms* in Elbląg (1965, p.32 and previous page) and the summer academy in Osieki, where he was given the role of 'director of sea waves' in Kantor's *Panoramic Sea Happening* (1967, see p.8). In 1970, his works were sent to the Tokyo Biennial, but were held up in transit and did not reach Tokyo in time. In their place, he sent a telex with the word 'blue' repeated five thousand times. Conceptual art was made as a necessary response to flawed reality.

Anka Ptaszkowska at Galerie 30, Paris, exhibition view of *Edward Krasiński*, 1975

TOP
Daniel Buren installing his work in the exhibition *Edward Krasiński*, Repassage Gallery, Warsaw, 1974

BOTTOM
The view of Warsaw from Stażewski's apartment after Buren's installation, 1974

From the very beginning, the founders of Foksal questioned the very notion of the terms 'exhibition', 'gallery' and 'art', writing manifestos and examining new modes of art. For them, an 'exhibition' was not a collection of artworks, but the entity. 'It is an exhibition instead of the work of art that becomes a fact,' they wrote in 'An Introduction for the General Theory of Place'. Krasiński commented: 'At one point I took control over the Foksal Gallery. It was the only place where I would exhibit.... I fell in love with this gallery and could never betray it.'[7]

In June 1968, and in spite of the ban on gatherings for political reasons, the supporters of the Foksal Gallery and their many guests met in Zalesie at a ball, *Pożegnanie wiosny (Farewell to Spring)*, which referred to the political events of March 1968 in Poland. Krasiński prepared grotesque decorations, staging the painting *The Land of Cockaigne* 1567 by Pieter Bruegel the Elder (1525–1569), with three mannequins as gluttons lying around the tree, and a gargantuan 'bar for the giants' (see p.54).[8]

However, tensions within the group resulted in an unsolvable conflict in 1970, triggered by Kantor's reaction to the 'New Regulations for the Foksal Gallery' proposed by Ptaszkowska and Borowski, who wanted to transform the gallery into an institution circulating information about artistic actions. At the same time, the concept of a joint exhibition by Krasiński and photographer Eustachy Kossakowski was rejected by the group. Consequently, Ptaszkowska and Tchorek left the gallery, and Krasiński and Stażewski did not exhibit there for over a decade.

That same year Ptaszkowska, Kossakowski and Krasiński went to Paris. Krasiński stuck his tape in the yard of the Musée d'Art Moderne de la Ville de Paris and the windows of the Rive Gauche galleries. Ptaszkowska decided to stay in France and left Krasiński for Kossakowski. Krasiński returned to Poland and moved into a small room in Stażewski's studio. Some remember that it was Mewa Łunkiewicz-Rogoyska, just before her death, who suggested that Krasiński should take over the room. The relationship between Stażewski and Krasiński was often compared to that of father and son. They lived together, or rather next to each other.

In Paris, Ptaszkowska, never losing her ties with Warsaw, especially Stażewski and Krasiński, established an experimental gallery, naming it with the consecutive number of each exhibition or event (opposite). She befriended French artists, including the guru of the Foksal Gallery, Daniel Buren (b.1938). In 1974, she victoriously brought Buren to Poland. He had the chance to meet Stażewski and placed his white stripes on the windows of his apartment. From that moment, the view of Warsaw from inside the room has always been fragmented (bottom left). He carried out the same intervention at the Repassage Gallery, where Krasiński had a solo show (top left).

Krasiński and Stażewski reconnected with the Foksal Gallery after the Martial Law period (13 December 1982 – 22 July 1983) in Poland. The gallery's existence was in jeopardy and the artists unanimously supported it. These difficult moments brought people back together. Ptaszkowska, in collaboration with Swedish museum director Pontus Hultén (1924–2006), suggested a number of initiatives, forging international connections between the Foksal Gallery, the Muzeum Sztuki in Łódź and large institutions abroad. In 1985, the Foksal Gallery artists were paired with foreign artists in an exhibition entitled *Dialogue* at the Moderna Museet in Stockholm. Krasiński was partnered with Lars Englund (b.1933), Henryk Stażewski with Daniel Buren. Buren built *Cabane éclatée*, an environment within which Stażewski's paintings were displayed.[9]

Milk and Vodka

Krasiński was a peripatetic of the city. He had his own paths. His café was Miraż and an artwork of his hung over his table. 'This is my bistro,' he said. When he got older, he pretended to choose places closer to his home and Solidarność Avenue, which he sometimes called 'my Champs Élysées'. He spent mornings curing his hangover, but never lost the clarity of his mind and was always ready with a quip or a joke.

After Stażewski's death, the circle of friends visiting the studio tightened. But Krasiński still cultivated holidays: his nameday, his birthday, Christmas. On Christmas Eve, guests showed up at noon for a bite of salted herring and a glass of vodka. Yet, as much as he enjoyed company, he also craved solitude.

In the 1990s, Krasiński made friends with curator and gallerist Stefan Szydłowski, who was trying to establish a 'folk university' at the public library in Legionowo on the outskirts of Warsaw. And, naturally, he invited artists to participate. Krasiński pictured himself and Szydłowski playing table tennis. At one end of the ping-pong table he stood a life-size picture of Szydłowski, at the other end one of himself, both holding ping-pong bats, with the ball hanging on a thin thread, its movement represented by two pieces of white board on which appeared blue adhesive tape.

The folk university was closed in 1994, when Koji Kamoji (b.1935) for his exhibition *Haiku – Water* dug a well inside the library, an act agreed by Szydłowski, but when the digging commenced Szydłowski lost his job as librarian. A year earlier on the terrace of Krasiński's studio, Kamoji installed the work *The Bottom of the Sky*, composed of sheets of aluminium reflecting the sky. Szydłowski grew closer to Krasiński, eventually becoming his helper and assistant. A regular guest to the studio at that time was Krasiński's friend, philosopher Stanisław Cichowicz (below).

In 1993, a conference took place in Krasiński's apartment at which various critics and friends talked about his oeuvre. He listened and smiled, as if knowing that they were still far from figuring him out. Daniel Buren came back to Warsaw for the event and once again placed his stripes on the windows, this time dedicating them to Krasiński.

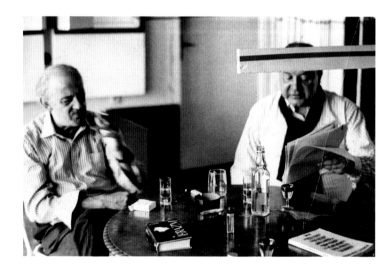

Edward Krasiński and Stanisław Cichowicz in the artist's studio, Warsaw, 1980s

In 1995, Szydłowski organised Krasiński's 70th birthday in Lutsk, the artist's hometown, now in the Ukraine. As Deputy Director of the Centre for Contemporary Arts in Warsaw, Szydłowski put together a small show of Krasiński's work at the medieval Lubart Castle and rented a coach to transport Krasiński's closest friends and family. An enlarged photo of Krasiński and his brother as teenagers and a reproduction of his school report from Year 5 formed part of the exhibition. Krasiński famously posed for a photograph lying on a table, surrounded by dishes – a throwback to his old bohemian style (below).[10]

Throughout this entire period, the Foksal Gallery remained most important to him. The gallery's size, 5 × 7m, was his favourite. He exhibited there many times in the 1990s and became close to the young generation of curators: Andrzej Przywara (b.1968), Joanna Mytkowska (b.1970) and Adam Szymczyk.[11]

During the second half of the 1990s, Krasiński began to be recognised by curators outside Poland. At the very end of his life, he was being rediscovered. When Peter Pakesch (b.1955) became Director of the Kunsthalle Basel, Switzerland, he invited Krasiński to put on a solo show. Maria Hlavajova (b.1971) included him in *Manifesta 3* in Ljubljana, Slovenia, in 2000, and he exhibited in London, Paris, New York and Tokyo.

However, throughout most of his life he was not taken too seriously, mainly because of his alcoholism. At the Foksal Gallery, there was always a bottle waiting for him, hidden in an umbrella box. Everybody called him by a diminutive of his name: Edzio. To friends, Stażewski was Henio, too, but Krasiński was always Edzio. He played with this as if he liked the self-humiliating or provocative attitude.

He drank milk and vodka, the only items, along with pork chops, which he ate cold, that were always in his fridge. He did not like the words 'work of art'. He did not want any notion of working to be attributed to his art. And he never really seemed busy. When it turned out that his friend with an amputated leg received a smaller pension than he did, he quipped, 'Obviously they know that an artist makes more of his head than his leg.'

Yet he treated himself seriously. Once a collector visited him interested in buying a work, but Krasiński refused to unpack any. He claimed that all of them were

Opening of the exhibition *Finally in Łuck*, Wołyńskie Muzeum Krajoznawcze, Lutsk, 1995. From left: unidentified woman, Janina Ładnowska, Adam Szymczyk, Dorota Monkiewicz and Paulina Krasińska, with Edward Krasiński on the table

equally good and his guest should take pot luck. They did not make a deal because the collector suggested that he would not discuss the price and simply put a sum of money into an envelope. When a curator invited him to participate in a group show, Krasiński declined. He heard that there were sixteen outstanding artists invited to take part and retorted: 'I thought two or three were outstanding.' Sometimes, when commenting on other artists' work, he said with a smattering of French: '*Pourquoi* is he doing that? *Pourquoi*?' When he was in a good mood, he sang, '*Comment ça va, comme ci, comme ci, comme ci, comme ça.*'

In the joint on the opposite side of the street to his apartment, he lost money playing blackjack. Due to his eccentricities and his stutter on vowels, the patrons nicknamed him 'cocoa' (*Kakałko*), assuming that he was an aging homosexual. But when they read an article about him in a newspaper, they rechristened him 'count': Count Krasiński.

For a certain period, gambling was his second addiction. He played until the last coin left his pocket. When the Zachęta National Gallery of Art bought a number of his works following an exhibition there, curator Magda Kardasz used to take him a small instalment each week, so that he would not lose the whole amount in one fell swoop. He then went to church, asked the Holy Mary for help and stopped playing on slot machines. When a priest visited and blessed him with a sign of the cross on his forehead, Krasiński returned the gesture, blessing the priest. He sometimes showed up in Gruba Kaśka Café in his dressing gown and slippers. He enjoyed watching television and reading detective novels.

1999

In 1999, curator and critic Hans-Ulrich Obrist (b.1968) gives a lecture at the Foksal Gallery and visits Krasiński. He is guided around the studio by Joanna Mytkowska and Andrzej Przywara, who explain the origins of the objects and the history of the place. Krasiński does not say much. 'I feel so weak, I'm about to die,' he complains. 'Don't be silly, Edziu,' Przywara comforts him. 'You're supposed to be going to Sweden.' Krasiński is also preparing his contribution to the group show at Jeu de Paume in Paris. He will hang photographs of his friends in the space, as if they were all present at the opening.

Obrist does not receive a proper answer from Krasiński: 'I would like to ask you, Edward, what you think about personified abstraction?' 'Hell, I have a roll of tape in my hand so I stick it on. Wolves pee to mark their territory: I stick the blue tape to mark mine.' A moment later he asks everyone to leave: 'I need to lie down, leave me now.' 'This is the end,' says Przywara.[12]

Edward Krasiński in his studio, Warsaw, 1990s

1 Working on this essay, I returned to the research I conducted with Maria Matuszkiewicz in 2006 and 2007, which focussed on the history of Stażewski's and Krasiński's studio and included a number of oral-history interviews. I borrow most of the anecdotes in this essay from those interviews. We presented the research at the conference 'Avant-garde in the Bloc', 5–6 October 2007. Maria Matuszkiewicz, Karol Sienkiewicz, 'Alternative Topographies: The Studio of Henryk Stażewski and Edward Krasiński', in: *Avant-garde in the Bloc*, Gabriela Świtek, ed., Warsaw and Zürich 2009, pp.144–59.

2 The film was shown at the exhibition *Edward Krasiński ABC*, curated by Andrzej Przywara at the Bunkier Sztuki Gallery in Kraków, 10 April – 22 May 2008.

3 Miron Białoszewicz, *Donosy rzeczywistości* (*Denunciation of Reality*), Warsaw 1973, p.80.

4 Miron Białoszewicz, *Dokładane treści (fragment dziennika)* (*Added Contents [Excerpts from a Diary]*), in *Kwartalnik Artystyczny* (*Quarterly Art*), no. 1 (37), 2003, p.14.

5 'Drôle d'interview: Edward Krasiński in conversation with Eulalia Domanowska, Stanisław Cichowicz, and Andrzej Mitan' (1993), in Sabine Breitwieser, ed., *Edward Krasiński: Les mises en scène*, exh. cat., Generali Foundation, Vienna 2006.

6 A few years ago, art historians and curators became interested in Hanna and Gabriel Rechowicz as precursors to the neo-surrealist painters and as authors of unusual architectural mosaics using simple materials such as stone and glass. Max Cegielski, *Mozaika. Śladami Rechowiczów* (*Mosaic: In the Footsteps of the Rechowiczs*), Warsaw 2011; Klara Czerniewska, *Gaber i Pani Fantazja* (*Gaber and Lady Fantasy*), Warsaw 2011.

7 'Drôle d'interview', p.33.

8 It was Paweł Althamer who reconstructed Krasiński's decorations when the ball was restaged at the Centre for Contemporary Art, Ujazdowski Castle, in 2006.

9 Daniel Buren reconstructed the piece in the Muzeum Sztuki in Łódź in 2009.

10 Journalist Leszek K. Talko wrote a report for the newspaper *Gazeta Wyborcza* describing the journey. Leszek K. Talko, 'Srebrny jubileusz niebieskiego paska' ('Silver Anniversary of the Blue Line'), *Gazeta Wyborcza*, 7 April 1995.

11 In 1997, Mytkowska, Przywara and Szymczyk established the Foksal Gallery Foundation to support the activities of the Foksal Gallery. But, in the face of growing tension over the gallery's programme, the foundation and the gallery went their separate ways. It was the Foksal Gallery Foundation who took care of Krasiński's studio after the artist's death and who runs the Institute of the Avant-Garde.

12 'Abstraction in Person / Dynamic Memory. Hans-Ulrich Obrist in Conversation with Edward Krasiński, Joanna Mytkowska and Andrzej Przywara', in *Edward Krasiński*, exh. cat., Foksal Gallery Foundation, Warsaw; Klosterfelde, Berlin; and Anton Kern Gallery, New York 2001, pp.20–5.

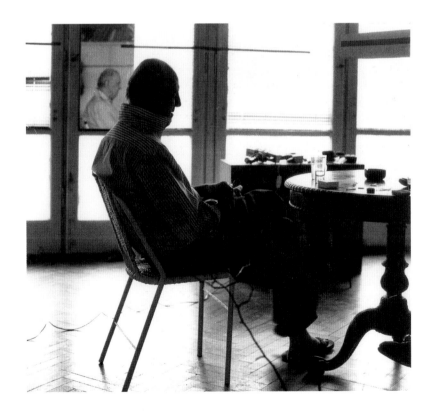

Karol Sienkiewicz

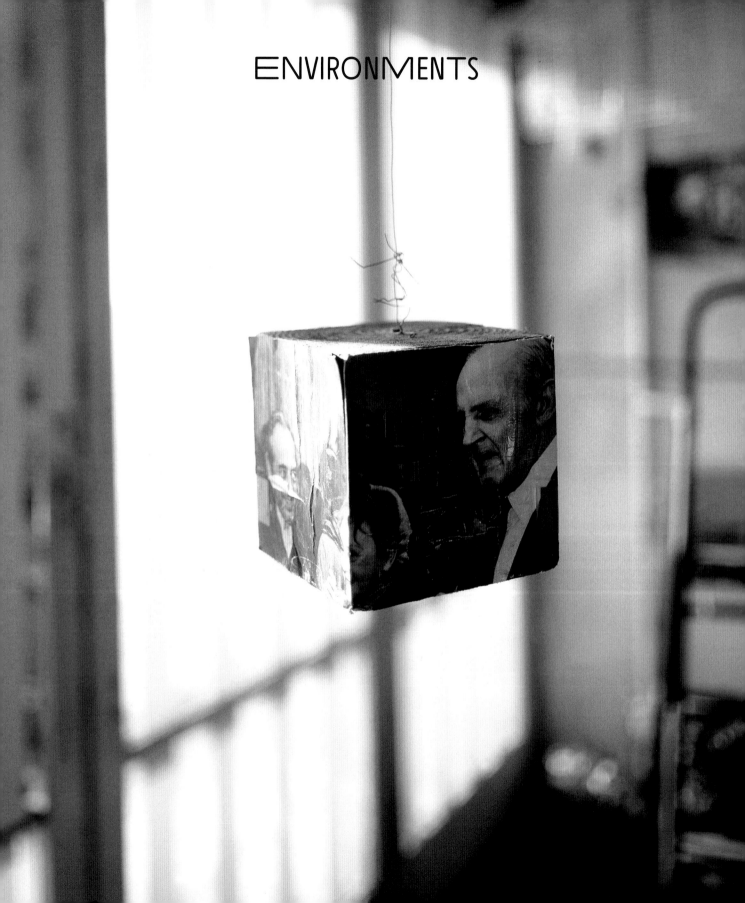

ENVIRONMENTS

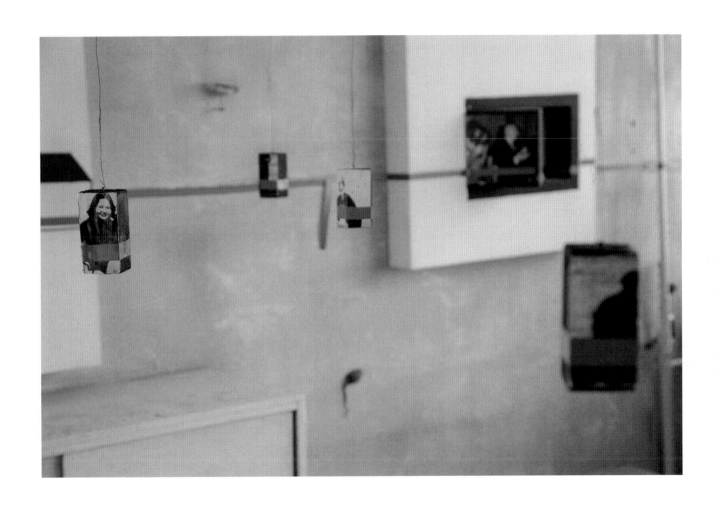

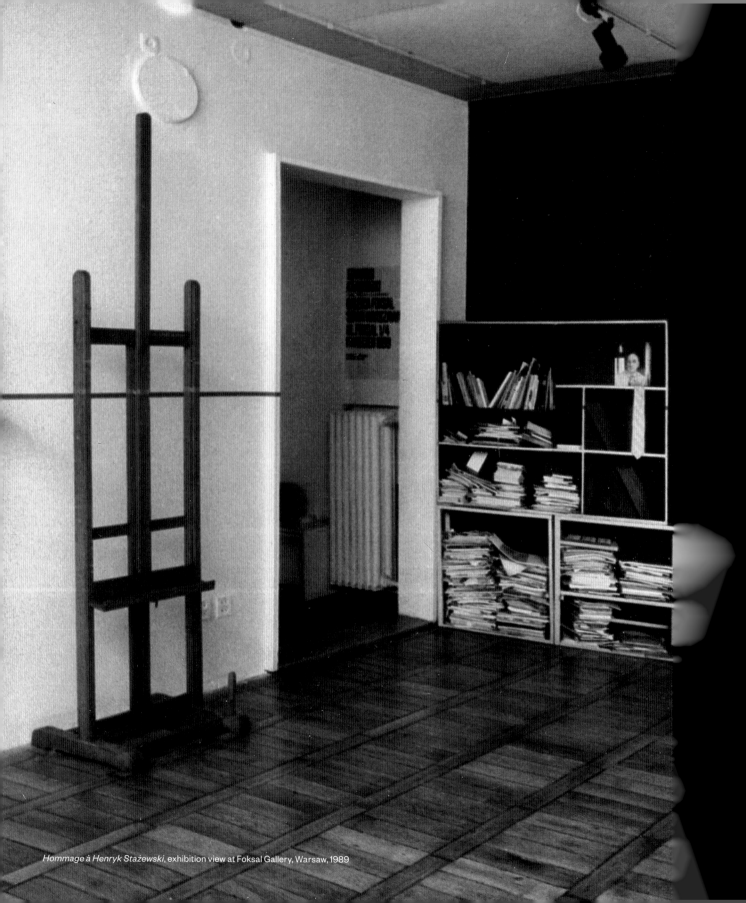

Hommage à Henryk Stażewski, exhibition view at Foksal Gallery, Warsaw, 1989

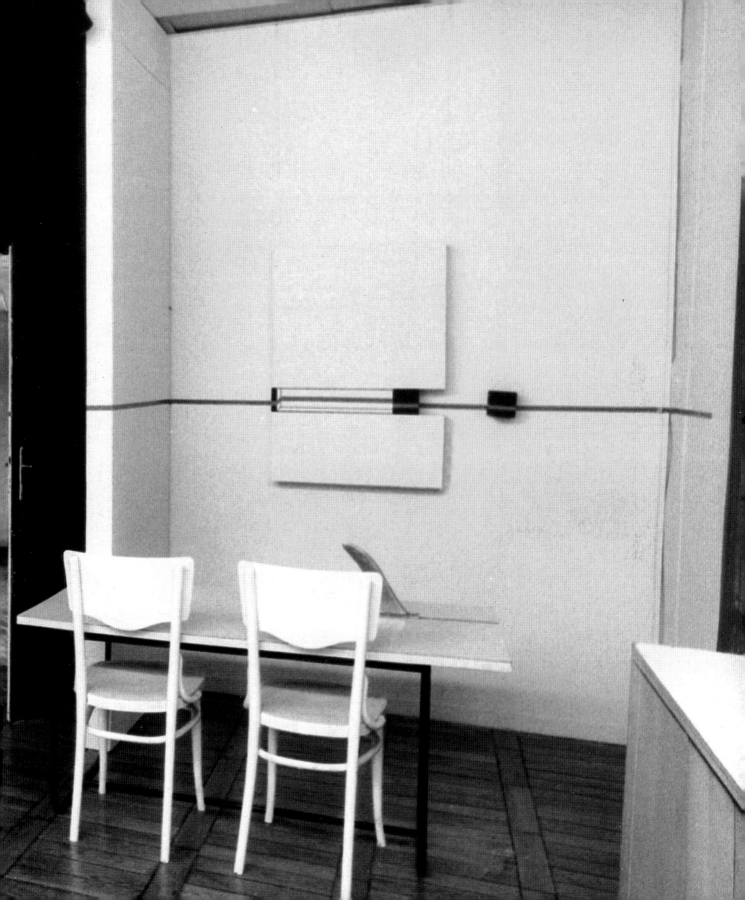

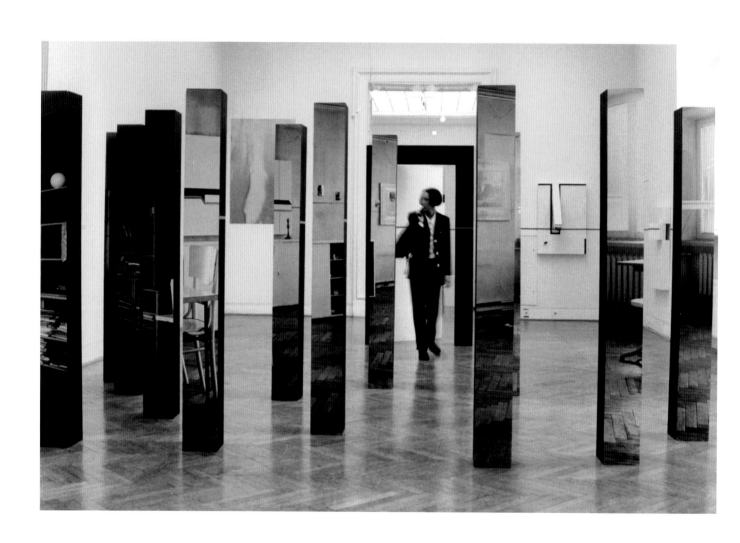

124 Edward Krasiński's installation *Atelier-Puzzle* 1992, exhibition view of *Edward Krasiński* at Zachęta Gallery, Warsaw, 1997

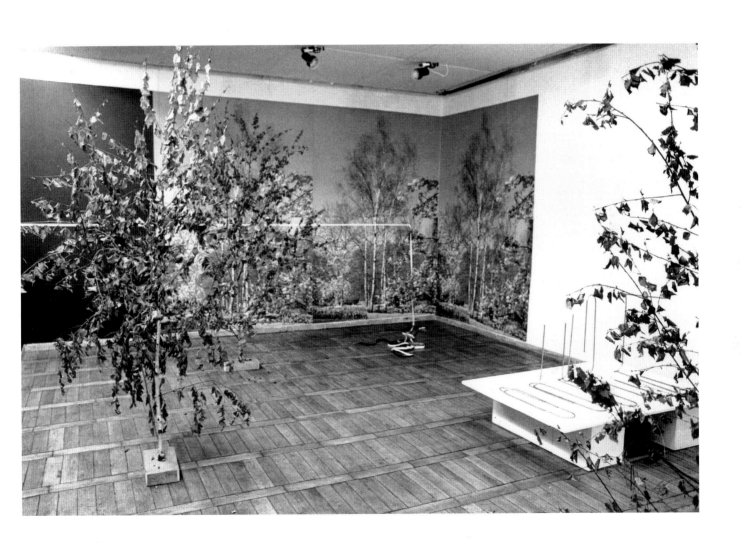

Edward Krasiński, exhibition view at Foksal Gallery, Warsaw, 1985

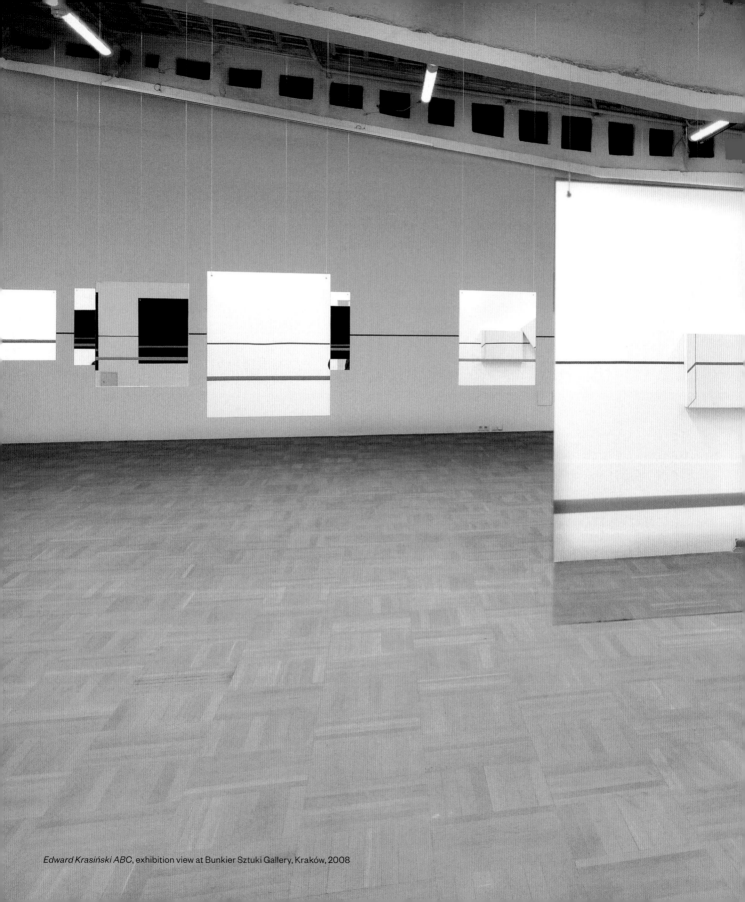

Edward Krasiński ABC, exhibition view at Bunkier Sztuki Gallery, Kraków, 2008

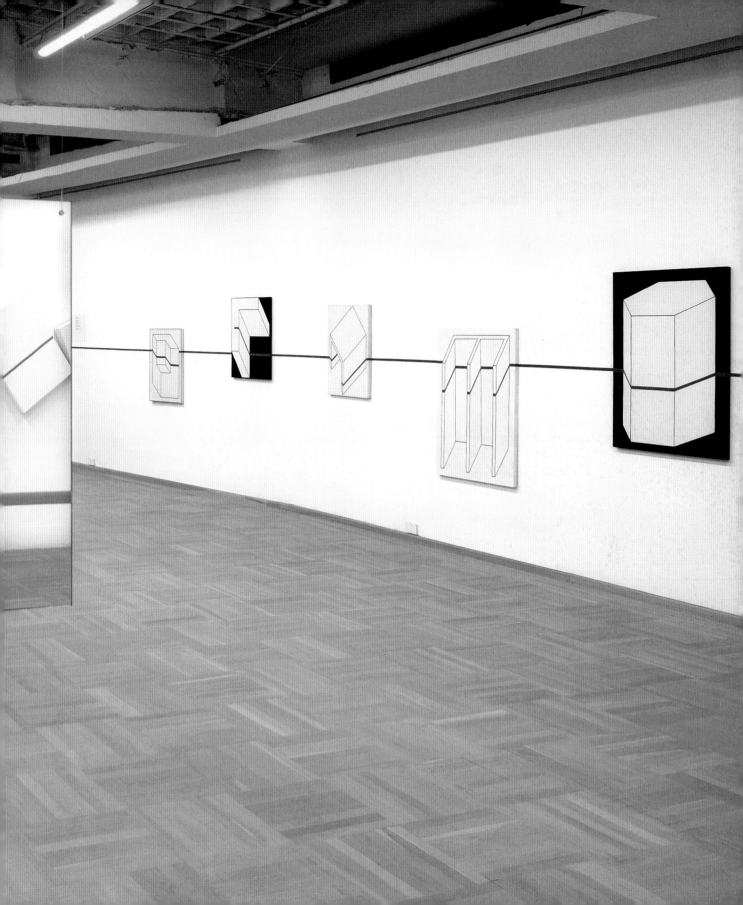

CHRONOLOGY

1925

Edward Krasiński is born on 3 March in Lutsk, Poland, in what is current-day Ukraine.

1940–2

Krasiński studies at the German-run Arts and Crafts School in Kraków, southern Poland, until the school is closed down in 1942.

1945–8

Following the city's liberation in January 1945, Krasiński continues his studies at the Academy of Fine Arts, Kraków.

1954

Krasiński relocates from Kraków to the Polish capital Warsaw, where he will live and work for the rest of his life. For the first decade of his time in Warsaw, he lodges with the artists Hanna and Gabriel Rechowicz. Krasiński works as an illustrator for various magazine, poster and book commissions, while also developing a painting practice inspired by Dada and surrealism. Theatre director, set designer and painter Tadeusz Kantor (1915–1990), who studied in Kraków, also moves to Warsaw during this period.

1962

He meets artists and critics inspired by the avant-garde who form a dynamic social and artistic scene around Krzywe Koło (Crooked Wheel) Gallery, Warsaw, including Marian Bogusz, Włodzimierz Borowski, Zbigniew Dłubak, Stefan Gierowski, Erna Rosenstein, Henryk Stażewski and Alina Szapocznikow. The artist participates in *Confrontations* 1956–62 and *Reasons* 1962, two group exhibitions at Krzywe Koło. His output includes sculptures such as *Untitled* 1962 (p.28), originally exhibited outdoors. The Krzywe Koło Gallery scene was highly influential for the development of contemporary art in Poland, but by 1965 it was

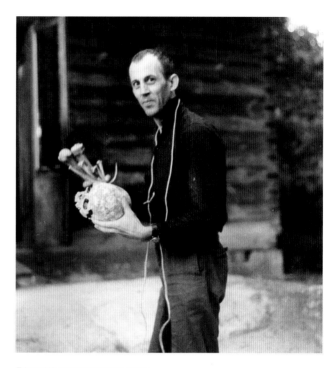

Edward Krasiński in Zalesie, 1960s

deemed too subversive and forced to close by the authorities.

Krasiński participates in the *9th Exhibition of Painting and Graphics of the Warsaw Artist-Circle ZPAP* at Zachęta – National Gallery of Art, Warsaw.

He marries art critic and curator Anka Ptaszkowska (b.1935). Their daughter, Paulina, is born in 1966.

1963

Krasiński is included in the Grabowski Gallery's exhibition *Five Polish Painters* in London, the artist's first show outside Poland.

1964

A major photoshoot with Eustachy Kossakowski (1925–2001) captures the outdoor staging of Krasiński's suspended sculpture *Spear* c.1963–4 in Zalesie Górne, a village 20km south of Warsaw, where Ptaszkowska's family have a home (p.42).

Krasiński participates in a group painting exhibition at Krzywe Koło Gallery, Warsaw, *Confrontations*.

At *The Second Summer Academy* in Osieki, Koszalin, Krasiński exhibits *The Great Spear* and other works outside, between the trees.

1965

The artist's first solo exhibition takes place at the Krzysztofory Gallery, Kraków (pp.38, 39, 44).

The *1st Biennale of Spatial Forms* is staged by Galeria EL in Elbląg, northern Poland, which supports the production and installation of public-realm

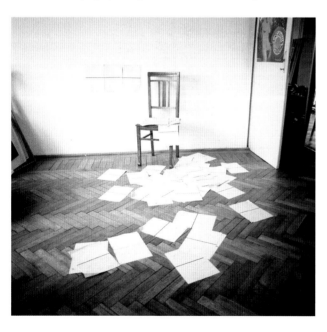

Untitled 1969, photographed in the artist's studio, Warsaw

sculptures by contemporary artists throughout the city, including a 7m-high abstract metal sculpture by Krasiński (p.113). The biennial is framed as an assuredly socialist endeavour, with local factory workers manufacturing the large-scale sculptures in collaboration with the artists.

At *The Third Summer Academy* in Osieki, Koszalin – *International Meeting of Artists and Art Theorists* – the artist participates in Tadeusz Kantor's 'happening' *Cricotage*, Warsaw.

1966

First Symposium of Artists and Scientists: Art in the Changing World is held at Zakłady Azotowe, a nitrogen plant in Puławy. Organised by critic Jerzy Ludwiński (1930–2000), it debates the collaboration between art, science, industry and technology.

The Foksal Gallery, in the centre of Warsaw, is founded by a group of artists, including Edward Krasiński and the painter Henryk Stażewski (1894–1988), one of the major figures of pre-Second World War Polish constructivism, and three art critics – Wiesław Borowski, Anka Ptaszkowska and Mariusz Tchorek.

The essay 'An Introduction to the General Theory of PLACE' (top right) is published to articulate the collective aims of this new space and workshop, which offered no storage facilities and only a modest temporary exhibition space of 35m².

Krasiński stages a solo exhibition at Foksal Gallery, and also participates in its inaugural summer group exhibition.

1967

Krasiński takes part in a number of important group exhibitions in Poland, including the inaugural exhibition of the Muzeum Sztuki Aktualnej in Wrocław; the summer magazine exhibition at Foksal Gallery; and the thematic

The artist's personality, which is said to be manifested in its purest form, is revealed at the exhibition mutilated, artificially portioned, and dosed in a rythm that is incompatible with his actual maturing. The artist is hanging as a cut beef, while we are trying in vain to reconstruct the living animal out of the cuts. Besides the author, persuaded by the learned that sincerity is his essential virtue, feels an awkward uneasiness seeing the result of his frankness in festive splendour of a public show.

Why not to make this uneasiness, as the most genuine feature of the event, into its very object?

The PLACE then. Well the PLACE. The PLACE, for certain.

The PLACE is an area that arises by virtue of setting aside all and any principles holding in the universe.

The PLACE is not a space category, it not an arena, a scene, a postument, a screen, a pedestal, and above all it is not an exhibition.

The PLACE is isolated and at the same time it must get exteriorised. Its existence is not a merely subjective matter and it cannot be called into being by purely private endeavours. It must be conspicuous and significantly objective, while at the same time it cannot subsist if it fails to protect itself against the world's impact and against getting identified with the world.

The PLACE is a sudden gap in the utilitarian approach to the world. All and any standards valid beyond the PLACE no longer hold within it. Therein space is devoid of its utilitarian significance; all its measures, reasons, Euclidean and non-Euclidean interpretations are left behind. Events, if they occur at all, are deprived of any outer meaning whatever. There is no hesitation within the PLACE, since there is no difference between the wrong and the right, the good and the good-for-nothing, everything merely and simply is there. The PLACE is neither strange nor common, refined or vulgar, wise or stupid. It is neither dream nor wake.

The PLACE is not transparent. What it is, is the actual presence. There are no criteria of better or more valuable filling of the PLACE. It may even be empty but, its emptiness must be conspicuously present.

The PLACE is one and unique. It cannot be divided and it does not procreate. The PLACE is what we are in.

Only when we step outside, can we conceive it as one among many places comparable with it. The PLACE can become an object of hatred only from abroad.

Any area of the world may be possessed and thus constituted as the PLACE. From worldly point of view this is by no means a peculiar area. The PLACE cannot be recognized by its appearance. It does not modify the world's laws because it has nothing to do with them at all. The PLACE may indeed look exactly like any other fragment of reality. However, there are some areas in the world that are thought of as particularity fit for becoming PLACES.

The PLACE is neither a construction nor a destruction. It comes into being as a result of an indemnified decision. The PLACE has no sufficient reason in the world. It is in the artist that this reason subsists. It is he that calls forth the PLACE. It is created by him who steps within it. It is only in the PLACE, and not outside of it, that „art is created by all".

The PLACE cannot be mechanically fixed up but it must be incessantly perpetuated.

A slightest moment of inattention may be enough for it to get sunk in what is around it. There are numerous anonymous forces that professionally destroy the PLACE or produce its fake substitutes. These forces take advantage of the PLACE still left and they manipulate with elements taken up from it — with element restituted to real standards and measures. The PLACE cannot be bought or collected. It cannot be arrested. It cannot be an object of virtu.

'An Introduction to the General Theory of PLACE', fragment of *Program Galerii Foksal PSP*, Foksal Gallery, Warsaw, 1967

Edward Krasiński participating in Tadeusz Kantor's 'happening' *Letter*, Foksal Gallery, Warsaw, 1967

exhibition *Space – Movement – Light*, also at Muzeum Sztuki Aktualnej.

He is also included in the *Guggenheim International Exhibition: Sculpture from Twenty Nations* staged at the Solomon R. Guggenheim Museum in New York, although he does not travel to the United States for the exhibition. The exhibition toured to three additional venues in Canada, but Krasiński's sculpture, *No.7* 1967, was purchased by the Governor of New York, Nelson A. Rockefeller, following its New York debut and was not included in these later iterations of the exhibition (p.66).

Krasiński participates in two of Tadeusz Kantor's 'happenings': *Letter* at Foksal Gallery, Warsaw (below), and *Panoramic Sea Happening* at the Osieki summer academy, Koszalin (p.8).

1968

The artist's second solo exhibition at the Foksal Gallery is again photographed by Eustachy Kossakowski (pp.56, 58). The opening night of the show is interrupted by demonstrations in the streets near the gallery, which

mark the beginning of the March 1968 student uprisings in Warsaw.

In June, at their home in Zalesie Górne, Krasiński and Ptaszkowska, along with other members of the Foksal Gallery circle, host a ball with the dramatic title of *Farewell to Spring*, which alludes to the protests and wilfully disobeys government restrictions on public gatherings. Krasiński designs the ball's decorations, involving the creation of numerous grotesque figurines and foodstuffs, staged in homage to the painting by Pieter Breugel the Elder, *The Land of Cockaigne* 1567 (p.54).

Krasiński has a solo exhibition at Grabowski Gallery, London.

1969

Krasiński has a solo exhibition at Krzysztofory Gallery, Kraków.

The group exhibition *Assemblage d'hiver / Winter Assemblage* at Foksal Gallery, Warsaw, is marked by the publication of Krasiński's poster and photo-documented performance, *J'AI PERDU LA FIN!!!* (pp.62, 63)

At the artist's home in Zalesie Górne, a photoshoot by Kossakowski captures Krasiński's first documented use of blue adhesive Scotch tape, an everyday manufactured product that would become his signature artistic material. The tape's temporary intervention on the building, its surrounding landscape and the bodies of his family members is at a constant height of 130cm, which becomes the horizon line for all future excursions of the blue line.

Krasiński participates in the group exhibition *Kulturfestival Intermedia '69*, Studentenhochhäuser am Klausenpfad und Umgebung, Heidelburg, Germany.

The Foksal Gallery's founding group of artists and critics suffers a schism, which is precipitated by Kantor's reaction to the circulation of the proposed 'New Regulations for the Foksal Gallery'. Subsequently, Krasiński and Stażewski do not exhibit at the gallery for fifteen years. This break results in Ptaszkowska relocating to Paris, accompanied

Telex sent by Edward Krasiński to curators of *Between Man and Matter: 10 Tokyo Biennial*, 1970

by Krasiński and Kossakowski. In Paris, Ptaszkowska establishes a contemporary art space named sequentially after its consecutive exhibitions, but maintains strong links with Warsaw.

1970

Krasiński's inclusion in the tenth international Tokyo Biennial, *Between Man and Matter*, is disrupted due to the delayed shipment of his works from Poland to Japan. In the sculptures' place, he sends a telex to the organisers: the word 'blue' repeated 5,000 times. This is exhibited in place of his works until they arrive in Tokyo, at which point a precise installation diagram drawn up by the artist is used to stage their configuration on an oversized, low plinth (left). Artists who exhibit in this biennial include Barry Flanagan, Giuseppe Penone, Luciano Fabro, Robert Morris and Carl Andre, alongside artists associated with what would become known as the 'Mono-Ha' or 'School of Things', including Jiro Takamatsu and Lee Ufan.

Krasiński is included in the *3rd Salon des Galeries Pilotes*, which tours from Lausanne to the Musée d'Art Moderne de la Ville de Paris. At the exhibition's Paris

opening Krasiński submits his blue tape to public exposure for the first time, performing his action inside the building's courtyard and on the front windows of several important Left Bank art galleries, alongside French conceptual artist Daniel Buren (b.1938), with whom he forms a close friendship and working relationship.

Following the end of his marriage to Ptaszkowska, Krasiński returns from Paris to Warsaw. He moves into a top-floor apartment on Solidarność Avenue, sharing with Henryk Stażewski, who has occupied the flat since 1962. Together, Krasiński and Stażewski continue the apartment's tradition of hosting informal salons and social occasions for the city's artistic circles.

1972

The artist produces the first of his *Intervention* works, incorporating maps and household objects such as a telephone. The *Interventions* evolve over the following twenty years to include axonometric drawings and finally three-dimensional volumes into their wall-mounted reliefs.

During the Edinburgh Festival, a collaboration between the Richard Demarco Gallery

Edward Krasiński's design for an exhibition of his works at the *Between Man and Matter: 10 Tokyo Biennial*, 1970

and the Muzeum Sztuki in Łódź results in a group exhibition with the aim of surveying the state of contemporary Polish art, brought to Scotland, and in many artists' cases the UK, for the first time. The Atelier '72 group exhibition at the Demarco Gallery, Edinburgh, introduces the work of forty-five Polish contemporary artists, including Magdalena Abakanowicz, Henryk Stażewski, Tadeusz Kantor and Edward Krasiński to British audiences. Tadeusz Kantor's theatre group Cricot 2 Theatre performs The Water Hen in the Forrest Hill Poorhouse.

Krasiński's work is included in the group exhibition 10 Polish Artists, Benson Gallery, Bridgehampton, New York.

c.1973–5

Krasiński installs an early group of Interventions in the wards and bedrooms of the hospital in Komorów, just south of Warsaw, during his stay there (pp.86, 89).

1974

Ptaszkowska arranges for French conceptual artist Daniel Buren to travel to Warsaw, where he visits the Stażewski/Krasiński studio, applying his signature vertical stripes to the apartment's windows (p.115). On the occasion of Krasiński's solo exhibition at Repassage Gallery, Warsaw, Buren intervenes and installs the stripes on the gallery's windows.

Krasiński participates in the group exhibition Experience and Research at Muzeum Sztuki in Łódź.

1975

Krasiński holds solo exhibitions at Galerie 30, Paris (the space run by Ptaszkowska, p.114), and PolArt – Galerie für Polnische Kunst, Alfred Hempel Kg, Düsseldorf, Scotch blue – Breite 19mm, Länge unbekannt.

Group exhibitions this year include Polish Constructivism,

Everson Museum of Art, Syracuse, New York, and Polnische Gegenwartskunst, travelling from Muzeum Narodowe Wrocław to venues in Hamburg, Hannover and Stuttgart.

1976

A solo exhibition, Intervention, at Galeria Pawilon DESA, Kraków.

Group exhibitions include 17 Contemporary Painters from Poland, Albright-Knox Gallery, Buffalo, New York; Contemporary Polish Paintings, Galeria Zapiecek, Warsaw; XXXVII Biennale di Venezia. Ambiente, participazione, strutture culturali, Venice.

1977

Solo exhibitions at the Galeria Zapiecek and Galeria Krytyków, both in Warsaw.

Selected international group exhibitions include 16 Contemporary Polish Artists, The Aldrich Museum of Contemporary Art, Ridgefield, Connecticut, and 22 polnische Künstler aus dem Besitz des Muzeum Sztuki Łódź, Kölnischer Kunstverein, Cologne.

1978

Solo exhibition at Galeria Pawilon DESA, Kraków, and group exhibitions including 7th Festival of Fine Arts in the Warexpo, Warsaw; 15 polnische Künstler, Rathaus, Augsburg; The Characterizing Line, Muzeum Sztuki, Łódź; and the major touring group show Contemporary Sculpture from Poland, travelling to venues in Madrid, Bilbao, Lisbon, Barcelona, Paris and Wrocław.

1979

Krasiński participates in numerous group exhibitions, including L'avanguardia polacca 1919–1978, Palazzo delle Esposizioni, Rome; 17th Meeting of Artists, Art Scholars and Art Theorists – Osieki '79. The Fourth Dimension, Osieki, Koszalin; Ten Polish Contemporary Artists

from the Collection of Muzeum Sztuki in Łódź, Demarco Gallery, Edinburgh; 35 Years of Painting in Folksy Poland, Muzeum Narodowe, Poznań and Zachęta – National Gallery of Art, Warsaw.

1980

Krasiński stages another urban public-realm intervention, the action taking place this time at the Bar Gruba Kaśka, in Warsaw, where he installs his blue tape behind the bar of one of his regular haunts.

1981

Group shows include Contemporary Painting in Eastern Europe and Japan, Kanagawa Prefectural Gallery, Yokohama; National Museum of Art, Osaka; Kreis und Quadrat. Postkonstruktivismus in Polen, Galerie Deploma, Düsseldorf.

On 13 December, a state of martial law is declared in Poland, which triggers an unofficial boycott of public institutions by artists, lasting until 1984.

1982

Solo exhibitions at Galeria 72, Chełm, and Galeria Mała ZPAF, Warsaw.

Group exhibitions include Échange entre artistes 1931 – 1982, Pologne – USA, organised by Ptaszkowska, which travels from Paris to Belfast and Dublin.

1983

Solo exhibition at Galeria RR, Warsaw.

1984

Krasiński's solo exhibition at Foksal Gallery, Warsaw, is presented as a retrospective surveying his practice over the last twenty years, partly achieved through photographic documentation of his early work by Tadeusz Rolke (b.1929). The exhibition marks the artist's first involvement with Foksal Gallery after a fifteen-year hiatus.

Krasiński is featured in the group exhibition The Language of Geometry at Zachęta – National Gallery of Art, Warsaw.

1985

Dialog exhibition at Moderna Museet, Stockholm.

The artist's solo exhibition at Foksal Gallery, Warsaw, incorporates real trees within the gallery space juxtaposed with photographic reproductions of woodlands, and his work Paperclips (p.125).

1986

Solo exhibition at Foksal Gallery, Warsaw, introduces the dramatic architectural motif of the corridor/labyrinth.

Group show together with Koji Kamoji and Henryk Stażewski, Foksal Gallery, Warsaw.

1987

For his solo exhibition at Foksal Gallery, Warsaw, Krasiński unveils the room-sized installation Labyrinth 1987 (p.52), which tours to Paris the following year.

1988

Solo exhibition at Galerie J&J Donguy, Paris (pp.103, 134–5).

On 10 June, Henryk Stażewski dies at the age of ninety-four. The artist's family remove all of his paintings and artworks from the shared studio/apartment, and Krasiński gradually begins the process of transforming the public areas of the apartment into a new manifestation of studio space and installation artwork.

1989

The solo exhibition Edward Krasiński: Hommage à Henryk Stażewski is presented at the Foksal Gallery, incorporating 1:1-scale photographic replicas of the shared apartment/studio space, in memory of Stażewski (pp.107, 122–3).

1990

Solo exhibition at Foksal Gallery, Warsaw.

The artist is included in a group exhibition examining the impact and legacy of the Krzywe Koło Gallery, held at the National Museum in Warsaw.

1991

Krasiński is granted a major retrospective exhibition at the Muzeum Sztuki in Łódź.

1992

Solo exhibition, *Corridor*, at Galerie J&J Donguy, Paris.

Group exhibitions include *Polnische Avantgarde 1930 – 1990* at the Neue Berliner Kunstverein, Berlin, and *Das offene Bild: Aspekte der Moderne in Europa nach 1945* at Landesmuseum Münster and Museum der bildenden Künste, Leipzig, where Krasiński debuts his major installation *Atelier-Puzzle* 1992 (p.124).

1993

Edward Krasiński: Ping-Pong, solo exhibition and symposium at Miejska Biblioteka Publiczna, Legionowo.

Group exhibitions *Włodzimierz Borowski, Edward Krasiński, Koji Kamoji* at Miejska Biblioteka Publiczna, Legionowo, and *Osieki 1963 – 1981. International Meeting of Artists, Art Scholars and Art Theorists. Documents* at Muzeum Okręgowe, Koszalin.

1994

The Place of Art and Sausage, artist's intervention in a butcher's shop, 64 Solidarność Avenue, Warsaw.

Solo exhibitions *Puzzle*, Foksal Gallery, Warsaw, and *Edward Krasiński: My Daughter's House and I*, Galeria Stara, BWA, Lublin.

Krasiński shows his 1994 installation work, incorporating photographic replicas of his studio

in the group exhibition *Der Riss im Raum: Positionen der Kunst seit 1945 in Deutschland, Polen der Slowakei und Tschechien*, Martin Gropius Bau, Berlin, touring to Zachęta – National Gallery of Art, Warsaw.

1995

Solo exhibitions at Foksal Gallery, Warsaw, and at Starmach Gallery, Kraków.

Krasiński stages another public intervention in the Gruba Kaśka Bar, Warsaw, installing his actual-size photographic image in a prominent place at the bar's front door.

In March, Krasiński travels to his hometown of Lutsk to open a solo exhibition, *Finally in Łuck*, to celebrate his 70th birthday at Wołyńskie Muzeum Krajoznawcze (p.117).

1996

Major solo retrospective exhibition at Kunsthalle Basel, Switzerland.

Group exhibitions include *Polish Sculpture of the 20th Century*, National Museum in Warsaw; *Contacts*, Foksal Gallery, Warsaw; *Modern Polish Sculpture 1955 – 1992*, Slovenian

National Gallery, Bratislava; and *Horizons: 14 Polish Contemporary Artists*, touring from Museum of Contemporary Art, Kyongju, Sonje Museum of Contemporary Art, Kyongju to Chosun Ilbo Gallery, Seoul (1997).

1997

Solo exhibitions at Foksal Gallery, Warsaw and Zachęta – National Gallery of Art, Warsaw (p.124, opposite).

Inclusion in Polish Art Festival: *Express Polonia, Art from Poland between 1945 – 1996*, Ludwig Museum, Budapest.

1998

Solo exhibition at Galeria Arsenal, BWA, Białystok.

Artist Paweł Althamer and curator Adam Szymczyk make a film of Krasiński in his studio (Karol Sienkiewicz essay p.109).

1999

Group exhibitions *Aspekte / Positionen: 50 Jahre Kunst aus Mitteleuropa 1949 – 1999*, Museum Moderner Kunst Stiftung Ludwig Vienna, and *Experiences of Discourse: 1965 – 1975*, Centre for Contemporary Art, Ujazdowski Castle, Warsaw.

2000

Touring group exhibition *Beyond Preconceptions: The Sixties Experiment*, Prague, Buenos Aires, São Paulo, Rio de Janeiro and Berkeley, California.

Krasiński is included in *Manifesta 3*, Ljubljana, and *L'autre moitié de l'Europe*, Galerie Nationale du Jeu de Paume, Paris (below).

2001

Touring solo exhibition at Klosterfelde, Berlin, and Anton Kern Gallery, New York (2002) with the twelve-part mirror work *Untitled* 2001.

Group exhibition *In-Between: Art from Poland 1945 – 2000*, Chicago Cultural Centre, Chicago.

2004

Solo exhibition, *Infinity of the Line: Hommage à Edward Krasiński*, presented by the Muzeum Sztuki in Łódź.

On 6 April, Krasiński dies in Warsaw at the age of seventy-nine.

Untitled 2000, exhibition view of *L'autre moitié de L'Europe* at Galerie Nationale du Jeu de Paume, Paris, 2000

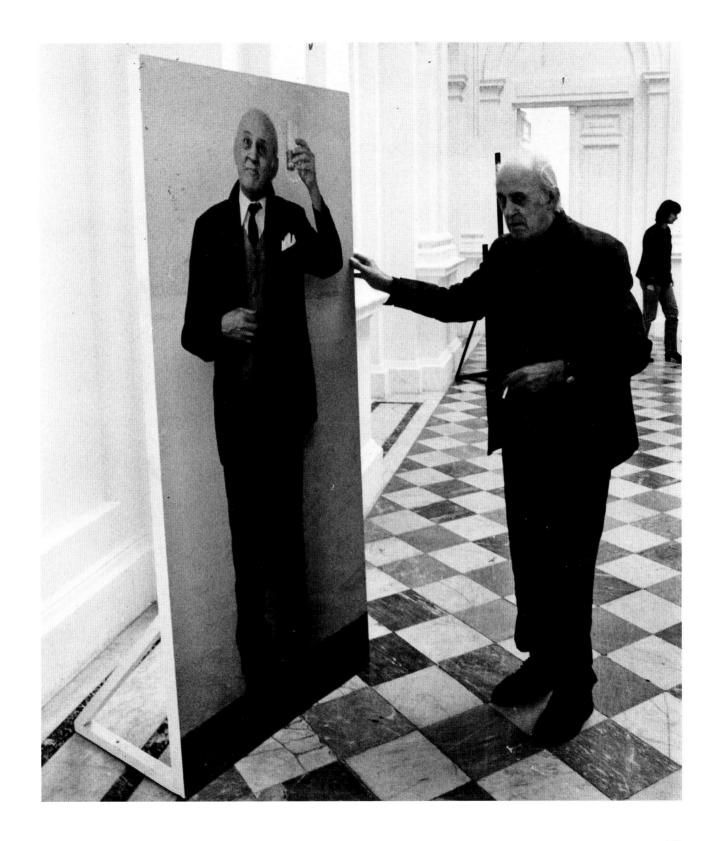

Edward Krasiński at the opening of his solo exhibition, *Edward Krasiński*, at Zachęta Gallery, Warsaw, 1997

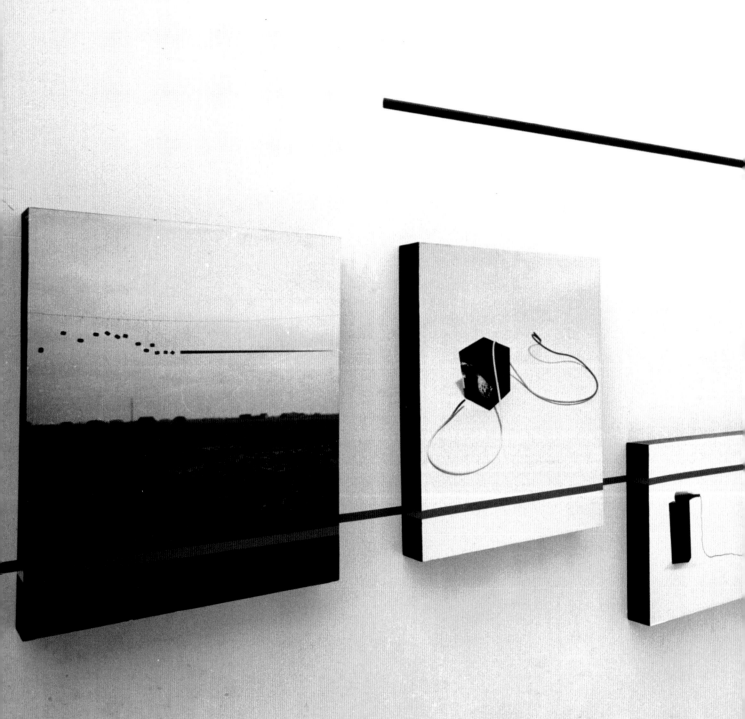

Edward Krasiński exhibition, showing *Retrospective K140* 1984 and *Untitled* 1965, Galerie J&J Donguy, Paris, 1988

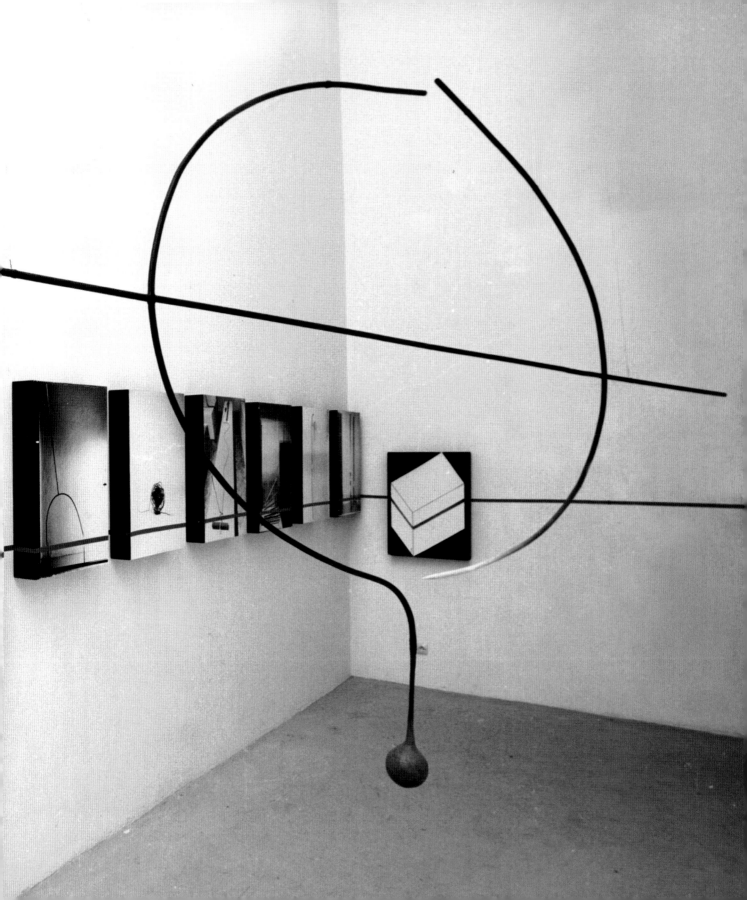

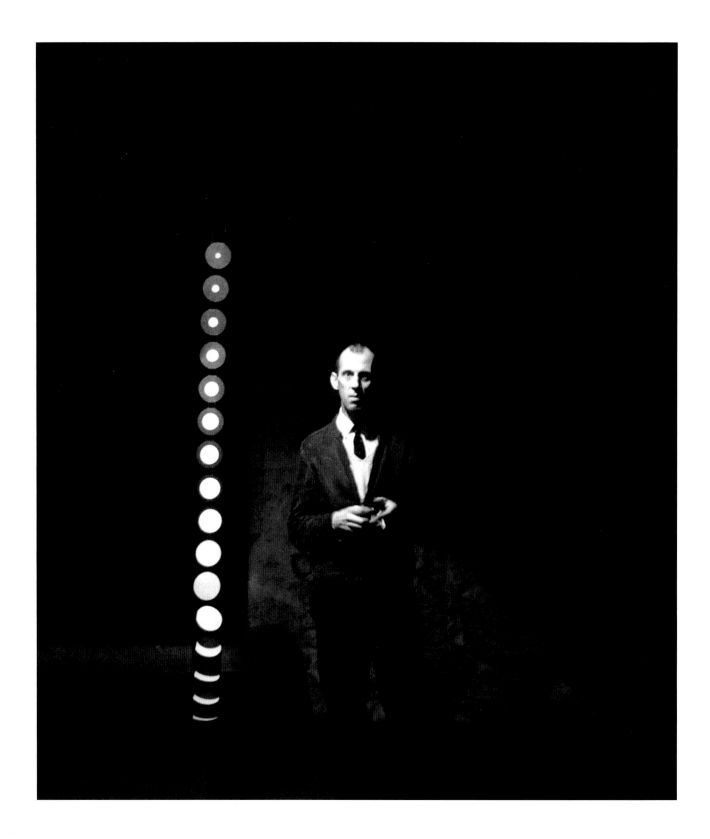

136 Edward Krasiński at the opening of his first solo show at Krzysztofory Gallery, Kraków, 1965

LIST OF EXHIBITED WORKS

This list includes all works shown in
Edward Krasiński, Tate Liverpool
21 October 2016 – 5 March 2017
and Stedelijk Museum Amsterdam
1 July – 15 October 2017
Any works illustrated in the publication
that do not appear below are not exhibited

All works are by Edward Krasiński unless
otherwise stated
Page numbers indicate works that appear
in this catalogue
Dimensions of artworks are given in
centimetres, height before width
*Work only appears in the exhibition
at the Stedelijk Museum Amsterdam

Untitled c.1960
Wood, metal, roofing felt and acrylic paint
58 × 56 × 41
Paulina Krasińska and Foksal Gallery Foundation
p.25

Net I 1962
Wood, metal, plastic and acrylic paint
49 × 39 × 10
Paulina Krasińska and Foksal Gallery Foundation
p.27, right

Untitled 1962
Wood, metal, plastic and acrylic paint
85.5 × 44.5 × 32.5
Collection Philipp and Christina
Schmitz-Morkramer, Hamburg
p.28, left

Composition in Space IX 1963
Wood, metal and acrylic paint
53 × 54 × 15
Private Collection, Turin, Italy
p.29, bottom

Spear c.1963–4
Wood, metal and acrylic paint
70 × 5 × 540
Paulina Krasińska and Foksal Gallery Foundation
pp.30–1, top middle work

Composition in Space 1964
Wood, wire and acrylic paint
61 × 54 × 21
Paulina Krasińska and Foksal Gallery Foundation
p.37, top right work

Composition in Space 1964
Wood, metal and acrylic paint
52 × 50 × 18
Paulina Krasińska and Foksal Gallery Foundation
p.37, top left work

Composition in Space 1964
Wood, metal and acrylic paint
71 × 29 × 15
Paulina Krasińska and Foksal Gallery Foundation
p.37, bottom right work

Composition in Space 1964
Wood, canvas, metal and acrylic paint
81.5 × 40 × 15
Paulina Krasińska and Foksal Gallery Foundation
p.28, right

Composition in Space 1964
Wood, metal and acrylic paint
48 × 105 × 35
Paulina Krasińska and Foksal Gallery Foundation
p.30, top left work

Untitled 1964
Metal and acrylic paint
23 × 105 × 5
Paulina Krasińska and Foksal Gallery Foundation
p.36, bottom

Untitled c.1964
Metal and acrylic paint
14 × 157 × 5
Paulina Krasińska and Foksal Gallery Foundation
p.35, bottom

Object in Space 1964–5
Wood, metal and acrylic paint
260 × 100 × 11
Paulina Krasińska and Foksal Gallery Foundation
p.39, back right work

Composition in Space 1965
Wood, metal and acrylic paint
12 × 132 × 2.3
Muzeum Sztuki in Łódź
p.35, middle

Spear 1965
Wood, metal and acrylic paint
45.5 × 240
Zachęta – National Gallery of Art, Warsaw
p.35, top

Spear c.1965
Wood, metal and acrylic paint
198 × 72 × 5
Paulina Krasińska and Foksal Gallery Foundation
p.39, front left work

Untitled 1965
Metal and acrylic paint
210 × 260
Kontakt. The Art Collection of Erste Group
and ERSTE Foundation
pp.40, 134–5

Untitled 1965
Wood, cardboard, metal and acrylic paint
189.9 × 8.2 × 8.2
Presented by Tate Patrons 2007
p.34

Untitled 1965
Wood, cardboard, metal, plastic and acrylic paint
195 × 41 × 41
Paulina Krasińska and Foksal Gallery Foundation
p.41, bottom left

Untitled 1965
Wood, metal and acrylic paint
10 × 192
Paulina Krasińska and Foksal Gallery Foundation
p.33

Composition in Space 4 1966
Wood, cardboard, metal and paint
200 × 47 × 57
Muzeum Sztuki in Łódź

Untitled 1966
Wood, metal and acrylic paint
233 × 89 × 8
National Museum in Warsaw
p.41, bottom right

Bar 7 1967
Wood, steel and acrylic paint
30.5 × 425.5 × 19
Starmach Gallery, Kraków
p.59, left

H6 1967
Wood, aluminium, metal and acrylic paint
28 × 320 × 6
Muzeum Sztuki in Łódź
p.58, front left work

Untitled 1967
Wood, metal, photograph and acrylic paint
28 × 37 × 15
Paulina Krasińska and Foksal Gallery Foundation
p.59, bottom right

Untitled 1967
Wood, metal, plastic and acrylic paint
34 × 260 × 8
Paulina Krasińska and Foksal Gallery Foundation
p.60, bottom

Untitled 1967
Wood, metal, plastic, photograph and acrylic paint
121 × 31 × 26
Paulina Krasińska and Foksal Gallery Foundation

Untitled 1967
Wood, metal and acrylic paint
52.5 × 227 × 17
Private Collection, Turin, Italy
p.61, top right

i-4 1968
Aluminium, metal, plastic and acrylic paint
27 × 114 × 9
Muzeum Sztuki in Łódź
p.61, top left

K 3 1968
Wood, plastic, metal, plaster, canvas and
acrylic paint
55 × 46 × 2 (cable length c.450)
Muzeum Sztuki in Łódź
p.79

K 5 1968
Wood, plastic and acrylic paint
155 × 16 × 12
Muzeum Sztuki in Łódź
p.78, right

K 6 1968
Wood, plastic, rubber and acrylic paint
300 × 12 × 2.6
Muzeum Sztuki in Łódź
p.78, left

Untitled 1968
Fibreboard, cardboard, plastic and
transfer lettering
11 × 44 × 100
Presented by Tate Patrons 2007

Untitled 1968
Wood, steel, photograph and acrylic paint
18 × 71 × 58.3
Presented by Tate Patrons 2007
p.59, top

Untitled 1968
Metal, rubber and acrylic paint
73.5 × 11.5 (diameter)
Paulina Krasińska and Foksal Gallery Foundation

K... Composition with a Cylinder 1969
Wood, rubber, plastic and acrylic paint
65 × 16 (cable length c.470)
National Museum in Poznań

L 1969
Paper, plastic, plaster and acrylic paint
363 × 34.5 × 3
Muzeum Sztuki in Łódź

L Composition with a Book 1969
Wood, paper, plastic and acrylic paint
12 × 16 × 30
National Museum in Poznań
p.77

L 3 1969
Paper, plastic and acrylic paint
17.5 × 13.5 × 9
Národní galerie v Praze / National Gallery, Prague
p.72, bottom

N... (Intervention 4, Zig-Zag) 1969
Wood, plastic and acrylic paint
70 × 1.5 (folded), 770 × 1.5 (stretched)
Generali Foundation Collection – Permanent
Loan to the Museum der Moderne Salzburg
pp.80–1, work on left of group of three *Zig-Zags*

N... (Intervention 4, Zig-Zag) 1969
Wood, plastic and acrylic paint
70 × 1.5 (folded), 700 × 1.5 (stretched)
Generali Foundation Collection – Permanent
Loan to the Museum der Moderne Salzburg
pp.80–1, work on right of group of three *Zig-Zags*

N... (Intervention 4, Zig-Zag) 1969
Wood, plastic and acrylic paint
70 × 1.5 (folded), 630 × 1.5 (stretched)
Generali Foundation Collection – Permanent
Loan to the Museum der Moderne Salzburg
pp.80–1, work at top of group of three *Zig-Zags*

L-Untitled 1969
Plastic and acrylic paint
Dimensions unknown
Private Collection, France
p.76

Untitled 1969, reconstructed 1978
Wood, string and cardboard
11.5 × 49 × 30
Presented by Tate Patrons 2007
p.61, bottom

Intervention 1974
Wood, fibreboard, metal, ceramic, plastic,
adhesive tape, enamel paint and household paint
110 × 75 × 15
Paulina Krasińska and Foksal Gallery Foundation
p.49, top

Intervention 1974
Plywood, adhesive tape and acrylic paint
110 × 95.5 × 12
Muzeum Ziemi Chełmskiej in Chełm, Galeria 72
p.101

Intervention 10 1974
Wood, fibreboard, metal, adhesive tape and
acrylic paint
111 × 75.5 × 11
Generali Foundation Collection – Permanent
Loan to the Museum der Moderne Salzburg
p.48, middle work

Intervention c.1974
Fibreboard, adhesive tape and oil paint
99.5 × 69.5
Signum Foundation, Poznań
p.89, left work

Intervention 1975
Hardboard, adhesive tape and oil paint
70 × 50 × 3
Grażyna Kulczyk Collection
p.93

Intervention 1975
Fibreboard, adhesive tape and acrylic paint
70 × 50
Muzeum Okręgowe im. Leona Wyczółkowskiego
in Bydgoszcz
p.87

Intervention 3 1975
Hardboard, adhesive tape and acrylic paint
70 × 50 × 4
Grażyna Kulczyk Collection
p.94

Intervention 10 1975
Hardboard, adhesive tape and oil paint
100 × 70 × 3
Grażyna Kulczyk Collection
p.88

Intervention 11 1975
Wood, plywood, adhesive tape and acrylic paint
99.7 × 70 × 3.3
Starmach Gallery, Kraków
p.95

Intervention 13 1975
Fibreboard, steel, adhesive tape and acrylic paint
100 × 70 × 3.2
Muzeum Sztuki in Łódź

Intervention 15 1975
Hardboard, adhesive tape and acrylic paint
69.9 × 50 × 3.3
Presented by Tate International Council 2007
p.92, right work

Intervention 25 1975
Harboard, adhesive tape and oil paint
100 × 70 × 3
Grażyna Kulczyk Collection
p.85

Intervention 27 1975
Hardboard, adhesive tape and acrylic paint
69.9 × 50 × 2.8
Presented by Tate International Council 2007
p.92, left work

Intervention I 1976
Fibreboard, adhesive tape and acrylic paint
100 × 70
Collection Philipp and Christina Schmitz-
Morkramer, Hamburg
p.97, right work

Henryk Stażewski (1894–1988)
no. 47 1976
Acrylic paint on fibreboard
64.8 × 64.8 × 3.5
Anka Ptaszkowska Collection, courtesy of
Museum of Modern Art in Warsaw

Intervention 14 1977
Fibreboard, metal, adhesive tape and acrylic paint
100 × 70 × 3
Muzeum Sztuki in Łódź
p.91, left work

Intervention 15 1977
Fibreboard, metal, adhesive tape and acrylic paint
100 × 70
Muzeum Sztuki in Łódź
p.90, right work

Intervention 16 1977
Fibreboard, metal, adhesive tape and acrylic paint
100 × 70 × 3
Muzeum Sztuki in Łódź
p.91, right work

Intervention 17 1977
Fibreboard, metal, adhesive tape and acrylic paint
100 × 70 × 3
Muzeum Sztuki in Łódź
p.90, left work

Intervention 1978
Hardboard, adhesive tape and acrylic paint
40 × 30 × 13
Anna and Jerzy Starak Collection
p.100

Intervention 1978
Fibreboard, adhesive tape and acrylic paint
100 × 70
Muzeum Narodowe w Szczecinie /
National Museum in Szczecin
p.98

Intervention 1983
Plywood, adhesive tape and acrylic paint
114 × 70 × 15
Private Collection, courtesy of Museum of
Modern Art in Warsaw
p.103, left work

Małgorzata Potocka (b.1953)
Trzy wnętrza (*Three Interiors*) 1983
Film, 35 mm transferred to DVD, colour, sound
46 mins (excerpt)

Retrospective K140 1984
Photograph, plywood and adhesive tape
Ten objects, each 70 × 50 × 10
Kontakt. The Art Collection of Erste Group
and ERSTE Foundation
pp.134–5

Paperclips 1985
Steel
Five objects: 1 × 14 × 65; 43 × 14 × 65; 48 × 14 × 65;
60 × 14 × 65; 61 × 14 × 64.5
Paulina Krasińska and Foksal Gallery Foundation
p.125

Intervention 1988
Plywood, adhesive tape and acrylic paint
Four objects, each 70 × 50 × 10
Sammlung Migros Museum für Gegenwartskunst
p.106

Intervention 1989
Plywood, adhesive tape and acrylic paint
71 × 100 × 10, extended part 10 × 68 × 10
Courtesy Galerie Natalie Seroussi
p.107

Intervention 1990
Hardboard, adhesive tape and acrylic paint
99.6 × 69.8 × 19.5
Anna and Jerzy Starak Collection

Intervention 1991
Acrylic paint on board
100 × 70
Muzeum Okręgowe im. Leona Wyczółkowskiego
in Bydgoszcz
p.104, left work

Intervention 1991
Acrylic paint on board
100 × 70
Muzeum Okręgowe im. Leona Wyczółkowskiego
in Bydgoszcz
p.104, right work

Installation 1994
Plywood, cardboard, fibreboard, wood, metal,
photograph and acrylic paint
Dimensions variable
Paulina Krasińska and Foksal Gallery Foundation

Intervention 1994
Plywood, adhesive tape, photograph and
acrylic paint
100 × 70 × 10
Paulina Krasińska and Foksal Gallery Foundation

Untitled 1994
Wood, adhesive tape, photograph and
acrylic paint
Twelve objects, each: 10 × 10 × 10; overall
dimensions variable
Paulina Krasińska and Foksal Gallery Foundation

Untitled 1996
Photograph, wood, rope and acrylic paint
200 × 100 × 73
Paulina Krasińska and Foksal Gallery Foundation

Untitled 2001
Mirror and adhesive tape
Fourteen objects, each 50 × 60 × 0.4;
overall dimensions variable
Paulina Krasińska and Foksal Gallery Foundation

SPONSORS AND DONORS

Sponsors and Donors

Art Fund
The Austin and Hope Pilkington Trust
The Austrian Cultural Forum
The Austrian Federal Chancellery
The Bloxham Charitable Trust
The City of Liverpool College
The Clore Duffield Foundation
Creative Europe programme of the
 European Union
Edge Hill University
The Estate of Francis Bacon
The Estate of H.W. Bibby
European Regional Development Fund (ERDF)
Foksal Gallery Foundation
Francis Bacon MB Art Foundation
The German Federal Foreign Office
Goethe-Institut London
Government of Mexico
Gower Street Estates
The Hemby Trust
Andrew Hochhauser
Institut Français du Royaume Uni
Grażyna Kulczyk
Liverpool City Council
Liverpool Hope University
Liverpool John Moores University
Maria Lassnig Foundation
Markit
Mersey Care NHS Mental Health Trust
The Ministry of Culture and National Heritage
 of the Republic of Poland and Culture.pl.
National Lottery through Arts Council England
Paul Hamlyn Foundation
Polish Cultural Institute
The Pollock-Krasner Foundation
The Preston Family Charitable Settlement
Pullman Liverpool
The Ravensdale Trust
The Romanian Cultural Institute in London
Francis Ryan & Peter Woods
Skelton Bounty
The Steel Charitable Trust
Tate Americas Foundation
Tate Liverpool Members
Terra Foundation for American Art
and those who wish to remain anonymous

Tate Liverpool Commissioning Circle

Jo & Tom Bloxham MBE
Ben Caldwell
Tom & Jane Samson
Roisin & James Timpson OBE
Ross Warburton & Caroline Barnard

Patrons

Elkan Abrahamson
Hilary Banner
Diana Barbour
David Bell
Lady Beverley Bibby
Jo & Tom Bloxham MBE
Ben Caldwell
Shirley & Jim Davies OBE
Jonathan Falkingham MBE
Julie Falkingham
Olwen McLaughlin
Mike Orsborn
Barry Owen OBE
Sue & Ian Poole
Philip & Jane Rooney
Jim & Jackie Rymer
Tom & Jane Samson
Alex Sharp
Alan Sprince
Roisin Timpson

Corporate Partners

Birmingham City University
The City of Liverpool College
David M Robinson (Jewellery) Ltd
DLA Piper
Edge Hill University
Liverpool Hope University
Liverpool John Moores University
MBNA

Corporate Members

The Art School Restaurant by Paul Askew
Bank of America Merrill Lynch
Bibby Line Group
Cheetham Bell
DWF
EY
Grant Thornton
Home Bargains
Lime Pictures
Rathbone Brothers Plc
Unilever R&D Port Sunlight

LENDERS TO THE EXHIBITION

Collection Philipp and Christina Schmitz-Morkramer, Hamburg

Foksal Gallery Foundation

Galeria Starmach, Kraków

Galerie Natalie Seroussi, Paris

Generali Foundation Collection / Museum der Moderne Salzburg

Grażyna Kulczyk Collection

Kontakt Art Collection – The Art Collection of Erste Group and ERSTE Foundation

Paulina Krasińska / The Estate of Edward Krasiński

Museum of Modern Art in Warsaw

Muzeum Okręgowe im. Leona Wyczółkowskiego in Bydgoszcz

Muzeum Sztuki in Łódź

Muzeum Ziemi Chełmskiej in Chełm, Galeria 72

Národní galerie v Praze / National Gallery, Prague

National Museum in Poznań

Muzeum Narodowe w Szczecinie / National Museum in Szczecin

National Museum in Warsaw

Małgorzata Potocka

Anka Ptaszkowska

Sammlung Migros Museum für Gegenwartskunst

Signum Foundation, Poznań

Zachęta – National Gallery of Art, Warsaw

and those lenders who wish to remain anonymous

IMAGE CREDITS

Every effort has been made to trace copyright holders; the publishers apologise if any omissions have inadvertently been made.

Front cover, pp.36 bottom, 60 bottom, 61 bottom, 92, 119, 120: photograph by Jan Smaga, courtesy Paulina Krasińska and Foksal Gallery Foundation, Warsaw

Back cover, pp.2, 8, 10 middle, 11 bottom, 12, 13, 14, 15, 19, 24, 26, 29, 35, 36 top, 40, 41 top and bottom right, 42, 43, 44, 48, 51, 52 top, 56, 57, 58, 59 top, 59 bottom right, 60 top, 61 top left, 63, 67, 68 top, 71, 72 bottoms, 74, 75, 76, 77, 78, 79, 82, 83, 86, 89, 103, 108, 110 left, 113, 114, 128, 129, 132, 133, 134–5, 136: photograph by Eustachy Kossakowski, © Anka Ptaszkowska and archive of Museum of Modern Art Warsaw, courtesy Paulina Krasińska and Foksal Gallery Foundation, Warsaw

p.4: photograph from the archives of the Department of Contemporary Art in Koszalin Museum

p.10 top: Private Collection / Bridgeman Images

pp.16, 17, 18, 49 top: photographs by Maja Wirkus, 2016, © Maja Wirkus; courtesy Paulina Krasińska and Foksal Gallery Foundation, Warsaw

p. 20: © 2016 Ewa Sapka-Pawliczak, legal successor of copyrights to Władysław Strzemiński's works, and Muzeum Sztuki in Łódź

pp. 21, 27 right, 28, 30–1, 33, 59 bottom: photograph by Wojciech Tubaja, courtesy Paulina Krasińska and Foksal Gallery Foundation, Warsaw

pp.25, 27 left: photograph by Bartosz Stawiarski, courtesy Paulina Krasińska and Foksal Gallery Foundation, Warsaw

p.28, left: Collection Philipp and Christina Schmitz-Morkramer, Hamburg

pp.29 top, 36 top: Private Collection

pp.29 bottom, 61 top right: Private Collection, Turin, Italy

p.32: photograph by Zbigniew Dłubak, archive of The Archeology of Photography Foundation, © Armelle Dłubak, The Archeology of Photography Foundation

pp.34, 59 top, 61 bottom: Presented by Tate Patrons 2007

p.35 top: Zachęta – National Gallery of Art, Warsaw

pp.35 middle, 61 top left, 78, 79: Muzeum Sztuki in Łódź

pp.35 bottom, 68 bottom, 105, 126–7, 130: courtesy Paulina Krasińska and Foksal Gallery Foundation, Warsaw

pp.37, 61 top right: photograph by Marek Gardulski, courtesy Paulina Krasińska and Foksal Gallery Foundation, Warsaw

pp.38, 39, 54: photograph by Jacek Maria Stokłosa

p.41 bottom left: photograph by Michał Diament, © Michał Diament

p.41 bottom right: National Museum in Warsaw

p.47: Courtesy Associação Cultural 'O Mundo de Lygia Clark'

p.49, bottom: © Succession Marcel Duchamp/ ADAGP, Paris and DACS, London 2016; photo courtesy of Moderna Museet, Stockholm

p.50 top: © Succession Marcel Duchamp/ADAGP, Paris and DACS, London 2016; photograph © Henri-Pierre Roché, courtesy Jean-Jacques Lebel

p.50 bottom: image courtesy the Artist and Cabinet, London

p.52 bottom: © Succession Marcel Duchamp/ ADAGP, Paris and DACS, London 2016; courtesy of Leo Baeck Institute, New York, and Philadelphia Museum of Art, Library & Archives, Gift of Jacqueline, Paul and Peter Matisse in memory of their mother Alexina Duchamp, 13-1972-9(303)

pp.59 left, 95: Starmach Gallery, Kraków

pp.62, 125, 129 top: Archive of the Foksal Gallery

pp.64, 66 top: © The Solomon R. Guggenheim Foundation, New York

p.66 bottom: © Judd Foundation/ARS, NY and DACS, London 2016; photograph The Jewish Museum/Art Resource/Scala, Florence

p.72 bottom: Národní galerie v Praze / National Gallery, Prague

p.72 top: © The estate of Eva Hesse, courtesy Hauser & Wirth, Zürich; photograph courtesy Tate Images

p.76: Private Collection, France

p.77: National Museum in Poznań

pp.80–1: © Generali Foundation Collection— Permanent Loan to the Museum der Moderne Salzburg; photograph Werner Kaligofsky

p.84: photograph by Krzysztof P. Wojciechowski, courtesy Monopol Gallery, Warsaw; Paulina Krasińska and Foksal Gallery Foundation, Warsaw

pp.85, 88, 93, 94: Grażyna Kulczyk Collection

pp.86, 104, 115, 116, 119, 122–3: Artist's archive, courtesy Paulina Krasińska and Foksal Gallery Foundation, Warsaw

p.87: Muzeum Okręgowe im. Leona Wyczółkowskiego in Bydgoszcz

pp.90–1: Kunst- und Ausstellungshalle, Bonn; photo by Peter Osvald

p.92: Presented by Tate International Council 2007

pp.96, 97, 99: photograph by Leszek Danilczyk, artist's archive, courtesy Paulina Krasińska and Foksal Gallery Foundation, Warsaw

p.98: Muzeum Narodowe w Szczecinie / National Museum in Szczecin

p.100: Anna and Jerzy Starak Collection

p.101: Muzeum Ziemi Chełmskiej in Chełm, Galeria 72

p.102: Courtesy of Coleção Teixeira de Freitas, Lisbon, and Foksal Gallery, Warsaw

p.106: Sammlung Migros Museum für Gegenwartskunst

p.111: photograph by Bogdan Łopieński

pp.107, 112, 117, 124: photograph by Tadeusz Rolke, © Tadeusz Rolke, courtesy Paulina Krasińska and Foksal Gallery Foundation, Warsaw

p.121: photograph by Szymon Rogiński

p.134–5: Kontakt. The Art Collection of Erste Group and ERSTE Foundation

p.143: photo by Konrad Pustoła, courtesy Paulina Krasińska and Foksal Gallery Foundation, Warsaw

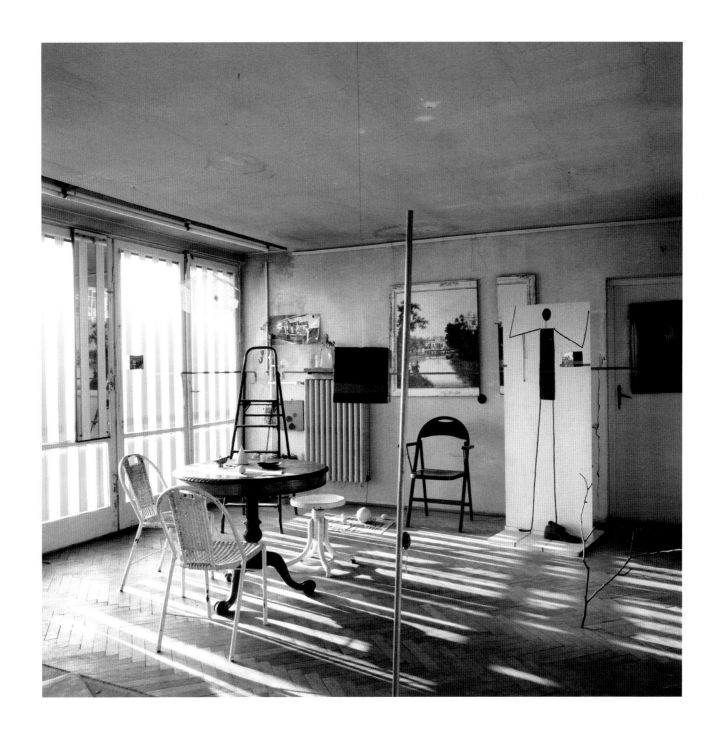

Edward Krasiński's studio, Warsaw

First published 2016 by order
of the Tate Trustees by
Tate Liverpool
Albert Dock, Liverpool L3 4BB
in association with Tate Publishing,
a division of Tate Enterprises Ltd,
Millbank, London SW1P 4RG
www.tate.org.uk/publishing

On the occasion of the exhibition
Edward Krasiński
at Tate Liverpool
(21 October 2016 – 5 March 2017)
travelling to
Stedelijk Museum Amsterdam
(1 July – 15 October 2017)

Publication supported by:

Foksal Gallery Foundation
and Grażyna Kulczyk

The Stedelijk Museum, Amsterdam
is supported by:

Gemeente Amsterdam

Principal Sponsor

Rabobank
Partner

BankGiro Loterij

Exhibition at Tate Liverpool supported by:

The Ministry of Culture and National Heritage of
the Republic of Poland and Culture.pl
and the Polish Cultural Institute in London

© Tate 2016

All works by Edward Krasiński © Paulina Krasińska
and Foksal Gallery Foundation

British Library Cataloguing in Publication Data
A catalogue record for this book
is available from the British Library

ISBN 978-1-84976-492-6

Project Editor: Catherine Hooper
Designer: Sara De Bondt
Headline typeface by Sara De Bondt studio
and Sueh Li Tan / TypoKaki
Colour reproduction and printing by Tecnostampa
– Pigini Group, Printing Division, Loreto – Trevi

Stedelijk Museum Amsterdam cat. no. 933

Jean-François Chevrier is Professor of the
History of Contemporary Art at the École
nationale supérieure des Beaux-Arts, Paris.

Kasia Redzisz is Senior Curator at Tate Liverpool.

Karol Sienkiewicz is an art historian and critic
based in Vancouver.

Stephanie Straine is Assistant Curator at
Tate Liverpool.

Front cover:
Edward Krasiński
Detail of *Intervention* 1983
Plywood, adhesive tape and acrylic paint
114 × 70 × 15
Private Collection, courtesy of Museum of
Modern Art in Warsaw; photograph by Jan Smaga,
courtesy Paulina Krasińska and Foksal Gallery
Foundation, Warsaw

Back cover: Edward Krasiński, *Intervention*,
Zalesie, 1969, photograph by Eustachy
Kossakowski, © Anka Ptaszkowska and archive of
Museum of Modern Art Warsaw, courtesy Paulina
Krasińska and Foksal Gallery Foundation, Warsaw

Dimensions of artworks are given in centimetres,
height before width

FSC MIX
Paper from
responsible sources
FSC® C127663